WITHDRAWN

Käthe Kollwitz

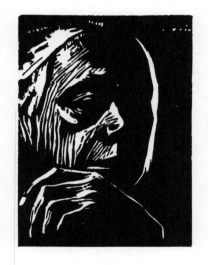

THE
Diary and Letters
OF
KAETHE KOLLWITZ

EDITED BY HANS KOLLWITZ

TRANSLATED BY RICHARD AND CLARA WINSTON

NORTHWESTERN UNIVERSITY PRESS

EVANSTON, ILLINOIS

FOREWORD

I FIRST became aware of the great German artist, Kaethe Kollwitz, in 1931 when a partner of mine came across a reproduction of one of her drawings in a European dealer's catalogue. We arranged an exhibition in our Gallery in Boston, and when the prints arrived we were struck by their great power and beauty. The first question about Kollwitz was—how were these prints executed? Technically, many did not fit into any of our categories of pure printmaking. Eventually we learned how she worked in mixed techniques, evolving an extremely personal idiom.

The second question was—what of Kaethe Kollwitz the woman? We could find out only the bare biographical facts; that she was born in Koenigsberg, East Prussia, married a doctor in Berlin; was refused the small gold medal for her "Weavers" series, inspired by Gerhart Hauptmann's play, by Kaiser Wilhelm II; lost her youngest son in World War I; and had her work banned by Hitler—all impersonal, cold facts. There may be a longer biography of Kollwitz in German, a language which I do not master, but I concluded that

this powerful, intense artist, during her lifetime, wished to keep her personal life private.

Therefore, when I read the manuscript of this volume, I found it poignantly revealing; the gripping and moving fragmentary statement of a great human being. In her graphic work and in her sculpture, there is tenderness, great power, and technical mastery. But I was not prepared for the light-hearted moods, her motherly absorption in her boys, and the full-blooded naturalness in things physical, which are revealed in this book. Though her early life was greatly influenced by her father and grandfather, both lay preachers, she did not settle into a Puritanical attitude. Her deep human feeling for the workers was neither sentimental nor abstract, but based on observation and knowledge of their hardships and their fleeting joys. Although the bulk of her papers was lost in the blitz of Berlin, what remains still reveals the intense feelings and thoughts of one of the greatest graphic artists of all time. That she was able to achieve this pre-eminence even while fulfilling the responsibilities of a wife and mother should be an inspiration to professional women everywhere.

The book could have been called "The Battle With Sculpture." While there are only short accounts of technical difficulties with lithography and etching, there are many passages on her troubles to satisfy herself about her sculpture. Her triumphs, such as the successful showing of the monument for her son Peter, are mentioned merely as incidents which would not have created a void if they had not occurred.

The loss of her son Peter, in the first World War, cast a shadow that was never dispelled. There is no word of blame or hate for the enemy—only profound sorrow for the youth of all countries sacrificed in War. She states and restates her willingness to have died to save her son. This is perhaps extravagant—no parent can achieve such aim. On the other hand the tale of her long struggle to complete the monumental sculptures for the Belgian cemetery where her son lies buried is a great saga of perseverance and of love.

As one who has known the work of Kaethe Kollwitz for over twenty years, I find this volume fascinating for the insight it gives into the life and mind of an extraordinary woman and a great and moving artist.

HUDSON D. WALKER

KAETHE KOLLWITZ, 1867-1945

July 8, 1867—Born in Koenigsberg as the daughter of Karl Schmidt and Katharina Schmidt (nee Rupp)

1885–86—Studies in Berlin with Stauffer-Bern

1888–89—Studies in Munich with Herterich

1891—Marriage to Dr. Karl Kollwitz and move to Berlin

1892—Birth of son Hans

1896—Birth of son Peter

1895–98—"The Weavers"

1902–08—"Peasant War"

1904—Journey to Paris

1907—Journey to Italy

October 22, 1914—Son Peter killed

February 6, 1919—Member of the Academy of Arts

1923—Woodcut series "The War"

1927—Journey to Russia

1928—Head of a master class for graphic arts

August, 1932—Unveiling of monuments at the Roggevelde military cemetery near Eessen

September 30, 1933—Resignation from the Academy

1934–35—Sculpture series "From Death"

July 19, 1940—Death of Karl Kollwitz

September 22, 1942—Grandson Peter killed

August, 1943—Evacuation to Nordhausen

November 23, 1943—Destruction of residence in Berlin, Weissenburger Strasse 25

July 20, 1944—Move to Moritzburg

April 22, 1945—Death in Moritzburg

CONTENTS

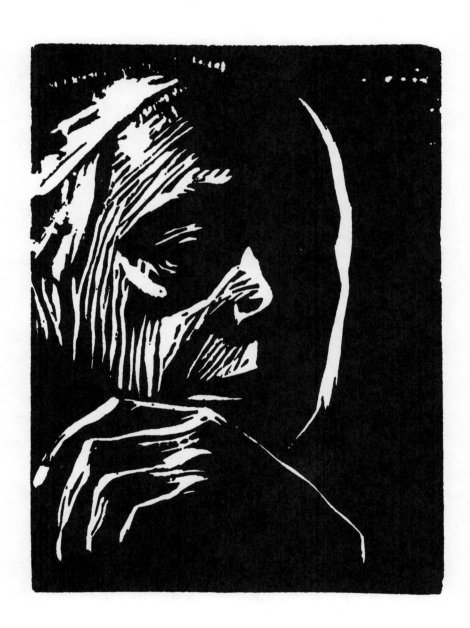

INTRODUCTION

MANY years ago I first asked my mother to set down an account of her life, because it seemed to me that everyone past fifty would be doing a service to himself and others if he clarified the more or less satisfactory results of his life and described the paths by which life led him or he led it to those results. I was all the more anxious to have such an account from my own mother, whose evolution as an artist was familiar to so many people, while almost nothing was known about her personal development. For she seldom spoke about her life, even to her children.

But no matter how I urged her, she would not comply with my wish. If anything in her life had been important, it was her work, she would reply. "And their works do follow them," she would quote when we talked about this matter. She said that her private life with its wholly personal events and all its follies was of no interest to any one. Moreover, she maintained, she did not write well enough to be able to present it in sufficiently objective fashion. Nevertheless, either my arguments made an impression upon her or she wished to give me pleasure, even against her convictions. In any case, one day—it must have been around 1922—I found on my birthday table a large brown

1

sketch-pad with a handwritten account of her childhood and youth up to the time she went to Munich. She ended these notes at the point where childhood and untrammeled youth lay behind her and she entered the realm of marriage and professional work which was still her realm at the time she set down her reminiscences.

I suppose she did not harbor any really deep objections to having the story of her personal life told, so long as she herself did not have to tell it. For she once asked me to do a book after her death. This book was to be entitled, "My Parents." It was a bitter moment for me when I realized that I could not undertake such a task. I could not call up memories of home in all their richness and detail, their beauty and pleasure, as some fortunate people can. Of course I have memories of childhood and youth in which my mother plays a part. But these memories are not sense memories; I do not hear her voice or see her face and how she moved. Both of us boys, myself and my brother Peter, who was four years younger than I, loved our home and above all loved our mother. But we loved her with that naturalness with which young animals as well as human beings love their mothers. While the feeling itself remains perfectly natural, the children never doubt that their mother is there for them and there is no talk of love at all. Love was simply there, felt but not shown; and our mother was not given to demonstrativeness.

Along with this reserve in talking about or showing love went a disinclination to speak about feelings at all, or about any personal matters. She could speak about other people and what happened to them, about books, about problems, even about her own works; but actually she never spoke about herself. This was consistent with the attitude which had prevailed in her grandparents' and parents' households: that one's work could be considered important, but oneself never. The same spirit underlies the inscription on the gravestone of her grandfather, Julius Rupp: "Man is not here to be happy, but to do his duty." To outsiders my mother gave the impression of being impregnable; only in her diaries can you see how she struggled with the antagonist within herself, and how essential that struggle was to her development.

When I think of Mother in retrospect now, the image of her earlier years, when she had all her powers, is almost totally blotted out by my picture of her last years of physical and spiritual suffering and weariness.

But some impressions of these earlier times survive. How Mother shared

our life when we were boys and she was still young. How she took part in our fantastic games, especially when these games were linked up with her own childhood. Until the destruction of our house I still had the manuscript of my first drama, "Siegfried and Gundhilda, or Treachery and Loyalty," in Mother's own handwriting; she had taken it down at my dictation when I was about eleven. Theatrical performances meant a great deal in our life together. Mother approved of them and enjoyed them, and she enjoyed also the funny incidents that sometimes occurred. In Schiller's play *Semele*, for example, I played Jupiter. The lines called for me to alternate light and darkness as a symbol of the divine power. I stood beneath the gas lamp in our room and turned the gas up and down, declaiming proudly: "Zeus alone can do this." How Mother laughed!

These amateur theatricals were among the high points of our lives as boys. Twice we gave performances in which the older generation took part—in the sweat of their brows, for learning parts by heart did not come easily to them. During a summer vacation in Ahrenshoop we gave a performance of *A Midsummer Night's Dream* in a truly Shakespearian forest clearing; and we staged the whole of Gorki's *Lower Depths* in our apartment on Weissenburger Strasse.

Mother loved laughter and longed for opportunities to laugh. People who have known her only in her serious moods, sitting with kind, melancholy eyes, listening attentively, or who know her only in her works, do not know the part of her that delighted in affirmation, in young people, in wit, laughter, high spirits and comedy. They do not know how she loved liveliness and grace of movement, which for her were embodied in the Viennese dancer Grethe Wiesenthal. Whenever Frau Wiesenthal visited Berlin she would always come to see Mother, and both Mother and I were captivated by her irresistible laughter and her gaiety, which we so loved and could not achieve for ourselves.

We did not have what is commonly called a social life. My father was overburdened by work; moreover, his professional circle and Mother's were too far apart to blend easily. For a few years during our boyhood, however, we held open house on Thursday evenings. The people who came to these evenings—writers, students, Russian exiles—dropped out of our lives entirely later on. Then too many people came to visit Mother alone in her studio or in our apartment; these were acquaintances passing through Berlin or people who wanted to meet her. Many of them were young, but most of them never

entered into our lives—the lives of Peter and me, that is. Mother would see anyone who wanted to call on her, although these visits often sapped her strength. People would bring their griefs and problems to her and usually left feeling relieved. But then *she* would have one more burden to bear. That was the usual way she helped people—although she also helped in a material way, when she was asked to or when she saw that help was needed. On the whole she differed radically in this from my father, who preferred to intervene actively rather than to listen passively. Because he was always kind and helpful, and because as a doctor he never treated a patient as a mere case or number, but always as a person in his own right, my father was universally revered.

There was a room in the top story of our home which in the course of years housed a remarkable variety of people: relatives and acquaintances who were passing through Berlin, political refugees, young people who were having trouble at home and wanted to get away from their parents for a while. Though some of these people made disturbing guests, in my parents' eyes they always had a right to this refuge.

On a trip to Paris my mother met a friend of her student days who was living with her son in great poverty. Mother simply took young Georg off with her to Berlin. He was my age, lived with us for years and has become a lifelong friend.

Both my parents were sympathetic to the "common people" and devoted themselves to them, Father by working with them and Mother by seeing into them, by trying to bring out in her art the characteristic qualities of the people, and by taking pleasure in their native rugged simplicity.

Although we had no official social life, a circle of relatives and friends had crystallized around us. We met mostly on Sundays in summer to go on picnics together. The expeditions were almost always organized and led by Mother, who had a wonderful feeling for places. Or we met on birthdays or some other festive occasion. These festivals are among our loveliest memories. The birthday celebration began in the morning, with candles set out, one for each year and the lifelight towering over them all. The lifelight could be blown out only by the birthday celebrant himself. Often the family would write verses for each year's light, or at least for the more important years. I still remember how Mother laughed one year when Ida, the cook who had terrified all of

us, had finally left for good and I commemorated this outstanding event by making up some verses parodying Goethe's epilogue to Schiller's *The Bell.*

My birthday was always a great thing because it came first in the summer succession of birthdays. It was a family tradition to spend this afternoon in Adami's Garden on the edge of Pankow Park. Beneath the flowering trees a long, festive coffee table was set, and here the whole family, blond heads, grey and white, assembled. After the coffee the grey heads and the white remained at the table and we boys went to the adjoining playground with its seesaws and gymnastic apparatus. But the climax of these festivals took place either at the Sterns' house—they were my mother's sister and brother-in-law, and were extremely musical—or in our own home. We were not particularly musical, but we loved to sing. We would all stand around in a circle, holding our glasses and singing the old song, *Lebe, Liebe.* As we sang:

> *Lebe, liebe, trink und schwaerme*
> *Und bekraenze dich mit mir,*
> *Haerme dich, wenn ich mich haerme*
> *Und sei wieder froh mit mir.*
> *(Live and love, drink, rejoicing,*
> *Wear a crown of gladness with me,*
> *Grieve with me when I am grieving,*
> *And frolic with me when I'm merry)*

we would clink glasses around the circle with the person next to us, at every word. The person whose glass was touched at the last word had to drink his glass and step out of the circle. Thus the circle grew smaller and smaller as we all became more excited to see who would be left in—as if being left in had some symbolic significance. If the birthday child had to step out early, someone usually sacrificed his place in order to let the child remain to the last if possible.

Then we played a game like the cup game in *Faust,* in which each person had to explain in rhyme the pictures on the cup. To the melody and rhythm of

> *Freut euch des Lebens, weil noch das Laempchen glueht,*
> *Pfluecket die Rose, eh' sie verblueht,*

5

each member of the circle to whom the handkerchief was thrown had to impro-
vise a new verse. There were some of us who covered ourselves with glory in
this game; to them the handkerchief was repeatedly tossed, while there were
others to whom the handkerchief was almost never thrown, out of pity. Mother
was among the latter. All in all, they were wonderful celebrations, nor did
they call for much alcohol. All that was needed was a readiness to enjoy, what
Mother meant by a "capacity for enthusiasm," which she herself had had so
strongly when she was young.

It was also wonderful to go traveling with Mother, or to take walks with
her—to be out in the open with her at all. At such times she was usually quiet;
when we were out to see things, she wanted to see, not talk. But often she was
so happy that, as she did once on a short trip to Rheinsberg, she would walk
hand in hand with me, singing folksongs. She loved nature, especially the pic-
turesque aspects of nature, and she drank in whatever she saw. But on none
of these trips which I made with her did I ever see her drawing. Nature did
not arouse her creative drive. That was why she found so much relaxation in
it. Although she took delight in the sensation of a reckless and dashing auto-
mobile ride, what she really loved was a walking tour which afforded the op-
portunity to stand still and just look. In the spring of 1907 when the Villa
Romana Prize enabled her to spend several months in Florence, she and a
younger friend of hers, Mrs. Stan Harding-Krayl, took a walking trip to
Rome through the Apennine villages and the deserted coastal marshes. The
two women were alone. But Mrs. Harding-Krayl was a courageous English-
woman who fended off potential trouble by her presence of mind and her
feared *bocca negra* (black mouth; that is, revolver). This exciting walking trip
through parts of Italy which were remote from civilization and sometimes
seemed wholly medieval, was one of Mother's greatest experiences. She and
her friend passed through villages where no strangers had been before. Once
the children gathered around them, numb with terror, until a small girl called
out with great relief: "But they are women." Unfortunately, the letters
Mother wrote and the journal she kept during this trip have all been burned.

Inspired by this walking tour, all four of us took a vacation walking trip
the following year through Thuringia and Franconia, and the year after that
we went through East Prussia and the Kurische Nehrung.

The diaries give us a valuable insight into Mother's methods of work and

her tempo. She constantly swung between long periods of depression and inability to work and the much shorter periods when she felt that she was making progress in her work and mastering her task. She suffered terribly during these spells of emptiness. Several times in her diaries she attempted to graph these periods and determine their course in advance. But this did not help her; she had to wait for the new surge of strength. Nor in such periods was she helped by poetry, which she loved so deeply, or by music. In general she was not a musical person; she did not "know anything about" music. But the great works of music which strike responsive chords deep within all people, aside from any musical background, meant a great deal to her—the Bach Passions, Beethoven's symphonies, Brahms' Requiem. Plastic art which had stimulated, excited or guided her in her youth—as for example the work of Klinger—did not mean nearly so much to her later. She was interested in it, but it no longer stirred her to the depths. Only when she encountered someone whose aims were the same as hers and who to her mind achieved them successfully, like Barlach, did she respond strongly. She turned to poetry far more than she did to the plastic arts. She read a great deal, and never casually; she read to find and fasten upon the essence. There was a good deal of reading aloud in our household. Often we read plays, dividing up the parts, and Mother read very well aloud, especially prose. Although she ordinarily lived withdrawn into herself, in this respect she needed to share with others by reading or telling about what she had read.

She was interested in modern poetry also, and was far more receptive to it than to modern painting. But the poet she always felt as most thoroughly hers was Goethe. He meant something to her at every age and in every situation in life, from the "tenderly youthful sorrow" of the early poems to the "seed for the planting must not be ground" from Wilhelm Meister, and to the verses from the *Westoestlicher Divan:* "God is master of the East, God is master of the West. All the northern and southern lands rest in peace within his hands." She took these verses as inspiration for her gravestone relief, in which two great hands clasp a weary human head within themselves.

It was always difficult for her to find a definite position in politics, and in fact she never really took one. When the First World War broke out she was overwhelmed by a frightful melancholy. But at the beginning she was swept out of this melancholy by the attitude of the young men, and especially by the

enthusiasm of my brother Peter and his friends. At that time we had not yet experienced war; we did not know the background of the war and were imbued with Hoelderlin's conception of "death for the Fatherland" and with the idea of sacrifice. Mother wanted to keep faith with her son who had given his life as a voluntary sacrifice; she felt that keeping faith meant she must also be willing to sacrifice. It was only after a terrible struggle with herself that she came, in the course of the war years, to take a view toward the war different from that of her deeply-loved son Peter, who had fallen in action on October 22, 1914. And shortly before the collapse in 1918, when Richard Dehmel called for the best men of the nation to volunteer and offer a last resistance, she publicly opposed his position in the essay reprinted here: "Seed for the planting must not be ground" [page 88].

To her dying day she held to the belief: "No more war." Again and again she urged that the idealism and readiness for sacrifice of the young people should be turned not toward war, but toward building a better life and society. When Nazism was knocking at the gates, she publicly took sides against it, and had to take the consequences: she was dropped as teacher at the Academy; she lost the excellent studio she had had there; and until the end of her life she was not again permitted to show her work publicly.

Because of her enforced isolation during these last years of her life, little is known about them, and I shall therefore describe some of their more important aspects.

The years after 1933 brought her new cause for suffering. She could not help learning of the horrors that were occurring in Germany; so many of those who were affected came to her to pour out their grief and dread. And all her life she was never able to observe the miseries of others without taking them into herself. That was the reason people told her their troubles. She seldom gave advice, but she listened, "preserved their words in her heart." Then came the war and brought new sufferings to more people. In the beginning she was personally spared. But soon the grim fate of all also came home to her. On July 19, 1940, my father died. A man full of love, deeply concerned about others, but basically happy and affirmative in spirit, he had been by her side for forty-nine years. Sometimes they had moved apart, sometimes she had felt chained to him and had rebelled against the fetters, as was inevitable with two people so fundamentally different; but still they were always very close.

8

And when the protection of this faithful companion vanished, we realized how much of a support he had been to her.

From then on her strength perceptibly diminished. Two years later, on October 14, 1942, I had to bring her word that our son Peter had fallen in Russia. My parents particularly loved him because he was their first grandchild and bore the name of their own son who had died in the First World War. Even then she bore herself proudly, did not grieve openly, scarcely wept; she tried to give us strength to bear it. But the blow had been deep and damaging—although at that time her mind was as active as ever. She still took in all that her visitors told her; she still responded to what she read and retained it. It was not so remarkable that she still remembered and could repeat the things she had learned as a young woman—the impressions of youth can always be summoned up out of their depths when the impressions of age no longer remain. But even at seventy-five she could still quote almost word for word from whatever she was reading.

However, she did virtually no more work, and that was a sign that her life forces were beginning to ebb. In August 1943, the bombings having become unendurable to her, she fled to Nordhausen in the Harz Mountains, where she was cordially welcomed into the home of Margarete Boening, the sculptress. Here was a community of younger people, and for a time their cheerfulness revived her. I recall visiting them one evening and finding them in the kitchen, washing dishes, with three young women singing and Mother listening with quiet delight. But the war followed her even to this apparently peaceful haven of Nordhausen. On November 23, 1943, her home in Berlin, Weissenburger Strasse 25, was totally destroyed. This house had become identified with her name; she had lived there since 1891, both her children had been born in it, her family had grown up in it, and it had seen the beginning and end of her artistic career. We were able to save some things from the fire; but all her letters, her mementos of her husband, son and grandson, were lost. A week later bombs struck our house in Lichtenrade, which had been a place of so much joy and so many memories for our parents. Now her children and grandchildren were homeless like herself. But even then she did not complain; she bore it all silently, but in bitterness.

About this time her heart began to fail her, and often she was on the brink of death. She felt her physical and spiritual forces slipping away, leaving only

sorrow, weariness, immobility, and frightful, tormenting dreams. It was then that she began to yearn for the release of death.

Gradually Nordhausen too became unsafe and we had to look for another refuge for Mother. Through the intervention of Prince Ernst Heinrich of Saxony, a collector, art-lover and admirer of my mother's work, we found two small rooms on the estate called Ruedenhof, in the village of Moritzburg, near Dresden. There Mother lived for more than half a year; my last and sharpest memories of her, overlaid by no later impressions, are of her there. When I came from Berlin on Saturdays—as time passed the trip became increasingly difficult—I would have to walk from Weinboehla through the forest which was by now quite dark. My arrival was usually a surprise. My daughter Jutta, who took care of her grandmother during those last months, would usually be sitting up in one of the two small rooms. Mother's light would be out. I would come in quietly and caress her, and she would say, "Is it Hans? Oh, that is good. Now I shall have good dreams tonight." And in the morning when she awoke she would say to Jutta, "Was it a dream, or did Hans come last night?" Then, when she could get up, we would sit together until I had to leave again early Sunday afternoon. We sat at the window looking out on her familiar view of the ponds and woods around Moritzburg, and the strange-looking castle.

We spoke very little about the present, which was already remote from her, and fading; rather we talked about the past, which was coming closer and closer to her all the time.

Toward the end, only one event of the war struck her hard. There was a young craftsman from the Rhineland, Josef Faasen, who about a dozen years before had presented her with a huge and beautiful candle which he had made himself. This candle later burned at all birthdays and festivals. He later wrote to her, and then came to see my parents, and Mother became very fond of him. All of us who knew him loved him; he was an unspoiled, naive, loving and lovable person with a remarkable gift for telling stories; he told them with great vividness and sense of form. Unfortunately his letters to Mother have also been burned. He had always said, "I will come to see you again," and Mother firmly believed it. But then for several nights in succession in Moritzburg she dreamt she saw his tear-stained face—this happened around the time he actually died in battle.

10

My last visit was on Good Friday, 1945. I read Mother the Easter story from the gospel of St. Matthew—which she knew so well as the text of a favorite oratorio. Then I read her the Easter walk from *Faust,* which she so loved. Shattered by age though she was, she seemed like a queen in exile; she had a compelling kindliness and dignity. That is the last memory I have of her. My daughter was beside her when she died on April 22, 1945. Her last words were, "My greetings to all."

She was buried in the small, quiet cemetery at Moritzburg. Later her body was exhumed and cremated at an impressive ceremony in Meissen, because it had been her wish to be buried in the Central Cemetery at Berlin-Lichtenberg, beside her husband and her brothers and sisters, beneath the gravestone she herself had fashioned. There she rests . . . "in peace within His hands."

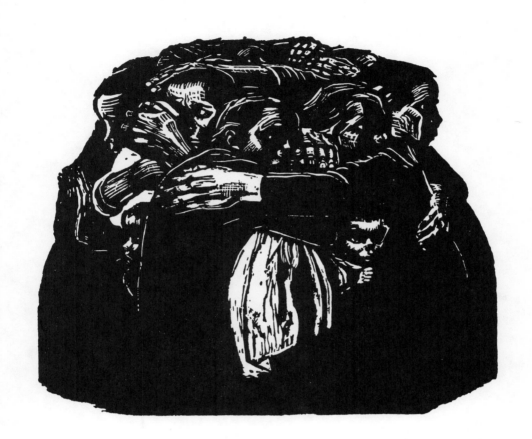

THE EARLY YEARS

I WAS the fifth child in our family. At the time of my birth we were living in Koenigsberg at Number 9 Weidendamm. I dimly remember a room in which I was doing pen drawings, but what I recall most distinctly are the yards and gardens. By passing through a front garden we came to a large yard that extended down to the Pregel River. There the flat brick barges docked and the bricks were unloaded in the yard and so piled that there were hollow spaces in which we played house. Running alongside the yard was another garden, also reaching to the river, and at its end there was a round pavilion built out over the water. I remember once hearing my Aunt Lina, who was then quite young, singing a lovely but very sad song in that pavilion.

To the right of the yard, but separated from it by low buildings, was another yard that connected with ours by a narrow lane between the buildings. I have very strong and lively memories of this other yard. At the end of it, along the Pregel, there was a raft for rinsing laundry. A dead girl was washed onto this raft one day and taken away in the "poor hearse." I can still see the terrifying hearse and coffin.

Besides this, the Ratke children lived there—Max, Lene and Liese. All of

them were older than I. Konrad and Julie, my brother and sister, were their real playmates, and I just tagged along. The Ratke children had lost their mother. Their father was a merchant and was sometimes drunk. Once I was with the girls in their house and I saw their drunken father staggering around. (Either I had heard the matter talked about or in remembering it later on I understood; at any rate, during the last years we were there I knew just exactly what his being "drunk" meant.)

In one of the low, oblong buildings that separated the two yards lived a man who made plaster casts. I often stood there watching him mold the plaster, and to this day I can smell the damp, plastery atmosphere of the place.

From the middle courtyard an alley went past the house to the street, the Weidendamm. Sometimes, though rarely, our games led us out into the street. The bigger children, however, often ran out there. Liese Ratke's short braids would fly up in the air when she ran, and her straight, pale-blond hair would stream back from her head like a banner.

We lived at Number 9 Weidendamm until my ninth year, and ever afterwards, as children, we remembered it with nostalgia. There were endless places to play and numerous adventures to be had in those yards. For example, a pile of coal had been unloaded from a boat and dumped in the yard in such a way that it sloped up gently and then fell off sharply on the side facing our garden. It was a risky matter to climb up it almost to the brink. I myself never dared, but Konrad did. Another boy who tried it was hurt; when he was right at the top and on the brink of the pile, a piece of coal slid out from under him and he fell onto the spiked fence surrounding the coal heap.

Then there was the pit filled with unslaked lime, with only a single plank across it. If you fell in, it was said, your eyes would be burned out.

Then there were the piles of clay we used to build forts out of—one on either side of the yard. The attacking party threw balls of clay which could really hurt.

I had reached that borderline age when a child's older brothers and sisters start finding it worthwhile to let it play with them. Later on I liked playing with boys, but at that time I was still very timid. I could not hold my own against the older children. For example, I remember that my ninth birthday was a black day for me. First of all, I did not like the number nine. Then I

received a set of skittles as one of my birthday presents. In the afternoon, when all the children were playing skittles, they would not let me play—I don't know why. As a result, I had one of my usual stomach aches. These stomach aches were a surrogate for all physical and mental pains. I imagine my bilious trouble began at that time. I went around in misery for days at a time, my face yellow, and often lay belly down on a chair because that made me feel better. My mother knew that my stomach aches concealed small sorrows, and at such times she would let me snuggle close to her.

In those days my sister Lisbeth was very small and I scarcely noticed her. Konrad was a nimble, lively and imaginative boy. He was not disobedient to Father and Mother; he did what they told him, but he was always getting into some new scrape, doing something that had not yet been forbidden. Once, during the days when he was reading books about Indians, he decided to emigrate to America. He simply set out over the meadows along the Pregel. It was only after a long search that he was traced and brought back.

I do not remember much about my sister Julie at that time. Later Mother told me that Julie had always been a solicitous child. Two years younger than Konrad, she was always trailing along behind her brother to save him from mischief. Even at that early age she had begun her mothering of us which we later so rebelled against.

Once Mother sent the two of us to visit Ernestine Castell. As Julie was preparing to leave with me, she took a lump of sugar out of the box and pocketed it. "What is that for?" Aunt Tina asked. "To cram into Kaethe's mouth if she starts to bawl," Julie answered.

This stubborn bawling of mine was dreaded by everyone. I could bawl so loudly that no one could stand it. There must have been one occasion when I did it at night, because I remember that the night watchman came to see what was the matter. When Mother took me anywhere, she was thankful if the fit did not come over me in the street, for then I would stop dead in my tracks and nothing could persuade me to move on. If the fit came over me at home, my parents would shut me up alone in a room until I had bawled myself to exhaustion. We were never spanked.

On the whole I was a quiet, shy child, and nervous as well. Later on, instead of these tantrums of kicking and roaring I had moods that lasted for

17

hours and even days. When in these moods I could not bring myself to use words to communicate with others. The more I saw what a burden I was being to the family, the harder it became for me to emerge from my mood.

What else was there about Weidendamm that we found so nice? There were the horses and carriage Father kept at that time. The horses were bays. The driver had a blue uniform coat; his name was Gudovius. Later, when Father gave up keeping the carriage, a suit for Konrad was made out of the blue coat. It always smelled of Gudovius, horses and the stable.

The bricks which were unloaded from the barges and piled in the yard were then taken to Father's building sites in brick wagons. In my memories these brick wagons are intimately bound up with the streets of Koenigsberg. They always moved in a procession at the slowest possible speed, dusty, groaning, squeaking, pulled by wretched nags and driven by coarse, crude drovers. One time a foal was brought into our yard in a brick wagon. It was blind. Konrad pleaded with Father to buy it. He rode on it, but the foal was so blind that it could not see where the walls and trees were. It kept bumping into things and almost crushed Konrad's legs.

My memory of my parents from those days is quite dim. Father was probably at work a good deal of the time. I imagine at that period we already had the set of blocks that Father had had made for us. They were big, solid blocks and we used them a great deal for building. We also had many long strips of wastepaper from Father's architectural designs. These were given us for drawing. Konrad's imagination always turned to wolves pursuing sleds, or similar themes. Father kept an eye on our work and soon began saving the strips of paper we had scribbled on.

I do not remember Mother at all from that time. She was there, and that was good. We children grew up in the atmosphere she created. Before Konrad's birth Mother had lost two children. There is a picture of her holding on her lap her first child, which was named Julius after my grandfather. This was the "firstborn child, the holy child," and she had lost it, as well as the one born after it. Looking at her picture you can see that she was truly Julius Rupp's daughter and would never let herself give way completely to grief. But although she never surrendered to the deep sorrow of those early days of her marriage, it must have been her years of suffering which gave her for ever after the remote air of a madonna. Mother was never a close friend and

18

good comrade to us. But we always loved her; for all the respect we had for our parents, we loved them, too.

A few minutes walk from the Weidendamm was the old Pauperhausplatz. Here, at Number 5, our grandparents lived. There is much to tell about them and their house.

Not until much later did we fully understand what we had lost in moving away from the Weidendamm. At the time we rejoiced in the change. Our new home on Koenigstrasse was one of the finest of the new houses Father had built. We lived on the lower floor, and next to us was my Uncle Julius (Rupp), who had just married and settled down there to practice as a doctor. Here my mother gave birth with great difficulty to her last child. The baby was named Benjamin in accordance with my father's wish. This baby too lived only for a year and then died, like the firstborn, of meningitis. I have a number of very vivid impressions of these events. It must have been shortly before the baby's death—we were sitting at table and Mother was just ladling the soup—when the old nurse wrenched open the door and called loudly, "He's throwing up again, he's throwing up again." Mother stood rigid for a moment and then went on ladling. I felt very keenly her agitation and her determination not to cry before all of us, for I could sense distinctly how she was suffering.

For me the death of Benjamin was associated with a complex of oppressive emotions. My parents had given me Schwab's *Legends of the Greek Gods* when I was very young, and I believed in these gods. I was aware, I suppose, that there was a Christian "dear Lord," but I did not love him. He was an utter stranger to me.

Lise and I had been sent out of the nursery. I don't know what Lise was doing, but I sat down on the floor, built a temple with my blocks, and was busy making a sacrifice to Venus. At that moment the door opened and Father and Mother came in. Father had his arm around Mother. They came over to us and Father said that our little brother was dead. (Probably he said that God had taken him.) I instantly felt certain that this was punishment for my unbelief; now God was taking revenge for my sacrifice to Venus. My relations with my parents were such that I said not a word about it; but what a weight there was upon my mind, for I believed myself to blame for my brother's death.

Then I saw little Benjamin lying on the bed in the front room and looking so white and pretty that I thought: If we only open his eyes, maybe he will

come alive after all. But I did not dare to ask Mother to open the baby's eyes and see whether everything would not turn out all right. I don't know whether I dared to touch the little dead body myself.

Konrad and I were in the big front room. Konrad stood at the door to the smaller room where the body lay. This door opened and Grandfather Rupp came out. This is the first conscious memory I have of him. He had been inside looking at little Benjamin. When he came out, he noticed Konrad and spoke gravely to him—saying, as I recall it, something like, "Do you see now, how fleeting everything is?" They were the earnest words of a minister and possibly (but perhaps not) Konrad understood them. To me, what Grandfather said sounded cruel and unloving.

Then I remember Grandfather speaking at the bier, and then Father and, I suppose, Grandfather and friends of the family drove together down Koenigstrasse and out through the Koenigstor to the Free Congregation's cemetery. Mother stood at the window and watched the hearse depart. I loved her terribly, but I did not go to her.

In those days my love for my mother was tender and solicitous. I was always afraid she would come to some harm. If she were bathing, even if it were only in the tub, I feared she might drown. Once I stood at the window watching for Mother to come back, for it was time. I saw her walking down the other side of the street, but she did not glance over at our house. With that distant look of hers, she continued calmly down Koenigstrasse. Once again I felt the oppressive fear in my heart that she might get lost and never find her way back to us. Then I became afraid that Mother might go mad. But above all I feared the grief I would endure if Mother and Father should die. Sometimes this fear was so dreadful that I wished they were already dead, so that it would all lie behind me.

I had made up my mind what I would do in that case. I would go to the Prengels and stay with them all the time.

There is not much more that I remember from the later years of our life in that house. We played croquet in the garden and had bad squabbles. When we began cheating one another at the game, our parents put the set away. Although here also we had a playground and garden adjoining the house, the grounds felt cramped compared to the spaciousness of our yards in the old house on the Weidendamm. But there was a large swing here, and I used to swing on it

standing up. I swung very high, so it seemed to me, and that was very nice.

From Koenigstrasse we moved to Prinzenstrasse. I am sure it was around this time that Father gave up his business and took over the duties of preaching for the Free Congregation.

The years that followed were very important to me. They were years of development, physically and mentally. I don't know just when I began to suffer from nocturnal frights, but it must have been around this time. These states of mine alarmed my parents; they feared epilepsy. My parents would send Konrad to call for me at school because they were afraid I might have a seizure during the day, but this never happened. Both Konrad and I hated this arrangement. Instead of walking with me, he stayed on the opposite side of the street.

Nights I was tormented by frightful dreams. The worst one I recall is the following: I am lying in my bed in the semidarkness of the nursery. In the next room Mother is sitting in the chair under the hanging lamp, reading. I can see only her back through the half-open door. In one corner of the nursery lies a large coil of rope such as is used on ships. The rope begins to stretch out and unroll, silently filling the whole room. I want to call Mother and cannot. The grey cable blots out everything.

Then there was a horrible state I fell into when objects would begin to grow smaller. It was bad enough when they grew larger, but when they grew smaller it was horrifying.

I experienced such states of unfounded fear for many years; even when I was in Munich they occurred, but in far feebler form. I constantly had the feeling that I was in an airless room, or that I was sinking or vanishing away. I cannot say whether my parents' alarm over these states was altogether justified. In any case, they were very much concerned about me at the time. Later on I was to be more capable and energetic than my brothers and sisters.

On the upper floor of our house lived a boy named Otto Kunzemueller who was my first love. We played out in the yard and garden with the other children of the house and were allowed a fair degree of freedom. Julie had discovered that Otto and I sometimes went down into the cellar to exchange kisses, and she told Mother about it, not to make things hard for us, but because she was really worried. For a while I was afraid I would no longer be allowed to play with Otto, but Mother obeyed her principle of silent trust; she said nothing to me and made no prohibitions. Our kisses were childish and

highly solemn. Each time, we gave one another only one kiss, which we called "a refreshment." Besides Julie, I don't think anyone found us out, for we used to clamber over the fence into the abandoned next-door garden, or go down into the cellar, for our kisses.

I know that it was a wonderful feeling. I literally loved Otto so deeply that my whole being was filled to the brim. But since I was wholly ignorant in matters of love and he, I imagine, no less so, the refreshment kiss was as far as we went. He made up the most fantastic cock-and-bull stories about his past life, and I believed them all.

One time Otto said to me that he could not marry me. Why? I asked in alarm. Because I belonged to the Free Congregation and he did not, he said. For my part, I had a bitter struggle over the question of marrying him because he had the awful name of Kunzemueller. Worse yet, the other boys always called him Kumstemueller.

We played marvelously together. The other boys played with me too. I was in their good graces in those days because I was good at ball-playing. And in winter we swooped down the slope of Prinzenstrasse on sled—I riding and Otto and the Trenck boy hitched to the sled like horses.

This love came to an end because the Kunzemuellers moved away. Otto promised to pay me visits by way of the garden fences, and one day he did so. But after that he never came again. I missed him terribly. I can still remember how it felt when, coming home from school on hot summer days, I went up the steps and looked out of the hall window into the empty playyard with its old pear tree. All my joy in it was gone. I suffered from longing, and all my games with others were dull and meaningless. I had scratched an "O" into the skin of my left wrist, and whenever a scab began to form I opened the scratch up again.

After this first crush of mine I was always in love. It was a chronic condition; sometimes it was only a gentle undertone to my ordinary life, and sometimes it took stronger hold of me. I was not particularly discriminating about my love-objects. Sometimes I fell in love with women. Rarely did the person I was in love with have the slightest suspicion of my feelings. At the same time I was plunged into those states of longing for I knew not what which torment the child at puberty. I felt the lack of any real friendship with my mother more distinctly than ever before. The moral tone of our upbringing was such

22

that—ignorant as I was of the scientific view of human nature—I inevitably felt guilt about my condition. I needed to confide in my mother, to confess to her. Since I could not conceive of lying to my mother, or even of being disobedient, I decided to give my mother a daily report on what I had done and felt that day. I imagined that her sharing the knowledge would be a help to me. But she said nothing at all, and so I too soon fell silent. My ignorance of the physical aspects of life lasted for many years. I had the wildest ideas about how babies were born. For example, I read Kleist's *Marquise von O.* and of course did not understand the whole basis of the story. I was convinced that I too might have a baby out of the blue.

During this period I was given a little help just once, by Konrad. Of course we did not talk about the matter. But once he found a drawing I had made in which I had expressed what was bothering me. After that he watched over my reading and kept a number of books out of my reach. Always without saying a word. Perhaps only the hint that he too was not altogether immune from such troubles gave me something to cling to. In any case I always looked up to him and wanted him to respect me.

As I look back upon my life I must make one more remark upon this subject: although my leaning toward the male sex was dominant, I also felt frequently drawn toward my own sex—an inclination which I could not correctly interpret until much later on. As a matter of fact I believe that bisexuality is almost a necessary factor in artistic production; at any rate, the tinge of masculinity within me helped me in my work.

I turn now from discussion of my physical development to my nonphysical development. By now my father had long since realized that I was gifted at drawing. The fact gave him great pleasure and he wanted me to have all the training I needed to become an artist. Unfortunately I was a girl, but nevertheless he was ready to risk it. He assumed that I would not be much distracted by love affairs, since I was not a pretty girl; and he was all the more disappointed and angry later on when at the age of only seventeen I became engaged to Karl Kollwitz.

My first artistic instruction came from Mauer, the engraver. There were usually one or two other girls in the class. We drew heads from plaster casts or copied other drawings. It was summer, and we sat in the front room. From the street below I could hear the rhythmic tramping of men laying paving

stones. Above the tall trees of the garden across the way hung the dense, hot, motionless city air. I can feel it to this day.

I was hard-working and conscientious, and my parents took pleasure in each new drawing I turned out. That was a particularly happy time for my father, in respect to us. All of us children were developing rapidly. Konrad was writing, and we gave performances of his tragedies; I was showing unmistakable talent for drawing, and so was Lise. I still remember overhearing my father in the next room saying happily to my mother that all of us were gifted, but Konrad probably most of all. Another time he said something that bothered me for a long time afterwards. He had been astonished by one of Lise's drawings, and said to Mother: "Lise will soon be catching up to Kaethe."

When I heard this I felt envy and jealousy for probably the first time in my life. I loved Lise dearly. We were very close to one another and I was happy to see her progress up to the point where I began; but everything in me protested against her going beyond that point. I always had to be ahead of her. This jealousy of Lise lasted for years. When I was studying in Munich there was talk of Lise's coming out there to study too. I experienced the most contradictory feelings: joy at the prospect of her coming and at the same time fear that her talent and personality would overshadow mine. As it turned out, nothing came of this proposal. She became engaged at this time and did not go on studying art.

Now when I ask myself why Lise, for all her talent, did not become a real artist, but only a highly gifted dilettante, the reason is clear to me. I was keenly ambitious and Lise was not. I wanted to and Lise did not. I had a clear aim and direction. In addition, of course, there was the fact that I was three years older than she. Therefore my talent came to light sooner than hers and my father, who was not yet disappointed in us, was only too happy to open opportunities for me. If Lise had been harder and more egotistic than she was, she would unquestionably have prevailed on Father to let her also have thorough training in the arts. But she was gentle and unselfish. ("Lise will always sacrifice herself," Father used to say.) And so her talent was not developed. As far as talent in itself goes—if talent could possibly be weighed and measured—Lise had at least as much as I. But she lacked total concentration upon it. I wanted my education to be in art alone. If I could, I would have saved all my intel-

24

lectual powers and turned them exclusively to use in my art, so that this flame alone would burn brightly.

In the years when a young person is developing, his gifts feed on everything that pours into him from all sides. During those years almost everyone has some talent, because he is receptive. My parents followed the principle of giving us the opportunity to develop ourselves without their pushing our noses into things. For example, the bookcases were open to all of us children, and no one checked up on what books we chose. They were mostly good books anyway. I read Schiller in a large, handsome edition with engravings by Kaulbach; and I read Goethe. Goethe took root in me very early, and all my life he has meant a great deal to me.

Father also read aloud to us occasionally. Once—whether it was at this time or later on, I do not know—he read to us Freiligrath's *The Dead to the Living*. This poem made an indelible impression upon me. Battles on the barricades, with Father and Konrad taking part and myself loading their rifles— these were some of my fantasies of heroism at this time.

Lise and I were part of one another. We were so merged that we no longer needed to speak in order to communicate with one another. We were really an inseparable pair. What we called "our game" could be played only with one another. We had no dolls, nor did we have any desire for them. But at the stationery store (Fraeulein Sander's on Koenigstrasse) we used to buy sheets of theatrical paper dolls, all of them characters out of different plays. We colored these figures with water-colors and cut them out. There were over a hundred of them, and we played constantly with them. In our room we were our own masters; we played all over the room, turning tables and chairs upside down according to the inspiration of the moment. Greek mythology, Schiller's dramas, our own inventions—we were never at a loss for subjects. Building blocks were brought up, palaces erected, altars, sacrifices, *The Minstrel's Curse* enacted, even to the collapse of the pillared hall. We were indefatigable. Lise, although she was three years younger than I, kept right up with me in everything and obeyed my orders. Without her, play was impossible.

During the following years, when we were passing out of childhood, this playing gradually stopped. We wanted to keep up our game and would start again and again, but it had outlived its time and died inwardly. I remember

how empty I felt; I was clearly aware of a loss. Gradually we slid over into other activities—usually Lise and I together, with her still following me. I loved her deeply and had resolved never to marry; but Lise too was not to marry. She would stay with me all the time and belong to me, so to speak.

She was infinitely goodhearted and easily hurt. Sometimes the devil in me prompted me to hurt her. When I got her to the point where she burst into tears, it wrenched my heart.

I owe a great deal to Lise because she would sit as model for me, and never tired of it. When I was drawing and could not solve a particular problem, she would put herself into the pose; she was always a good model and endlessly patient.

Aside from Lise, I have never had a really close friend. A few years later, though, Lisbeth Kollwitz became the friend of both of us. She had the happiest of temperaments and was much livelier than either Lise or myself. Knocking about town with her was great fun.

At this time we met Karl Kollwitz and his friends. They were still schoolboys, but already Social Democrats. Hans Weiss, who was older than Konrad and Karl and by nature fanatically political, came charging into our family with his theories on free love. He belabored Julie with all of August Bebel's ideas about women. Julie, however, was scarcely affected by his talk. Lise and I were not yet old enough for him.

The high point of every year was the summer vacation in Rauschen. From the time I was nine years old we spent our summers there. My parents had once taken a trip through Samland and arrived by chance at the fishing village of Rauschen, half an hour from the ocean. Shortly before, several men of the village had been drowned in a great storm at sea. My parents came upon one of these women, a Frau Schlick, who sat at the door of her house, brooding vacantly. My parents were very much taken with the little house by which she sat. They were particularly impressed by its situation. They rented it first, and finally bought it from Frau Schlick, with the arrangement that she and her two daughters would continue to live there the year round.

My father made some changes in the house, but it retained completely its character as a peasant house. The trip to Rauschen took some five hours. There was no railroad; we rode in a *journalière,* which was a large covered wagon with four or five rows of seats. The rear seats were taken out and the

back stuffed with all the things we would need for a stay of many weeks: bedding, clothing, baskets, boxes of books and cases of wine. What a joy it was when the *journalière* drew up in front of our house and all the things were loaded aboard. Then Mother, the servants and we children (Father usually came later) would be stowed away on the front seats, and the driver would jump up to his special seat up front. The three or sometimes four horses would start, and off we would go through the narrow streets of Koenigsberg, through the clanging Tragheim Gate, and then out across the whole of Samland. Shortly before we reached Sassau we would catch sight of the sea for the first time. Then we would all stand on tiptoe and shout: The sea, the sea! Never again could the sea—not even the Ligurian Sea or the North Sea—be to me what the Baltic Sea at Samland was. The inexpressible splendor of the sunsets seen from the high coastline; the emotion when we saw it again for the first time, ran down the sea-slope, tore off our shoes and stockings and felt once again the cool sand underfoot; the metallic slapping of the waves—that was the Baltic to us!

As I approached the impressionable years of girlhood, sentimental love for the sea became the rage. But Rauschen was still an unknown place, visited only by a few nature enthusiasts; you were alone with the sunset, and the coastline was not yet built up. This children's paradise is gone for good, now.

Mother would stay out there with us girls until September, when school started. Konrad was allowed to bring friends out for lengthy stays, and once we had Lisbeth Kollwitz there with us.

Here is a good place to speak briefly of school, which gave me no pleasure. Both my grandparents and my parents were opposed to public schools, and so we girls went for lessons to a small private school. This worked out well with Julie, and especially with Lise, but during my schooldays the school's little group of pupils did not learn very much. The headmistress was a tubercular lady; the teachers were, it seemed to me, completely mediocre. I liked only my classes in literature and history. I was stupid in arithmetic and not very good in anything else. During the vacations in Rauschen Father tutored Lise and me in mathematics for a time. Lise was surprisingly good, I surprisingly bad.

One thing for which I shall always be very grateful to my parents is the fact that they allowed Lise and me to wander about the town for hours in the

afternoons. In this, too, they exhibited an attitude of generous confidence and never checked up on us afterwards. Their one stipulation was that we should not take walks in Koenigsgarten. Koenigsgarten began around Tauentzienstrasse. However, we could cross through the quarter if our way led in that direction—and we usually saw to it that it did. In our own way we were a pair of highly conceited young chits; we let our scarves wave in the wind, dressed up, and were often silly and extremely childish. But we acted this way only when we were passing through the Koenigsgarten district. After that we behaved better. We bought cherries or whatever was to be had and then started off on what we called our loafing. That was what it really was. We loafed through the whole city and out of the gates, took the ferry across the Pregel and hung around the waterfront. Or we would stand and watch the longshoremen loading and unloading the ships. We knew the smallest quaint alleys that wound and twisted their way through the old town. How often we stood at the railing when drawbridges were raised and looked down upon the steamers and barges moving through the passage below. We looked down on the swarm of fruit barges, loafed our way through the Castle, loafed past the Cathedral, loafed around the meadows along the Pregel. We knew where the grain ships docked, with their crews of *jimkes* who wore sheepskin jackets and wrapped their feet in rags. They were Russians or Lithuanians, good-natured people. Evenings they stayed aboard their flat, shallow ships, playing the accordion and dancing.

All this apparently aimless loafing undoubtedly contributed to my artistic growth. For a long period my later work dealt with the world of the workers, and it can all be traced back to these casual expeditions through the busy commercial city teeming with work. From the first I was strongly attracted to the workman type—and this bent became even more marked later on. I was about sixteen when I made my first drawing of characteristic workman types; the drawing was based on the poem by Freiligrath, "The Emigrants." A year later, at my father's request, I showed this drawing to my teacher in Berlin, Stauffer-Bern, who recognized it as altogether typical—both of me and of the environment from which I came.

Later, between stays in Munich and my marriage, I set about perfectly consciously to make pictures of the classic situations in the worker's life. This work came to an abrupt end when I moved to Berlin because the type of work-

man to be found was entirely different from the kind which had interested me. The Berlin worker stood on a much higher economic plane than the Koenigsberg worker, and as far as the visual aspects of his personality went, he was useless as a subject for me. Later (especially during a visit to Hamburg) I strongly regretted not having stayed in Koenigsberg long enough to have gotten all I could out of that city.

I do not know when I first began attending the Free Congregation services. (Father and Mother, Konrad, Julie and I entered the congregation's hall and walked down the aisle between the rows of seats in order to reach the front row. We passed by the Prengels and I saw my cousin Max Prengel, who was about my age. I often played with him, but now, instead of a friendly, familiar nod he gave me a measured, dignified bow.) I assume that religious instruction and attendance at the Sunday meetings must have begun at the same time for the children of the community. I attended during the last years in which Grandfather Rupp was our speaker.

The spiritual content of the Sunday sermon was thoroughly discussed during the religious lesson, which was also given by Grandfather Rupp. In the next hour he wanted us to show something for it—best of all to give a summary of the whole sermon. This was very hard for me. As long as I was able to follow what was said, I could reproduce it; but following the sermon for a full hour was very hard, even for Konrad. After one sermon Grandfather told us how he had seen Konrad's face in front of him brighten when he said, "In conclusion . . ."

After the Sunday sermon a number of members of the congregation—Henriette Castell, Lonny Ulrich and Grandfather Rupp's children, sons- and daughters-in-law and the older grandchildren—gathered at Grandfather's house in the old Pauperhausplatz. Grandfather, who had retired to his room to rest for a while, would come down to join us in the parlor. Whenever he entered through the low, white door, he seemed to me very tall and awesome. All of us stood up and greeted him. I do not really know whether or not he was tall; at any rate he seemed so to me: tall, thin, dressed in black up to his chin, his eyeglasses having a faintly bluish tinge, his blind eye covered by a somewhat more opaque glass. Grandfather's hands were very beautiful; my mother's hands took after his. They were large and expressive in shape; he wore a signet ring.

By the wide window stood two old armchairs facing one another. There my grandparents sat. The entire window was wreathed around by ivy. Usually the company talked about the sermon, but politics or any other interesting matters were also discussed. The atmosphere, since it was no longer wholly spiritual, was more comfortable for me. In the dark corner to the right of the large window, behind Grandfather's chair, stood a table with a large portfolio of copper engravings; along the shorter wall to the left, behind Grandmother's chair, was a small wall shelf of books. From this shelf we sometimes took the Grimm fairy-tales. But most of the time Lise and I sat looking at the portfolio of pictures. Quiet as mice, we half listened to the conversation, but were more absorbed in the pictures. In the room hung a portrait of Grandfather in middle life, painted by Graefe. If I remember rightly, it was an excellent portrait; I believe it has remained in the possession of the Theobald side of the family.

This after-sermon hour in my grandparents' warm, bright room has stamped them in my memory as infinitely friendly, kind and intellectual. This impression is reinforced by the festive Sunday gatherings at our house and the Christmas celebration on the first of the Christmas holidays. I must speak of these separately.

Yet Grandfather delivering his sermons or conducting his classes in religion inspired in me no other emotion than awe. When we came into the religion class, we were to him not his grandchildren, but children of the community, just as close and just as distant as the others. That attitude in itself made me timid. But Konrad was not the least bit in awe of him. Whenever Grandfather was at our home and a discussion was going on—he was always the honored and respected center of every conversation—Konrad would sit on his footstool close to Grandfather's feet and bring up his questions without the slightest embarrassment. Nor did it bother Konrad to come late to religion class, and as he stood in the rear of the room, wriggling out of his overcoat, he would answer a question that Grandfather was asking someone up front. Konrad was not the least bit impertinent; he was simply naive and trusting, and so interested in all intellectual matters that he breathed easily in Grandfather Rupp's intellectual atmosphere and was completely receptive. Later on Grandfather often had him over to his house, helped him with Latin and Greek and talked over his reading with him or suggested some book he ought to read. Many of

Grandfather's pithy phrases remained in Konrad's memory. Grandfather was always ready to give, was always kindly and informative, and often laconically humorous. By the time Grandfather died Konrad was a university student; he had therefore been influenced by Grandfather at his most alert and critical age.

I was seventeen when Grandfather died. My sister Julie, who came between Konrad and me in age, received less of the intellectual influence but more of the moral. She often read aloud to Grandfather and dearly loved both our grandparents.

It was often said that the intellectual standard by which Rupp measured the members of his congregation was far too high. Rupp developed his religious-philosophical system in the course of the Sunday meetings. During the Thursday evening meetings, which were devoted to free discussion by all, subjects of preeminently ethical nature were taken up. Along with this went discussion of the Gospels.

Rupp drew almost exclusively from the Gospel of Matthew. He did not offer rationalistic explanations of the miracles, but passed over them. The excerpts from the four Gospels which were given to the children of the Free Congregation were, so to speak, the pure moral doctrines that Rupp believed Jesus had revealed to the world. However, we learned the Gospel according to Matthew thoroughly, and the most important pronouncements we committed to memory. Only the finest hymns of the old church hymnal were kept for the congregation, and the melodies were often set to new words. For example *Integer vitae* had a text which began, "Spirit of eternal truth." The anthem of the congregation, "We have found ourselves and broken the yoke in twain," was sung after "We had built up." The Congregation put out a collection entitled *Voices of Freedom*. It was an anthology of the purest maxims, from poems of Confucius down to selections from contemporary writers. Grandfather often chose an entry from these voices of freedom to discuss with us children during religion class. Thus the religion class included discussion of the sermon, discussion of the Gospels, examination of a significant poem or longer poetic work (such as Lessing's *Nathan the Wise*), and a bit of religious history. For the latter Grandfather had charts drawn up showing cross-sections of time. (Thus he did not only teach how the church developed in Italy in the fifteenth century; he showed how at the same time the religious idea was embodied in other lands and other continents.)

These religion classes were a rich diet, and the intellectually more advanced children got an enormous amount out of them. So did the children's parents (who were permitted to sit in). I later regretted not having been mature enough to profit by this instruction. Unquestionably I owed a great deal to Grandfather, but I felt relieved when Father took over the religion classes in Grandfather's place. Father adapted himself more to the average child and taught, in the main, simple ethics. Subsequently I was confirmed by Father himself; Julie had been given confirmation by Grandfather.

Grandmother appeared very small beside Grandfather. She wore a cap with pale-violet ribbons. Her face was kind and friendly; her temperament was the direct opposite of Grandfather's. Grandfather stood above material things and the happenings of the day; Grandmother was right in the midst of them. Our Aunt Bennina inherited Grandmother's lively temperament; so did Julie, but compounded in a different way.

The oldest child of the Rupps was our mother, who in appearance, mentality and temperament took after Grandfather. She married Father, twelve years her senior, when she was twenty-three. Between Grandfather and Father there always was a firm and cordial friendship. Since the youngest Rupps, Julius and Lina, were growing children when Father became a member of the Rupp family, he took as important a part in their upbringing as Grandfather, who was overworked and only too grateful to have his younger friend help with the education of the children.

The other children of the Rupps were Bennina, who was a beautiful, dark, passionate girl; Theobald, who combined his father's aspiring mind and his mother's earthy temperament; Antonia, a quiet, introspective person, exceptionally devoted to duty; Julius, who must have been wonderfully winning as a boy, since he was so charming and full of grace even in his old age. The sixth child was our dear Aunt Lina. There was only a year or two between her and Julius, and the two were as inseparable as Lise and I. They were always in and out of my parents' household as if they were the grown-up children of the house. Aunt Lina had Grandmother's temperament; she was beautiful and had the same springy step as her brother Julius. (How finely both carried themselves!) She had a splendid voice and wanted to become a singer. But our grandmother was thoroughly conservative and could not permit her daughter to perform in public as a singer of oratorios. Then this beautiful girl had a

32

love affair; her love was not returned. I can remember those years, when violent inner agitation made her behavior flighty and contradictory. But she worked out her inner struggle. I have probably never known a more delightful person, a person with so joyous and impulsive a manner, as Aunt Lina.

Two stories up in my grandparents' house, in a sweet, old-fashioned room, lived Aunt Berta. She was one of Grandmother's sisters, a small woman with a very finely-shaped head, and even in our childhood she seemed already old. As was common in the past, unmarried girls stayed with their parents or helped out in the houses of their married brothers and sisters. And so Berta lived with the Rupps, but her help was in the intellectual rather than the practical sphere. Grandfather was opposed to public school instruction, and although he had allowed both his sons to attend school, he taught the girls himself. Aunt Berta assisted him in this task; she gave lessons in English and French, and perhaps also in other subjects. Her lessons went according to a schedule which Grandfather carefully worked out. Mother, I know, was particularly good in English and well acquainted with English literature. She had read Shakespeare, Byron and Shelley in English.

We children were very fond of visiting old Aunt Berta. Her room had the pleasantest old furniture, including a sofa with side arms which actually had drawers. She owned a complete Goethe in the small Cotta original edition; a plaster cast of the Amazon group in front of the National gallery; and a Goethe with Gellini's illustrations. Also, even in summer she always had some *Pfeffernuesse* left over from Christmas. She first taught Lise and me to sew—we hemmed handkerchiefs—and we always had a great deal to talk about with her. She was a wise old spinster, such as children are often very fond of—for children like to slip away from their busy mother and even their grandmother to the quiet, old-fashioned cubbyholes where such old aunts live and where there are still such things as lamp trimmers.

All these people, now dead, formed the circle in which we grew up. They all contributed to rearing and shaping us, as did also some other old members of the Free Congregation. These were the Ulrich sisters and the Castell sisters. The Ulrich sisters were two aged canonesses, and in our wanderings through town we often paid them visits. They lived close by one another—Lonny in an old one-story chapter-house that had the nicest miniature garden out back, in a space really just big enough for hanging out the wash. Lonny Ulrich suffered

from heart trouble and died of dropsy after I left Koenigsberg. Her body was small and shapeless; she had a face that was like Socrates' in its ugliness. We seldom saw her when she did not have some knitting in her hands. She was extraordinarily shrewd and intellectually keen.

An uncompromising adherent of the purest Rupp doctrine, she was also a close personal friend of Grandfather Rupp. Later on, during the theoretic disputations between the followers of orthodox Rupp doctrine and my father's reformed doctrines, she vigorously opposed my father. She was happy to have us children visit her, and was an extremely kind hostess. For hours we sat in her tiny chamber with its old furniture and walls hung with pictures. She had a peculiar way of weaving into her stories of personal experiences all sorts of reflections, logical deductions, moralisms, and of presenting general ideas to children in quite concrete form. She considered it her special task to train the growing young people for life in the Congregation.

Her sister Olga Ulrich (who by the way was not a member of the Congregation) lived in a canonry nearby and was the queerest old canoness imaginable. She had the keen wit of her sister Lonny, but with her it took the form of broad humor. She had no scruples when it came to giving in to her own crotchets; in fact she was a kind of bohemian in the canonry. Often she went on long walking tours through Samland. She constantly violated the rules of the order. If the chapter house were already closed, she would let her late visitors go out through the window.

The Castell sisters were altogether different from the amusing Ulrichs. I knew them only as old ladies. They were big, heavy women with large, grave faces. Irony, witty turns of phrase and flashes of thought—these things were wholly foreign to them. In fact they despised such lightmindedness. Henriette, whom we called Yetta, was a favorite figure in the humor sheets which attacked the Free Congregation during the period of reaction. Yetta lent herself to their caricatures—big, always with a stocking and darning needle in her hand, the ribbons of her cowl loosened and tossed over her shoulders when she got excited. A fanatic nature enthusiast, she scorned all kinds of conventional and civilized behavior and often walked barefoot about the city. Once she decided to visit Goethe's Bettina von Arnim in Berlin. The difficulties of such a journey in the days before the railroad were enormous. But she *wanted* to visit Bettina and hear about Goethe. She reached Berlin and went straight to Bettina's

home. In her simplicity she was convinced that Bettina would instantly recognize her as a spiritual comrade and take her to her heart. Instead, a servant girl opened the door and said that her ladyship was not receiving. Whereupon Henriette turned about and set off for Koenigsberg that same day.

Ernestine Castell made a particularly strong impression upon me because of the way nothing had been able to break or bend her. She lived in an isolated one-story cottage situated on a road lined with old willows which ran through the Pregel meadows. She had an injured leg that had never healed properly, so that the only way we ever saw her was sitting in her armchair, the bad leg in a horizontal position. She was one of Grandfather Rupp's oldest friends and followers. She believed fervently in the form of community that Rupp had originally hoped for: imitation of the first Christian communities; communal property; the fraternal familiar form of address to be used among the members.

From what I have heard, the first years of the congregation fostered a type of life which somewhat resembled the kind of life found in present-day young idealistic communist circles.

Ernestine had no interest in questions of theory; the one thing she valued was the expression of personality. She had a number of young girls with her whom she was bringing up. I can well imagine that the emotional interpretation she put upon the ideas of the Free Congregation went counter to Grandfather's temperament and did not greatly please him. He liked sentimental enthusiasm no more than he liked Lessing—who was a favorite of the Castells. The younger members, however, felt that the Castell circle supplemented the idea of the community, that it filled a gap.

It was not easy for anyone to be taken into this circle. The members of it were a select group, and the guiding spirit was unquestionably Ernestine Castell.

I know of this early, highly personal and uncommonly interesting period only at second hand. In our day nothing survived of that period but Ernestine herself, the "Aunt Tina" whom we loved to visit, and she was already quite old. She still seemed to live in a different world from the real world. She knew Klopstock's entire *Messiah* by heart, and I have heard her recite long passages from it. What she liked best was to receive visits from the young men of the community. But she would not tolerate any realists, and above all not those

35

who leaned toward materialism. Such persons seemed to crush her into silence, and she turned them away.

I have spoken in such detail of these personalities because I wished to show the atmosphere in which we children grew. It was, I think, a blessed atmosphere. We grew up quietly, no doubt, but in a fruitful and meaningful tranquility. When we graduated from these circles, when we went out into the world—I to Berlin and later to Munich—we were plunged into a different kind of life—one which seemed, in all its struggles and joys, so much more torrential and powerful that by and by Koenigsberg, and above all the Free Congregation, seemed to me outmoded and finished with. But only for brief periods. At bottom I always loved it as a home, felt closeness and gratitude toward it.

"Blessed is he who remembers his fathers with gladness."

IN RETROSPECT, 1941

FROM my childhood on my father had expressly wished me to be trained for a career as an artist, and he was sure that there would be no great obstacles to my becoming one. And so after I reached my fourteenth year he sent me to the best teachers in Koenigsberg. The first was Mauer the engraver; later I studied with Emil Neide. Neide had painted *Weary of Life* which created a great stir. His brother was an inspector of the police, and all the painter's themes were drawn from the world of crime. Although *Weary of Life* was an important canvas painted with virtuosity and so sensational that it spread his reputation as far as America, his later work in this vein was artistically much weaker, and some of it was plain kitsch. On the other hand, I think very highly of a smaller and much quieter painting of his whose subject is again crime. It was entitled, *At the Scene of the Crime,* and was a dispassionate picture of the coroner's jury conducting an investigation in a gravel pit. As I remember it, this painting was on a really high artistic level.

Being a girl, I could not be admitted to the Academy. I therefore took private lessons with Neide, along with a young girl from Tilsit.

When I was seventeen, my mother made a trip for her health to a spa in Engadin. My father sent my younger sister Lise and me with her. Besides being a trip for the sake of Mother's health, this little vacation was intended to show us Berlin and Munich—especially Munich. In Berlin we had the opportunity to meet young Gerhart Hauptmann. He lived in Erkner, where he was a neighbor of my older sister. Her husband, Hofferichter, happened to meet Hauptmann on the commuter's train to Berlin, and they had become quite friendly. And so Lise and I were introduced to Hauptmann. He was still unknown, had only just written his *Lot of the Prometheans*. His house in Erkner was set in the midst of a large garden. I recall that we all sat in a big room, from which a short flight of steps led down into the garden. We were in a festive mood. There were Hauptmann, his wife, the painter Hugo Ernst Schmidt, Arno Holz, and my brother Konrad. It was an evening that left its mark upon us. There was a long table covered with roses in the large room, and we all wore wreaths of roses. We drank wine and Hauptmann read from *Julius Caesar*. All of us, young as we were, were carried away. It was a wonderful foretaste of the life which was gradually but irresistibly opening up for me.

After Berlin we stopped off in Munich for at least a week. In the Pinakothek there I saw the masters, and one of them had an effect upon me which was to be crucial for years to come: Rubens! I was carried away by Rubens. At the time I owned a small volume of Goethe. When the feeling completely overwhelmed me, I wrote in the margin of the book: "Rubens! Rubens! The early poems of Goethe! 'The temple has been built for me. . . .' " Goethe, Rubens and the feeling I had about them formed one complete whole.

From Munich we went up into the mountains to Engadin. The sole means of travel was by stage-coach. The coach had two high seats on a platform in the back, to which you mounted by means of a ladder. Mother took these seats for us, while she sat below, up front. It was heavenly. We shouted and sang with glee from our high places. Mother at this time was only forty-seven, so beautiful and so gay. In St. Moritz we met my brother Konrad, who was coming from London. Marx was dead, he told us. Konrad had spent much time talking with old Engels. Before we had been together very long we were plaguing Mother to drive with us from Maloggia Pass down into Italy. But she insisted that she must return home to Father. And so we drove only as far as Maloggia Pass in a small cart, and sat there and sang.

Konrad was studying at the university in Berlin. When I was seventeen I followed him there, to live in a boarding house and attend the art school for girls, with Stauffer-Bern as my teacher. Stauffer-Bern's instruction was extremely valuable for my development. I wanted to paint, but he kept telling me to stick to drawing. He saw the drawings I had done in Koenigsberg as illustrations of poems, such as Freiligrath's "Emigrants," and they prompted him to mention Max Klinger, who was his friend and whom at the time I had not heard of. I went to see Klinger's *A Life* at a Berlin exhibit. It was badly hung, but it was the first work of his I had seen, and it excited me tremendously.

Stauffer-Bern was interested in my work and backed me up in pressing my father to let me attend art school again the following winter. Luckily for me, nothing came of this. For by the next semester Stauffer-Bern had gone to Italy, where he died suddenly. For the time being I went back to Koenigsberg.

Back home, my father persuaded me to paint a genre picture. I started *Before the Ball,* and at my father's urging I finished the painting, in spite of my inward impatience with it. The following year, while I was in Munich, Father had the painting framed and entered in an East Prussia traveling exhibit. The picture was bought, and the buyer ordered from Miss Schmidt of Koenigsberg, currently in Munich, a companion piece to be entitled *After the Ball.* This order was missent to an East Prussian Miss Schmidt whom I did not know; she happily accepted the commission, and I was not required to paint a sequel to *Before the Ball*—which also made me happy. In Munich, of course, we all thought paintings on such themes the worst trash.

In my seventeenth year I became engaged to Karl Kollwitz, who was then studying medicine. My father, who saw his plans for me endangered by this engagement, decided to send me away once more, this time to Munich instead of Berlin. That was in 1889.

In Munich I lived in Georgenstrasse, near the Academy, and attended the girls' art school. Once more I had good luck in my teacher, Ludwig Herterich. He did not put so great a stress upon my drawing and took me into his painting class. The life I plunged into in Munich was exciting and made me very happy. Among the girls who were studying there were some who were very gifted. Among these were Linda Koegel, Eugenie Sommer, Marianne Geselschap. This group was later joined by a fine artist who became well known under the pseudonym of Slavona. She moved to Paris and married the art dealer Otto

39

Ackermann. I must also mention Emma Jeep. What she did in art was not particularly significant; later, as the wife of Arthur Bonus, she revealed her real gift for writing. Together with Bonus she did the well-known versions of the Icelandic sagas. Our two families were very close for many years. . . .

Attacked by a grave disease, Linda Koegel suffered from a peeling of the skin and paralysis—she remained paralyzed for some forty years. From her bed she went on doing drawings for church murals.

I was delighted by the spirit of freedom that prevailed among the girl students. At the beginning, however, Herterich's teaching seemed mannered to me; his pronounced coloristic art was not to my taste. I did not see colors the way he did. I used a trick to win a favored position in the class: I painted the way I knew he wanted me to paint. It was only later on that I really began to understand his colorism.

In Munich I learned a great deal. The day was filled with work; evenings we enjoyed ourselves, went to beer halls, took walks in the surrounding country. I felt free because I had my own house key.

A number of girls in our class formed a club together with Otto Greiner, Alexander Oppler, Gottlieb Elster. We would set a subject for an evening's painting. I recall for example that one of the subjects was "Struggle." I chose the scene from *Germinal* where two men fight in the smoky tavern over young Catherine. This composition was highly praised. For the first time I felt that my hopes were confirmed; I imagined a wonderful future and was so filled with thoughts of glory and happiness that I could not sleep all night.

But in the painting class I made no progress. My fellow students, Sommer, Slavona and Geselschap, had a much better feeling for color than I had. Color was my stumblingblock. Then by chance I read Max Klinger's brochure, *Painting and Drawing*. I suddenly saw that I was not a painter at all. Nevertheless, Herterich knew how to train the eyes, and in Munich I really learned how to see.

I so liked the free life in Munich that I began to wonder whether I had not made a mistake in binding myself by so early an engagement. The free life of the artist allured me. Next year, when the question was again raised whether I should return to Munich, my father left the choice up to me. I did so gladly. It seemed to me a good omen that the first person I should meet on the street in Munich was Herterich. As a matter of course I entered his school

again. Father had promised me only this one more semester, and although I had the chance to go to Berlin instead, I had decided upon Munich. But this semester did not prove as fruitful as I had expected. Later on I often regretted not having gone to Berlin. A great deal was happening there at the time. Hauptmann's *Before Dawn* had been performed; there was the burgeoning of the new literature inside and outside Germany. A highly stimulating group of artists and writers were living in Berlin at the time. My fiancé had also moved to Berlin to spend his half-year internship there. My brother Konrad was working on the editorial staff of the *Vorwaerts*. Compared with Munich, there was a noisy ferment about life in Berlin. Perhaps I would have been swamped by all that excitement; but perhaps too it would have had a fruitful influence upon me. In any case, the following year—1890—I was back in Koenigsberg. This time, thanks to the genre paintings I had sold, I was able to rent a small studio for myself. I had not yet completed the transition from painting to working in line. In fact, I wanted to paint; to be exact, I wanted to transfer the scene from *Germinal* to canvas. I would have to make studies for it. At that time Koenigsberg had a number of sailors' taverns near the Pregel, and visiting them at night was as much as one's life was worth. All I could do was to make my sketches in the morning at these places. The most interesting of them to me was the "Boat"—a tavern with double exits. As I stood outside I could hear a terrible din from inside; knife stabbings were commonplace occurrences.

My father no longer watched my work with the serene confidence that I was making progress. He had expected a much faster completion of my studies, and then exhibitions and success. Moreover, as I have mentioned, he was very skeptical about my intention to follow two careers, that of artist and wife. My fiancé had been put in charge of the tailors' *Krankenkasse,** and with this prospect for earning a livelihood we decided to take the leap. Shortly before our marriage my father said to me, "You have made your choice now. You will scarcely be able to do both things. So be wholly what you have chosen to be."

In the spring of 1891 we moved into the home in North Berlin where we were to live for fifty years. My husband devoted most of his time to his clinic and was soon burdened with a great deal of work. In 1892 I had my first child,

* A kind of "hospitalization" scheme. In return for medical care, members paid a small fee at regular intervals into the *Kasse,* or fund.

Hans, and in 1896 my second, Peter. The quiet, hardworking life we led was unquestionably very good for my further development. My husband did everything possible so that I would have time to work. My occasional efforts to exhibit failed. But in connection with one of these exhibitions, a show of the rejected applicants was arranged, and I took part in this. The press paid some attention to this project; in fact the press at this time was receptive to these beginnings which were later to develop into the highly interesting Independents, who were allied to the Paris Independents. There was much in these shows which was merely grotesque; yet the work was always far more interesting than that exhibited in the big shows at Lehrter Station, and Hermann Sandkul later on educated the public to take them seriously.

A great event took place during this time: the Freie Buehne's première of Hauptmann's *The Weavers*. The performance was given in the morning. I no longer remember who got me a ticket. My husband's work kept him from going, but I was there, burning with anticipation. The impression the play made was tremendous. The best actors of the day participated, with Else Lehmann playing the young weaver's wife. In the evening there was a large gathering to celebrate, and Hauptmann was hailed as the leader of youth.

That performance was a milestone in my work. I dropped the series on *Germinal* and set to work on *The Weavers*. At the time I had so little technique that my first attempts were failures. For this reason the first three plates of the series were lithographed, and only the last three successfully etched: the *March of the Weavers, Storming the Owner's House,* and *The End.* My work on this series was slow and painful. But it gradually came, and I wanted to dedicate the series to my father. I intended to preface it with Heine's poem, "The Weavers." But meanwhile my father fell critically ill, and he did not live to see the success I had when this work was exhibited. On the other hand, I had the pleasure of laying before him the complete *Weavers* cycle on his seventieth birthday in our peasant cottage at Rauschen. He was overjoyed. I can still remember how he ran through the house calling again and again to Mother to come and see what little Kaethe had done.

In the spring of the following year he died. I was so depressed because I could no longer give him the pleasure of seeing the work publicly exhibited that I dropped the idea of a show. A good friend of mine, Anna Plehn, said,

"Let me arrange everything." She entered the series for me, sent it in to the jury, and a few weeks later it was in the show at the Lehrter Station. Later I heard that the jury—Menzel was one of the members—had voted that the *Weavers* be given the small gold medal. The Kaiser vetoed the recommendation. But from then on, at one blow, I was counted among the foremost artists of the country. Max Lehrs, director of the Dresden collection of engravings and drawings, bought the series and succeeded in procuring the gold medal for it. To this day the *Weavers* is probably the best-known work I have done.

This triumph came to me as a surprise, but by then I was beyond the temptations of success. The *Secession* was started during those years. I was asked to join, and remained a member until it dissolved.

I should like to say something about my reputation for being a "socialist" artist, which clung to me from then on. Unquestionably my work at this time, as a result of the attitudes of my father and brother and of the whole literature of the period, was in the direction of socialism. But my real motive for choosing my subjects almost exclusively from the life of the workers was that only such subjects gave me in a simple and unqualified way what I felt to be beautiful. For me the Koenigsberg longshoremen had beauty; the Polish *jimkes* on their grain ships had beauty; the broad freedom of movement in the gestures of the common people had beauty. Middle-class people held no appeal for me at all. Bourgeois life as a whole seemed to me pedantic. The proletariat, on the other hand, had a grandness of manner, a breadth to their lives. Much later on, when I became acquainted with the difficulties and tragedies underlying proletarian life, when I met the women who came to my husband for help and so, incidentally, came to me, I was gripped by the full force of the proletarian's fate. Unsolved problems such as prostitution and unemployment grieved and tormented me, and contributed to my feeling that I must keep on with my studies of the lower classes. And portraying them again and again opened a safety-valve for me; it made life bearable.

Then, too, my temperamental resemblance to my father strengthened this inclination in me. Occasionally even my parents said to me, "After all there are happy things in life too. Why do you show only the dark side?" I could not answer this. The joyous side simply did not appeal to me. But I want to emphasize once more that in the beginning my impulse to represent

proletarian life had little to do with pity or sympathy. I simply felt that the life of the workers was beautiful. As Zola or someone once said, "Le beau c'est le laid."

As a result of my success with the *Weavers* the girls' art school asked me to teach graphic arts and conduct life classes there. The director of the school at the time was Fraeulein Hoenerbach, and among the teachers were Martin Brandenburg and Hans Baluschek. I taught there for two or three years and then gave it up.

When Fraeulein Hoenerbach first spoke with me about the job, I pointed out that my knowledge of etching technique was too slim for me to undertake to teach it. She said, "Don't worry about that. Koepping taught me how to 'cook' pretty well, and if you ever get in a hole I'll help you out." That came about very soon. I had to show the class how to make an etching ground. The process was a book with seven seals to me and I perspired with embarrassment as I started to trot out my meager knowledge before the eager girls standing in a group around me. Suddenly I heard Fraeulein Hoenerbach's voice; she had joined the group of students. "Yes, Frau Kollwitz," she said, "that is one way to do it. But I'd like to tell you how Koepping taught me to do it." Then she took the plate and other materials out of my hands and saved the situation for me.

My life between thirty and forty was very happy in every respect. We had sufficient to live on; the children were growing up and healthy; we went traveling. During these years I went to Paris twice. The first time was for only a brief stay, on the invitation of Lily and Heinrich Braun. The second time I stayed longer. Paris enchanted me. In the mornings I went to the old Julien School for the sculpture class, in order to familiarize myself with the fundamentals of sculpture. Afternoons and evenings I visited the wonderful museums of the city, the cellars around the markets or the dance-halls on Montmartre or the Bal Bullier. One of my friends and fellow artists, Ida Gerhardi, went there night after night to make sketches. The cocottes knew her, and when they were dancing they handed her their things to watch. Another friend was the painter Sophie Wolff. Sophie Wolff was at the time exclusively a painter; she was very well thought of among the Paris Independents. Later she turned to sculpture. Shortly before the outbreak of the World War she returned to Germany to stay. This move was greatly to her disadvantage.

She did not succeed in getting in Berlin nearly as good a position as the one she had had in Paris, and did not receive the recognition she deserved for her excellent sculpture and drawing.

We used to take our evening meal in one of those big cafés on Boulevard Montparnasse where the artists ate en masse, sitting together by nationalities. The art dealer, Otto Ackermann, husband of Maria Slavona, introduced me into the private galleries. I met a Russian woman named Kalmikoff, the philosophers Simmel and Groethuysen, who were then in Paris, and the writer Hermann Uhde. Twice I visited Rodin. The first time was at the Rue de l'Université, where I found him in his studio. He then invited Sophie Wolff and me to come out to Meudon. I shall never forget that visit. Rodin himself was taken up with other visitors. But he told us to go ahead and look at everything we could find in his atelier. In the center of a group of his big sculptures the tremendous Balzac was enthroned. He had small plaster sketches in glass cases. It was possible to see the full scope of his work, as well as to feel the personality of the old master.

Besides Rodin, I visited Steinlen, the creator of *l'Assiette au Beurre*, in his studio. He too is someone I shall never forget. He was a typical Parisian. The loose tobacco in his wide pants pockets, his continual rolling of cigarettes, his wife, his many children—all combined to produce that Parisian atmosphere.—Among the younger artists Ackermann introduced me to Hoetger, who was then still unknown.

I had planned to round out this tour by going to Brussels to visit Meunier, who was then very old. Unhappily, I never carried out this intention. Paris held me fast until the very last evening. Meunier died, and I never had the chance to meet him.

My longest absence from home came about through my winning the Villa Romana prize, which was given by Klinger. The prize was a grant for a year's living abroad; the purpose of the foundation was to acquaint artists with Florence and its art treasures. Supposedly, the artists would also carry on their own work. I did not work at all, although I was given a handsome studio in the Villa Romana. But there for the first time I began to understand Florentine art. At the beginning of my stay I had my younger son Peter with me; but when my husband came on a brief visit he took the boy back with him. Meanwhile I had met Stan Harding-Krayl, a highly original and tal-

ented Englishwoman who was married to a German doctor in Florence. She had gone on walking tours throughout Italy and proposed that I accompany her on her next one. And so we walked all the way from Florence to Rome, partly through the Campagna, partly along the seacoast. During the entire trip which lasted three weeks we saw only Italians. The people thought we were pilgrims; they fed us for nothing and asked only that we say a prayer for them in St. Peter's. One evening we saw the town of Pitigliano lying before us. Like all Umbrian towns, it was so built that from a distance it looked like a long chain of castles. It was situated on a narrow slope, and a single bridge led across to it. We walked across this bridge into the enchanted town, which had only length and no breadth; there were only stubs of narrow lanes to either side of the main road.

The day after our arrival was an important Catholic holiday. From our window we saw the procession marching by, the children dressed like angels.

On the slope of the town we discovered caves where the people kept their donkeys and other stock. They were Etruscan caves. We were told that an hour's walk further on we would come to a place where there were quantities of "old junk," as they put it, lying about. Next day we went there and found that it was quite so; we literally clambered over the limbs of gods. We bought some of the pieces and divided the spoil between us. From Florence I brought some things back to Berlin.

This walking tour through Italy did not take me to the places I most wanted to see: Perugia and Assisi. But it did give me vivid and characteristic impressions of the country and the people. On June 13, 1907 we crossed the Ponte Molle into the Eternal City. By then we were completely done in.

There was one day on which we went across the Via Appia and down as far as Rocco di Papa, where I was to meet our oldest son Hans. He was fifteen, and he came all the way from Berlin by himself, proud of his independence.

My impression of Rome was that it was scarcely worthwhile to begin studying its art treasures. The superabundance of classical and medieval art was almost frightening. After spending much too short a time there, I went back to Florence with Hans, and from there to Spezia. The same minute our train from Florence arrived in Spezia, another train pulled in from the north, bringing my husband and little Peter. We hired a boat and were rowed across to Fiascherino, a tiny fishing village. There we lived among the fisher-

men. After a while Stan and her husband followed us out there and we spent a glorious vacation together. A rather battered fishing boat was placed at our disposal. We spent whole afternoons on the water and in the cool grottoes. Once we rowed over to Carrara at dawn, climbed up to the marble quarries and rowed back at night. The night was so quiet that the stars were reflected in the sea and the drops of water fell like glittering stars from the oars. That summer I reached my fortieth year. Thin and brown from the sun and the Ligurian Sea, we finally returned home.

Meanwhile Hans had come to the age when he was beginning to write. We used the holidays for performances of his own plays, and then some of the classics. It began with Schiller and went on through Gorki's *Lower Depths* to Hofmannsthal's *Death and the Fool*. Our company consisted of our two boys and Georg Gretor, the son of an old friend from my student days in Munich, whom I had met again in Paris. She lent Georg to us for a lengthy stay—he was the same age as our Hans. Then there were my sister Lise's two oldest girls, Regula and Hanna Stern, who went on the stage when they were older. If there was a shortage of actors, the older generation was pressed into service. Gorki's *Lower Depths* in particular was a performance that turned everything in our household upside down.

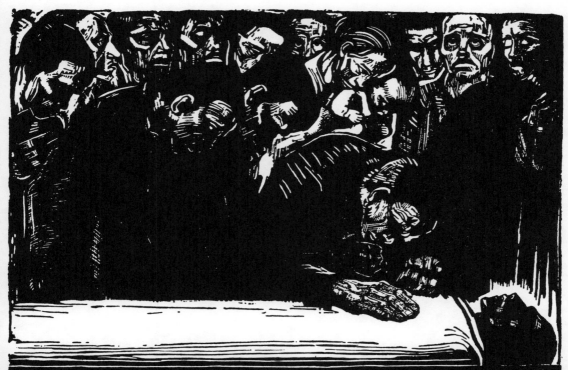

DIE LEBENDEN DEM TOTEN . ERINNERUNG AN DEN 15. JANUAR 1919

From the Diaries

A happy day yesterday. Finished drawing the fifth and last plate for *Simplizissimus:* the Home Industries. Toward evening a pleasant walk as far as the viaduct. I am so glad that I can work well and *easily* now. In this vein I could effortlessly go on making drawings for S. As a result of so much working on studies I have at last reached the point where I have a certain background of technique which enables me to express what I want without a model.

September 1909

Frau Pankopf was here. She had a bad black eye. Her husband had flown into a rage. When I asked her about him, she said he had wanted to be a teacher, but had become a worker in tortoise-shell and was well paid for his work. His heart became enlarged, and at the same time he had his first attacks of extreme restlessness. He went for treatment and then tried to work again. It wouldn't do; he tried to get other work; and last winter went about with a hurdy-gurdy. His feet swelled, and the longer it went on the

more he suffered from melancholy and nervousness. Wailed continually that he longed for death, could not support his family, and so on. When their next to the last child died, he remained in a state of hysterical misery much longer than his wife. Six of the children are living. Finally he started to have fits of rage and was taken to Herzberge.

The more I see of it, the more I realize that this is the *typical* misfortune of workers' families. As soon as the man drinks or is sick and unemployed, it is always the same story. Either he hangs on his family like a dead weight and lets them feed him—cursed by the other members of the family (Schwarzenau or Frank), or he becomes melancholy (Pankopf, Goenner), or he goes mad (likewise Frank), or he takes his own life. For the woman the misery is always the same. She keeps the children whom she must feed, scolds and complains about her husband. She sees only what has become of him and not how he became that way.

September 24, 1909

I looked at some Duerer drawings of hands in the print collection. Except for a very few things I am no longer so overwhelmed by Duerer. His stroke is distasteful to me, and so is his excessively subjective feeling for form.

December 30, 1909

On Saturday the Secession show was opened. I went there with Hans. My things were hung well, although the etchings were separate. Nevertheless I am no longer so satisfied. There are too many good things there that seem fresher than mine. Brandenburg is excellent this time. I wish I had done his dance, his orgy. In my own work I find that I must try to keep everything to a more and more abbreviated form. The execution seems to be too complete. I should like to do the new etching so that all the essentials are strongly stressed and the inessentials almost omitted.

I repeatedly dream that I again have a little baby, and I feel all the old tenderness again—or rather more than that, for all the feelings in a dream are intensified. What I have in these dreams is an inexpressibly sweet, lovely, physical feeling. First it was Peter who lay asleep, and when I uncovered him it was a very small baby exuding the warm bodily fragrance of babies.

I am gradually approaching the period in my life when work comes first. When both the boys went away for Easter, I hardly did anything but work. Worked, slept, ate and went for short walks. But above all I worked. And yet I wonder whether the "blessing" is not missing from such work. No longer diverted by other emotions, I work the way a cow grazes; but Heller once said that such calm is death. Perhaps in reality I "accomplish" little more. The hands work and work, and the head imagines it is producing God knows what; and yet formerly, in my so wretchedly limited working time, I was more productive because I was more sensual; I lived as a human being must live, passionately interested in everything. Now I am working on the second plate of *Death*. Sometimes, infatuated with my work, I think I am far surpassing myself. But after a two-hour pause—where is the stroke of genius? Then there seems to me nothing special about what I have done. That torments me. Potency, potency is diminishing.

Last night I was invited to a session of a group who wanted to renew the project for holding the "juryless" show. It was interesting meeting P . . . , Kober and two other boys who had been refused by the Secession. Their work meant nothing to me; I thought it all talented smears such as any gifted academy student can turn out. But they think themselves future Manets. P. said: I don't give a hoot about a juryless show, I'll make my own way, and so on. Now I already belong to the older generation, to those who have been

long *arrivés* and are blocking the way and taking the light from the youth. It is interesting, this eternally rising wave of the youngest youths. They cannot be understood by the more mature artists and by those who have technique and craftsmanship, for they almost never possess any special superiority. All their superiority lies in the young people's imagination. And yet youth has the right to see itself in this highly imaginative future light, just as the no-longer-young have the right to smile at the illusory values of the young and to turn away from them to their maturer concerns.

April 1910

This period in my life seems to me very fine. Great, piercing sorrows have not yet struck me; my darling boys are growing more independent. I can already see the time when they will break loose from me, and at the moment I look forward to it without sorrow. For then they will be mature enough for a life wholly their own, and I shall still be young enough for my own life.

May 15, 1910

Yesterday was the boy's eighteenth birthday, and at the same time the first day of vacation and the Saturday before Whitsuntide. . . . At four we went to Adami's. The weather was overcast, but very beautiful, the air damp and hot, the apple trees in bloom. There was a thundershower which we waited out in the hall; then, afterwards, the delicious air. . . . In the evening we all went to our house and had a bowl of punch. Karl was free at last and we spent several wonderful hours together. Rele, forgetting her rigidity and lack of grace, was light-hearted and light-footed, bedecked with May flowers, kept dancing and moving about all the time, not sitting still for five minutes. All of us were somewhat tipsy. Kati L. was gay and uninhibited as I have never seen her. L. a great good sport, his peculiar sensuality showing all the time. Lore sat quietly and contentedly watching most of the time, but now and then she leaped around like a witch in a circle. And our boys—it's odd. Usually Peter is the gayer of the two, but when they have been drinking Hans is almost always gayer than Peter. Hans was almost covered over with

54

May flowers. He jumped, danced and sang constantly, usually with Rele. I am certain now that he can give himself up to enthusiasm. When he was four years old and we sat on our little balcony to catch the breeze—Lise and I—I spoke of the kind of boy I wanted him to be. I don't remember all I said at the time, but at the end I added: And he must be capable of enthusiasm. He is, and that is good. Everyone sang and danced constantly. When we sang *Gaudeamus,* he led me as if it were a polonaise; and for another song all three of us danced, myself in the middle, Hans on my left and Peter on my right. Karl sat in the middle of the room singing, the song-book in his hand. Finally they began amusing mock squabbles. Rele drank a toast to science, Hans to life. Peter touched glasses with Rele and I with Hans and Hans Schroeder. As we drank, Rele was life itself, brimming over with the joy of living. But Peter, after the first effects of the wine passed, grew serious. He chided Rele. The wine had made him lofty and philosophically inclined.

When all the others were gone, Karl and I sat on the sofa, Rele, who had suddenly become quiet, in a chair between the door and the birthday table, the boys alternately in the middle of the room or near the life light, the one candle still burning. They read poems aloud. Peter read expressively Nietzsche's *Oh Noon of Life, Solemn Time,* then *The Little Passion.* Sitting beside me, he leafed through the book looking for Freiligrath's *The Dead to the Living* and Vischer's *Confession of Faith.* He did not read these aloud, but he told me, in a significant way, that he would read them *tomorrow.* Tomorrow, he said, he also wanted to write a great deal in his diary, not external experiences, but other things entirely. This last hour had been the only really lovely hour of the whole day, he added.

But today he slept until nine, stuffed himself with coffee cake, read the newspaper idly, took out his roller skates, and has not yet returned to his philosophical preoccupations.

How strongly I feel that this is a dividing period in their lives. How soon now something very real and definite will emerge out of the boys' lovelorn enthusiasms. Sensuality is burgeoning in all these young people; it shows up in every one of their movements, in everything, everything. It is only a matter of opening a door and then they will *understand* it too, then the veil will be gone and the struggle with the most powerful of instincts begin. Never thereafter will they be entirely free of sensuality; often they will feel it their

enemy, and sometimes they will almost suffocate for the joy it brings. Now all of them—Hans, Georg, Rele and Margret—are not yet quite awakened. I feel at once grave, ill at ease and happy as I watch our children—our *children*—growing to meet the greatest of instincts. May it have mercy on them!

<div align="right">*May 20, 1910*</div>

In Friedenau, on the way to the Prengels, Mother takes notice of houses, the plantings, the small gardens. Afterwards Uncle Prengel remarks that he too has these simple pleasures, for example the green of the chestnut trees before his window. It is a kind of stupefaction. The intellect falls asleep; there remains above all sensuous pleasure in the things that meet the eyes. I keep thinking about Nils Luhne who during his last years could sit by the side of the road looking at the grain field in "a strange, vegetative trance." It is really a kind of vegetative life that the old lead, one far removed from the needlessly passionate emotional life of the young. Troublesome experiences too are rejected by the old.

<div align="right">*June 1910*</div>

Read several short stories by Hugo von Hofmannsthal, and his *Venice Delivered*. He is most characteristic in his short stories. In one of them he tells of a rich young man and his four servants. The story is full of horror and extremely Hofmannsthalesque. The adventure of General Bassompière—he took his inspiration from Goethe's tales of emigrants—is to my mind very lovely, written in a smiling, sensuous language. It reminds me a little of the Decameron. Then there is also the story about an Italian captain; it too seems quite good to me, although the horror in it is somewhat outré. Then the fine letter he wrote about his inability to create. *Venice Delivered*, on the other hand, I do not like. Here as in the *Electra* he blusters in order to give the impression of strength which he does not have. It is as though a person with a weak voice were suddenly to begin shouting. There is the same sense of impotence when he tries to give the impression of strength by depicting cruelty and voluptuousness. Strength he does not have.

I have had Frau Naujoks sitting as model for the group for the past three weeks. I am fond of her; she is loyal and good-natured. She totally supports her invalid husband. He has been sick for seven years; I hardly think she hopes he will ever be well. She wishes he would recover, but if he does not, then she wants to marry a healthy man and move to the country. She is twenty-eight, her husband thirty-four. She has lost one baby. At first she sat with little Hermann Sost. She was splendid with the boy when she held him on her lap and fooled with him. The boy was highly pleased with her nakedness; he behaved like a little animal, a young faun, with her. And she too was full of good-natured animal spirits. She has this nonsensical way of chattering with children which is just right for them. But the little boy had lice, and besides he'd sit still only when he was asleep, so that I finally took Trudchen Schulz as a model. She is just as old as the boy, but she sits quite still and it is possible to work from her. She too is shapely, and she is very clean. But Frau Naujoks keeps thinking about little Hermann with his "thick Negro lips" and his "shiny nose from all that eating."

September 29, 1910

My wish is to die after Karl. I could endure living alone better than he could. I am also closer to the children. But if I should die Karl could not manage alone. If I die, Karl would find it unbearable by himself. He loves the children enough to die for them, and yet there is alienation between them . . . That is why Karl would be so unbearably alone if I should die before him. I know no person who can love as he can, with his whole soul. Often this love has oppressed me; I wanted to be free. But often too it has made me so terribly happy. I scarcely think I would ever leave him for very long. Growing old is partly an inescapable process of accommodation and adjustment. Only a year ago I thought that once Hans was out of the house—but in any case as soon as both boys were out of the house—I should like to go away for a long time. To Paris. Now I desire this much less strongly. I get to working nowadays as often as I need. That is what counts.

Alexander Oppler came to see my group. He told me what I really already knew, that my work as *work* is not adequate. For he is essentially the professional sculptor who gets his sculptures absolutely finished. Three-dimensionality. He is right and he is not right. Assuming that he finds a model who corresponds exactly to his conception and who can take exactly the desired pose, he can turn out something; in fact he can do remarkably beautiful work. But if he does not find such a model he is sunk. It reminds me of what Boecklin says about painters who never get to work because they never get over their tribulations with models. But Oppler is right in that what I am doing now is dilettantish stuff.

November 1910

The performance of *Oedipus* on November 7. Very grand, very powerful. Even though it is neither Sophoclean nor classical, even though it is done in circus style—"King Oedipus in Karlshorst"—it is still new, stirring, tremendous in its dimensions, deeply tragic. After the announcement of Jocasta's death the people are hurled back and forth in front of the palace like roaring surf. The whirlpool. Then, when blinded Oedipus appears, the moaning scream with which the populace reels back out of the arena. Oedipus speaking to the Chorus from his majestic height, seeing the Chorus only as a dim mass, seemed to be listening only vaguely, reluctantly, with the irritated, impatient expression of a person hearing something unpleasant. Then his *screaming* as he comes out of the palace, his desperate wailing. Jocasta with blood-red mouth, holding both arms out horizontally as she sees the inevitable approaching.

November 20, 1910

Karl told me about a patient of his, a worker's wife who treats her husband very badly, beats him black and blue, and at the same time writes

under the name of "Doris" poems full of yearning passion to her "swain," a cashier.

I imagine the following sculpture as utterly beautiful: a pregnant woman chiseled out of stone. Carved only down to the knees so that she looks the way Lise said she did the time she was pregnant with Maria: "As if I am rooted to the ground." The immobility, restraint, introspection. The arms and hands dangling heavily, the head lowered, all attention directed inward. And the whole thing in heavy, heavy stone. Title: *Pregnancy*.

. . . What about myself? Summing up of 1911? Progress? No progress in my relationship with Karl. What he always speaks of, what seems to him still the sole worthwhile goal of our long living together—that we should grow together in the deepest intimacy—I still do not feel and probably never will learn to feel.

Are not the ties with the boys also growing slacker? I almost think so. For the last third of life there remains only work. It alone is always stimulating, rejuvenating, exciting and satisfying. This year I have made excellent progress in sculpture. I can see an advance between the first group of mother with child and the last finished group. This group, in which the child sits between the mother's legs and she holds his feet with her left hand, is about done as far as working from the model goes. Now I have taken it up again; but it still has a dead side that I do not know how to attack.

What strange expressions people use in distress. At her husband's grave Dr. Bab's wife kept crying, "My boy, my boy!"—A man who had treated his wife very badly sobbed beside her body after she died, caressed her and

murmured again and again, "Little girl, little girl, little girl."—When Hans had his heart attack, I heard myself saying, "My charming, beloved boy!"

March 1912

Peter drew from a nude female model for the first time. "Well, how did she look?"—"Awful. I don't know, are they all as bad as that?"

New Year's 1912-13

Was the last year good? It was peaceable. It brought me little sorrow. When I cried, most of the time the reasons were not so heartbreaking. . . . My impression of Hans is that he does not always find in me what he seeks. He is moving forward swiftly and I am not. Does he feel that I am getting old? Am I perceptibly aging? I do not know. Sometimes I feel almost paralyzed, at other times buoyant. Sometimes I stop believing in the value of my working, and that is bad. Formerly I did not look to either side. Now I feel myself vulnerable; sometimes I am a prey to despair. And I am too much upset by the young people with their different point of view. If I had great strength within myself they would hardly trouble me, but now I feel that my work has no echo, feel as if I have been tossed into the scrapheap. And so I have. All that one can do is put on blinkers and plod along by oneself, paying no attention to anything else. I've worked almost exclusively in sculpture this year. I don't know whether I will get anywhere. If not, what then? Can I possibly go back to etching?

June 1913

Recently, in connection with the struggles over the Secession and my position on them, Karl said to me: Up to now you've had an altogether different mode of life. You've felt attracted or repelled, and have chosen your associates only by those lights. You have always been subjective and have never been concerned about analyzing relationships in themselves. Now you are in a situation where it is vital to be concerned about analyzing relationships in themselves.

September 1913

Rarely have I been so without illusions in regard to my work as I am now. Sometimes it seems to me that I am fortunate in beginning to work in sculpture at a time when all the old values are being overthrown. I too might begin anew, unencumbered by any technique, simply newborn. But unfortunately I cannot.

September 1913

Karl cannot spare himself or conserve his energies. He gives himself up to his work without reserve. And all bargaining, weighing and holding back in the realm of emotions is alien and repugnant to him. He gives himself entirely to me. He is spendthrift because his stock of love and kindness is inexhaustible.

September 1913

I went to *Tristan* with Peter. At the beginning I got a great deal out of it. Later, I suppose, I was too tired. The overture seemed to me very beautiful, this welling, ecstatic rush of music. Then, later, in the second act, when Isolde is waiting for Tristan—just before he arrives, that storm of expectation.

September 1913

I am working on the group of lovers, with the girl sitting in the man's lap. My deep depression after the summer vacation has dissipated, but I still do not have any real faith. Sometimes it seems to me that all I lack is moral courage. I do not fly because I do not dare to throw myself into the air like Pégoud. Actually, with my technique—even in sculpture—I should trust myself more. Is my lack of courage a token of age? All the ifs and buts that older people are aware of. Pechstein exhibits his talented sculptural sketches without any scruples. He doesn't give a hoot that they are nothing but sketches.

Sunday. The last day before our trip either to Globsow or to Georgens-walde. A rather dull day. A day that reminds me of days at home which were so leaden and boring. I recall distinctly the feeling I often had at home, the desire to get away, just to have things different and to live my own life. Just not to go on in the humdrum, traditional style. At such times I could not stand looking at the rooms. I want to remember that in connection with the boys.

August 27, 1914

In the heroic stiffness of these times of war, when our feelings are screwed to an unnatural pitch, it is like a touch of heavenly music, like sweet, lamenting murmurs of peace, to read that French soldiers spare and actually help wounded Germans, that in the franc-tireur villages German soldiers write on the walls of houses such notices as: Be considerate! An old woman lives here.—These people were kind to me.—Old people only.—Woman in childbed.—And so on.

A piece by Gabriele Reuter in the *Tag* on the tasks of women today. She spoke of the joy of sacrificing—a phrase that struck me hard. Where do all the women who have watched so carefully over the lives of their beloved ones get the heroism to send them to face the cannon? I am afraid that this soaring of the spirit will be followed by the blackest despair and dejection. The task is to bear it not only during these few weeks, but for a long time—in dreary November as well, and also when spring comes again, in March, the month of young men who wanted to live and are dead. That will be much harder.

Those who now have only small children, like Lise her Maria, seem to me so fortunate. For us, whose sons are going, the vital thread is snapped.

September 30, 1914

Cold, cloudy autumnal weather. The grave mood that comes over one when one knows: there is war, and one cannot hold on to any illusions any

more. Nothing is real but the frightfulness of this state, which we almost grow used to. In such times it seems so stupid that the boys must go to war. The whole thing is so ghastly and insane. Occasionally there comes the foolish thought: how can they possibly take part in such madness? And at once the cold shower: they *must, must!* All is leveled by death; down with all the youth! Then one is ready to despair.

Only one state of mind makes it at all bearable: to receive the sacrifice into one's will. But how can one maintain such a state?

[Peter Kollwitz was killed on October 22, 1914.]

December 1, 1914

Conceived the plan for a memorial for Peter tonight, but abandoned it again because it seemed to me impossible of execution. In the morning I suddenly thought of having Reike ask the city to give me a place for the memorial. There would have to be a collection taken for it. It must stand on the heights of Schildhorn, looking out over the Havel. To be finished and dedicated on a glorious summer day. Schoolchildren of the community singing, "On the way to pray." The monument would have Peter's form, lying stretched out, the father at the head, the mother at the feet. It would be to commemorate the sacrifice of all the young volunteers.

It is a wonderful goal, and no one has more right than I to make this memorial.

December 9, 1914

My boy! On your memorial I want to have your figure on top, *above* the parents. You will lie outstretched, holding out your hands in answer to the call for sacrifice: "Here I am." Your eyes—perhaps—open wide, so that you see the blue sky above you, and the clouds and birds. Your mouth smiling. And at your breast the pink I gave you.

February 15, 1915

In the studio I looked at my former sketches. Saw that I have gone along by roundabout ways—which were perhaps necessary—and yet am making

progress. I do not want to die, even if Hans and Karl should die. I do not want to go until I have faithfully made the most of my talent and cultivated the seed that was placed in me until the last small twig has grown. This does not contradict the fact that I would have died—smilingly—for Peter, and for Hans too, were the choice offered me. Oh how gladly, how gladly. Peter was seed for the planting which should not have been ground. He was the sowing. I am the bearer and cultivator of a grain of seed-corn. What Hans will become, the future will show. But since I am to be the cultivator, I want to serve faithfully. Since recognizing that, I am almost serene and much firmer in spirit. It is not only that I am permitted to finish my work—I am obliged to finish it. This seems to me to be the meaning of all the gabble about culture. Culture arises only when the individual fulfils his cycle of obligations. If everyone recognizes and fulfils his cycle of obligations, genuineness emerges. The culture of a whole nation can in the final analysis be built upon nothing else but this.

April 27, 1915

I am working on the offering. I had to—it was an absolute compulsion— change everything. The figure bent under my hands of itself, as if obeying its own will—bent over forward. Now it is no longer the erect woman it had been. She bows far forward and holds out her child in deepest humility.

July 15, 1915

Prayer is, as it has always been for me, petition. Luther says a prayer ought to be short and ardent. Benevenuto Cellini prays: "Help me now, God, because I want to help myself." That is prayer demanding and attaining influx of strength. It is said that prayer ought to be a coming to rest in God, a sense of uniting with the divine will. If that is so, then I am—sometimes—praying when I remember Peter. The need to kneel down and let him pour through, through me. Feel myself altogether one with him. It is a different love from the love in which one weeps and longs and grieves. When I love him in that way I do not pray. But when I feel him in the way which I want to make outwardly visible in my work, then I am praying. That is also

why the parents on the pedestal are kneeling as they carry their dead son. And are wholly in meditation, and in him.

We read Tolstoy's story of the two pilgrims who set out for Jerusalem. It is very beautiful. What moved me so much yesterday was the second old man's coming to Jerusalem but not receiving the inner blessing. The spiritual state of a man who takes all the necessary steps to achieve an inner experience and does not attain it. This feeling I very often have. This year has been a pilgrimage, and instead of being transformed inwardly I go on living in the same narrow interior circle. Not wholly. It is still somewhat different from the way it was. Somewhat different.

How Karl and I are now growing more and more intimately used to one another. What life did not accomplish up to a year ago, this year has accomplished. Yes, new flowers have grown up which would not have grown without the tears shed this year. There is in this a little of what Goethe says in *Tasso:*

> *Men do not know the souls of one another.*
> *Only the galley slaves know one another*
> *Who side by side are chained, and gasp for breath.*

Later: What I wrote about the galley slaves sounds like excessive pathos. I mean by it only that sorrow shared brings people together.

September 1915

What can the goal of humanity be said to be? For men to be happy? No, or at any rate that is only a subsidiary goal. The goal is the same as it is for the individual. The individual strives first of all for happiness in the usual sense, happiness in love, and so on. On a somewhat higher plane is the joy of self-development. Bringing all one's forces to maturity. Still above that is becoming one with God, "until like a singing serpent your life shall sometime find full resonance in togetherness." This union with God can be achieved in

a long life and in a very short one. Translating this to all humanity, it means: Humanity's goal goes beyond the first stage of happiness—elimination of poverty, disease and so on—and also beyond the complete development of the forces within itself. The goal is to develop divinity, spirituality.

November 1915

I am reading Walter Heymann—his poems and letters from the front. Again I feel quite distinctly that it is not proper for me to lament over the war. Certainly I know what it is *like*. But I may not complain. No one may for whom the dearest person in the world has gone, as Peter went. Heymann's wife surely does not complain. Nor would it be right for her to. It is right for us to weep for our loved ones, but we must be worthy heirs. We may also be against the war. We may work—must help work—so that this one will be the last. But I must stop giving way to this type of personal grief.

December 1915

The idea of eternity and immortality doesn't mean anything to me at present. The spirit in Peter goes on living. True enough—but what does this spirit mean to him? The great world spirit which entered into him and which goes on working after its dwelling is shattered—that is something not conceivable. What was important was this particular form which grew. This unique person, this human being who could live only once. What continues is spirit in itself, but yet not Peter's spirit. Peter's spirit was inseparable from his body. That is why for me there is no consolation at all in the thought of immortality. The one consolation would be to believe in a personal continuance of life. Then one would have to imagine that the great spirit embodied itself in a similar form, so that one caught the breath of something again when one came across such a person.—If he had had a child, there would be traces of him left.

When one says so simply that someone has "lost his life"—what a meaning there is in that—to lose one's life.

66

Recently Karl said, "His death has made us no better." The narrowness in me—that is the worst. To extend, expand, become something higher—that is what one asks of oneself. To remain the same person one was before fate struck—this must not be. Transformation through a single act of will has not come about. Therefore it must take place slowly.

. . . Where are my children now? What is left to their mother? One boy to the right and one to the left, my right son and my left son, as they called themselves. One dead and one so far away, and I cannot help him, cannot give to him out of myself. All has changed forever. Changed, and I am impoverished. My whole life as a mother is really behind me now. I often have a terrible longing to have it back again—to have children, my boys, one to the right and one to the left; to dance with them as formerly when spring arrived and Peter came with flowers and we danced a springtide dance.

All day devoted to hanging pictures in the Secession. Acting on the jury and hanging too is very instructive.

A show ought to have a face, and the pictures exhibited must fit into this face. From that it follows that mediocre pictures may possess the features which are fitting for the face and often must be accepted, while better pictures which have unsuitable features must sometimes, and justly, be rejected. Necessary injustice in all exhibitions.

My unpleasant position on the jury. I always find myself forced to defend the cause of a woman. But because I can never really do that with conviction, since most of the work in question is mediocre (if the works are better than that the other jury members will agree), I always become involved in equivocations.

Recently I reflected that my big work will hardly be finished before next summer, so that the time when I might show it will probably coincide with my fiftieth birthday show. If it were possible to obtain the Secession for the purpose, that is, if we could count on attendance covering the expenses, that would be something to consider. In conjunction with the usual spring Secession show. Then, in the central hall, only this big work, and in the three smaller halls to the right drawings and graphic work, and in the blue hall, sculpture: the small work which is now being exhibited and which seems to be a total failure, the mother with the child, the old pietà sketch, the still unborn gravestone, the parents. That might turn out to be a good show.

February 21, 1916

Read an article by E. von Keyserling on the future of art. He opposes expressionism and says that after the war the German people will need eccentric studio art less than ever before. What they need is realistic art.

I quite agree—if by realistic art Keyserling means the same thing I do. Which refers back to a talk I had recently with Karl about my small sculptures.

It is true that my sculptural work is rejected by the public. Why? It is not at all popular. The average spectator does not understand it. Art for the average spectator need not be shallow. Of course he has no objection to the trite—but it is also true that he would accept true art if it were simple enough. I thoroughly agree that there must be understanding between the artist and the people. In the best ages of art that has always been the case.

Genius can probably run on ahead and seek out new ways. But the good artists who follow after genius—and I count myself among these—have to restore the lost connection once more. A pure studio art is unfruitful and frail, for anything that does not form living roots—why should it exist at all?

Now as for myself. The fact that I am getting too far away from the average spectator is a danger to me. I am losing touch with him. I am groping in my art, and who knows, I may find what I seek. When I thought about my work at New Year's 1914, I vowed to myself and to Peter that I would be

more scrupulous than ever in "giving the honor to God, that is, in being wholly genuine and sincere." Not that I felt myself drifting away from sincerity. But in groping for the precious truth one falls easily into artistic oversubtleties and ingenuities—into preciosity. I suddenly see that very clearly, and I must watch out. Perhaps the work on the memorial will bring me back to simplicity.

March 31, 1916

I am overcome by a terrible depression. Gradually I am realizing the extent to which I already belong among the old fogies, and my future lies behind me. Now I am looked upon more or less kindly as a dignitary. If I had less of a name I would be treated like Loewenstein and Siewert; I would be rejected.

What can be done? Return, without illusions, to what there is in me and go on working very quietly. Go on with my work to its end. Show seasons are naturally always disturbing because I see all the strange, youthful and new things passing before me, and they excite me. I compare them with myself and see with disgusting clarity what is feeble and reactionary in my own work.

When I am at the Secession, in the midst of artists who are all thinking about their own art, I also think of mine. Once I am back home this horrible and difficult life weighs down upon me again with all its might. Then only one thing matters: the war.

April 18, 1916

Last night I dreamed once more that I had a baby. There was much in the dream that was painful, but I recall one sensation distinctly. I was holding the tiny infant in my arms and I had a feeling of great bliss as I thought that I could go on always holding it in my arms. It would be one year old and then only two, and I would not have to give it away.

Worked. I am making progress on the mother. I think about little Peter's consoling words to me: "Don't worry, Mother, it will be beautiful too."

In Peter's room. Then I drove out to Heinersdorf and from there walked a while in the direction of Malchow. A country road lined with willows. Up in the branches of one of them five boys crouched. To the left, broad, open fields. Peter certainly walked along this road. I heard larks singing. There was such a feeling of tranquillity in me that I thought: if age brings with it this peace, then I understand why old people do not voluntarily depart from life. Younger, still active people see in the old only strength decaying, but the old person himself experiences something new in himself, the peace of God which more and more fills him. If that is so, stagnation is only an outward illusion; the old person himself has the valid feeling of further development, and this keeps him from putting an end to his life. It always comes back to this: that only one's inner feelings represent the truth. The feelings of age, not yet being experienced, are still a foreign realm to us. It is an "impertinence toward life" in Keller's sense to see no value in age.

For our silver wedding anniversary

Dear husband: When we married, we took a leap in the dark. We were not building upon a firm foundation, or at least one firmly believed in. There were grave contradictions in my own feelings. In the end I acted on this impulse: jump in—you'll manage to swim. Mother, who realized all that and was often worried, once said to me: "You will never be without Karl's love."

That has been true. I have never been without your love, and because of it we are now so firmly linked after twenty-five years. Karl, my dear, thank you. I have so rarely told you in words what you have been and are to me. Today I want to do so, this once. I thank you for all you have given me out of your love and kindness. The tree of our marriage has grown slowly, somewhat crookedly, often with difficulty. But it has not perished. The slender

seedling has become a tree after all, and it is healthy at the core. It bore two lovely, supremely beautiful fruits.

From the bottom of my heart I am thankful to the fate which gave us our children and in them such inexpressible happiness.

If Hans is let live, we shall be able to see his further development, and perhaps we may expect children of his. If he too is taken, then all the sunlight that out of him lighted, warmed and made everything golden will be smothered; but we shall still hold tight to one another's hands to the end, and remain heart to heart.

<div align="right">Your Kaethe.</div>

<div align="right">*July 8, 1916*</div>

Now I am forty-nine years old . . . What has the last year brought me? What have I brought to it? I feel that I have become older and feebler. When I see my body, my withered face, my old hands, I become discouraged. How can such a person accomplish as much as I still want to accomplish? Sorrow and longing eat away at strength, and I need strength. I *beg* that I may be able to do the work. Above all the work for Peter, but also all the rest of it. Once I have done that I will be glad to die, but first I must do it.

When I am here with Mother, I often feel like her. I stand with my hands behind my back, looking out of the window and humming to myself like her. Suppose for me too all that was left of life was to look on?

New strength—that is what I *beg* for.

<div align="right">*August 12, 1916*</div>

Lily Braun says in her testament: ". . . I have never ceased, in spite of the frightful harshness of my fate, to affirm life and, with the deepest conviction, suffering also. I am thankful to *all* I have experienced, no matter how hard it has been, for in the end everything has given me strength, furthered my development. . . ."

Otto is living. If he had fallen would she also have affirmed his death because it furthered her development? When such a thing happens, can there be any thought of furthered development? Does what she says arise out of

<div align="right">71</div>

supreme egoism, or is it the same as Rupp's: "The eternally generous God never takes without giving more than he takes?"

Can I affirm the sudden cutting off of a man's life on earth and the possibility that this experience—*his death*—enriches my life? It seems to me one does not talk like that when one's children die. Her experiences in the party, in her family—she can only mean such things when she talks about the "frightful harshness" of her fate which yet led her to further development.

August 22, 1916

Stagnation in my work.

When I feel so parched, I almost long for the sorrow again. And then when it comes back I feel it stripping me physically of all the strength I need for work.

Made a drawing: the mother letting her dead son slide into her arms. I might make a hundred such drawings and yet I do not get any closer to him. I am seeking him. As if I had to find him in the work. And yet everything I can do is so childishly feeble and inadequate. I feel obscurely that I could throw off this inadequacy, that Peter is somewhere in the work and I might find him. And at the same time I have the feeling that I can no longer do it. I am too shattered, weakened, drained by tears. I am like the writer in Thomas Mann: he can only write, but he has not sufficient strength to live what is written. It is the other way round with me. I no longer have the strength to form what has been lived. A genius and a Mann could do it. I probably cannot.

For work, one must be hard and thrust outside oneself what one has lived through. As soon as I begin to do that, I again feel myself a mother who will not give up her sorrow. Sometimes it all becomes so terribly difficult.

Hoyer has answered my letter. His reply is very kind. He too calls me Mother. But that doesn't bother me. Now all three of them call me that, Hans Koch, Noll and Hoyer. At first I felt alarm, then happiness, and now diffidence—wondering what I can give them. I can really be a mother only to my own.

72

I suppose it is conceivable to broaden out so that one can feel great love for other children than one's own, but again it is the same as in my work: I feel that *I cannot*. I am not broad enough for that. My strength is insufficient.

August 27, 1916

Read an essay on liberalism by Leopold von Wiese. It showed me all the contradictory elements within myself. My untenably contradictory position on the war. How did I come to it? Because Peter sacrificed his life. What I saw so clearly then and what I wanted to preserve in my work now seems to be once more so dubious. I think I can keep Peter only if I do not let anyone take away from me what he taught me then. Now the war has been going on for two years and five million young men are dead, and more than that number again are miserable, their lives wrecked. Is there *anything at all* that can justify that?

And now Wiese speaks of the necessity of "opposing utterly all sacrifice of the living to a lifeless idea." "For a pair of happy eyes means more than all the doctrines of worldly wisdom." Surely that is something different from the joy in the law with which Peter and his fellows marched into the field. And different from what Rupp taught: "Man is not born for happiness, but to do his duty."

September 1916

My work seems so hopeless that I have decided to stop for the time being. My inward feeling is one of emptiness. How shall I find joy outside of the work? Talking to people means nothing at all. Nothing and no one can help me. I see Peter far, far in the distance. Naturally I will not give it up—possibly I cannot—but I shall make a pause. Now I have no joy in it. All day yesterday I took care of a host of things. But what for?

October 11, 1916

Everything remains as obscure as ever for me. Why is that? It's not only our youth who go willingly and joyfully into the war; it's the same in all na-

tions. People who would be friends under other conditions now hurl themselves at one another as enemies. Are the young really without judgment? Do they always rush into it as soon as they are called? Without looking closer? Do they rush into war because they want to, because it is in their blood so that they accept without examination whatever reasons for fighting are given to them? Do the young want war? Would they be old before their time if they no longer wanted it?

This frightful insanity—the youth of Europe hurling themselves at one another.

When I think I am convinced of the insanity of the war, I ask myself again by what law man ought to live. Certainly not in order to attain the greatest possible happiness. It will always be true that life must be subordinated to the service of an ideal. But in this case, where has that principle led us? Peter, Erich, Richard, all have subordinated their lives to the idea of patriotism. The English, Russian and French young men have done the same. The consequence has been this terrible killing, and the impoverishment of Europe. Then shall we say that the youth in all these countries have been cheated? Has their capacity for sacrifice been exploited in order to bring on the war? Where are the guilty? Are there any? Or is everyone cheated? Has it been a case of mass madness? And when and how will the awakening take place?

I shall never fully understand it all. But it is clear that our boys, our Peter, went into the war two years ago with pure hearts, and that they were ready to die for Germany. They died—almost all of them. Died in Germany and among Germany's enemies—by the millions.

When the minister blessed the volunteers, he spoke of the Roman youth who leaped into the abyss and so closed it. That was one boy. Each of these boys felt that he must act like that one. But what came of it was something very different. The abyss has not closed. It has swallowed up millions, and it still gapes wide. And Europe, all Europe, is still like Rome, sacrificing its finest and most precious treasure—but the sacrifice has no effect.

Is it a breach of faith with you, Peter, if I can now see only madness in the war? Peter, you died believing. Was that also true of Erich, Walter, Meier, Gottfried, Richard Noll? Or had they come to their senses and were they nevertheless forced to leap into the abyss? Was force involved? Or did they want to? Were they forced?

74

I think of Richard's poem:

> *Then let me now be snatched away*
> *And keep me here no more.*
> *For I have had before today*
> *More than my fill of gore.*

. . .Well, Peter, that is over now. You have your friends in the hereafter. "Down to the grave—up to the stars!" You are united, all of you who swore you would die for Germany. You are dead two years now, and turned wholly to earth. Your spiritual part—where is it? I can hope for this kind of reunion —that when I too am dead we may find ourselves in a new form, come back to one another, run together like two streams. Do not withhold yourself from me. Perfect your form in mine. May your short life on earth some day reach perfection in another shape—perhaps in another place entirely. I want to be there then. Stuff of your stuff and spirit of your spirit. I want to flow together, united, deeper, stronger, swifter. Dearest, dearest one, together with you! Can it not be, must it not be so, that what are akin will leap together? Like crystals forming? When I am free of this temporary form, my spirit cannot be assigned like a servant to just any place, can it? My liberated spirit will see and unite with kindred spirits? And those human beings who have loved one another deeply here can unite in a new form. How barren this consolation used to seem to me. The spirit is not the man and he, the individual man, never comes back as he has been.

But now I like to think that I shall be united with the spiritual part. But I do not want to find Hans ahead of me over there. Hans must live longer than I, and when he dies we will be together to receive our beloved and become one. And Karl? Before me? After me? We ought to remain united, all four of us.

This is now only half wish, half fancy, but if it really becomes *belief*, so that I feel it, then I would also have to experience something of it in this life, now. And in fact I can often feel Peter's being. He consoles me, he helps me in my work. He is far away when my thoughts are elsewhere; I am aware of

75

him approving or rejecting, glad or sad. My awareness of him is sometimes stronger, sometimes weaker. If he is *there,* not visible, the spiritual part or essence of him, then it must be possible by training my faculties to feel him more strongly. As I write this I do not know whether the whole thing is not, perhaps, an intellectual jest. But I can find out whether it is true. I do not mean the presence of the dead in the figurative, intellectual sense. I mean the possibility of establishing a connection here, in this life of the senses, between the physically alive person and the essence of someone physically dead. I don't care whether that is called theosophy or spiritism or mysticism. No doubt everyone can find out for himself whether it is possible.

Was not Peter affecting Hans the night that Peter died and Hans decided to enter the medical corps, and so was not sent to the front?

Undoubtedly there are reciprocal effects, but I doubt whether I can sense them with my crude antennae. Sometimes I have felt you, my boy—Oh, many, many times. You sent signs. Wasn't it a sign when on October 13 I visited the place where your memorial is to stand, and there was the same flower that I gave you when you departed?

The theosophists say it is possible to learn gradually to feel one's way toward that other world. Formerly I said I did not want that at all. And surely sensing the presence of the loved dead doesn't just depend upon those exercises. But the theosophist idea ties up with the idea expressed in the *Cherubinischer Wandersmann* [of Andreas Silesius]:

> *The spark is there in thee, make room and give it air!*
> *By holy love and longing thou canst make it flare.*
>
> *Seek and thou shalt find, knock and make thy plea.*
> *The door will open to thee, all will be given thee.*
>
> *If thou canst lift thy spirit out of place and time*
> *Thou mayst behold eternity before the hour's chime.*

February 1, 1917

Went to see Milly Steger at her studio recently. I like her and her work is strong. Somewhat soulless. To her there are only formal problems. Her ap-

proach is entirely different from mine. She is an orderly person, works like a man and has big commissions for buildings, etc. . . .

I've worked. On the father. Before I left I removed the cloths covering Peter's head. The head is turned to one side. The blanket still lay over the body. Emerging out of the wholly wrapped-up figure, his head looked utterly beautiful, with his serious, devout smile. Perhaps I shall do the work so that the entire body is wrapped in a blanket and only the head left free.

Today circumstances forced me to interrupt the work on the father and take up the plaster cast of the mother. Sawed off the head and placed it experimentally in an entirely different position. Possibly what I said will come about—that by continuing to work on the plaster I shall be able to raise myself above the average in one spot first and then, sticking to that, gradually pull up the other parts of the work. Climbing like a snail, creeping, taking the tiniest steps, but at least going *upward*.

Yesterday I attended an evening of readings by Durieux and Eysold at Cassirer's. Everything was pretty dull, except that Durieux read a story by Leonhard Frank about a waiter who had an only son. The son falls "on the field of honor." And then afterwards, at a social democratic meeting, the waiter suddenly finds words. The procession on the streets, growing; "they want to make peace." The enormous stir of the people at the end, and the sounding bells, "Peace, peace, peace!" It was unendurable. When she stopped reading, a man's voice cried out again and again, "Peace, peace, peace!"

To know all this, to know that the longing for peace is so fervent everywhere in Europe, the same everywhere, and yet the war *cannot* stop and goes on day after day, and every hour young men must die!

Read in the *Rundschau* old Tolstoy's diary of the year 1898. There is still something so alien to me in this life in Christ. Yet it is probably the same as what Grandfather meant. Where do I stand? I too want to be free of everything that hinders my real self. And what is this real self? What do I want of life, and what have I wanted? I wanted to develop myself, that is to unfold, and not myself the Christian, but myself Kaethe Kollwitz. When I wanted to be able to die in place of my boy, that was out of love for him. I acted out of love for him. Peter did more; he died not out of love for a person, but out of love for an idea, a commandment.

Do I too recognize such a commandment, in obedience to which I live or die, whichever is asked of me? Would it not always be only out of love for some human being for whose sake I would wish to die? Since I am living, since I was not permitted to go in the children's place—I would have done so gladly—I want to live my own life to the end. Once more myself, Kaethe Kollwitz. I want to see how far I can still go in my work.

Ethical perfection, which sometimes seems to me more, sometimes less worth striving for, often strikes me as something foreign. And as something that interferes with the colorfulness of the individual. The difference is that Karl feels goodness as a strength, while to me it is more something soft and colorless. For me, too, the first requisite is strength—only I do not know whether it grows out of striving after goodness and love.

Strength is what I need; it's the one thing which seems worthy of succeeding Peter. Strength is: to take life as it is and, unbroken by life—without complaining and overmuch weeping—to do one's work powerfully. Not to deny oneself, the personality one happens to be, but to embody it. To make oneself better—I mean that now not in the Christian, but rather in the Nietzschean sense. To weed out of oneself the elements of chance, evil, stupidity, and to reinforce what in the broader point of view is of worth in us. *"Mensch werde wesentlich!"*

Read [Lessing's] *The Education of the Human Race.* A comforting light in these dark times. "Take your imperceptible step, eternal Providence. But

let me not despair of you because it is imperceptible.—Let me not despair of you, even if your steps should seem to me to be going backward. It is not true that the shortest line is always the straight line."

February 1917

I am half on vacation now. On account of the show I am not working in the studio, but doing the necessary preparatory work at home. I am also doing some work on the drawings for Steinthal. After dinner I sometimes go on calls with Karl. I am reading and gathering my forces again after all the busyness, the superficial matters with which I've been taken up lately. Today, as I returned from going on calls with Karl—the weather had that half springlike quality that always starts me daydreaming—I imagined the following picture of my old age, say from my sixtieth year on. By then I can scarcely count on doing any too serious artistic work. At some pretty place nearby—say, Ferch—Karl and I will have a cottage with a garden, a small potato field, at least one dog. We will work in the garden and each of us will go about his own pursuits. Karl will do scientific research and I, as far as I am still able, small sculptures and drawings. Above all we will live in nature and will have with us a few children whom we will take from the city for the whole long summer. City children. They will go to the village school and play about in the open, learn to swim, to row, and so on. If they could be our own grandchildren—how wonderful that would be. But if not, then strangers' children. The plan calls for money, but by then we will have it. Many books! If the winter proves too long, we would go to Berlin for a few months. Faithful old Lina would take care of the household; some nice young girl—we know many of them—would be in charge of the children. Four or five children, I think. That would be a lovely life.

March 1917

Looking through my drawings for the show I found some of my very old ones, done between the ages of fourteen and seventeen. It is the same as it always is with me—I can hardly endure my old things. Not hard to understand. At one glance you see your shortcomings, and usually they are short-

79

comings which have been somewhat repressed later on, but which still represent a danger. In my work it is the story-telling aspect. Almost all my early drawings are anecdotes. I drew almost everything imaginable that I saw or thought of or that happened. One way to put it, I suppose, is that then too I was "contending with life." It is quite clear where this impulse comes from. At the time I knew only narrative art and was interested in nothing else, and that was the case for a long time. Actually it was only after Munich that my things stopped being so painfully anecdotic. I often think that Lise is the more gifted of us two, but at home this was not recognized because my father was more impressed by my realistic representation. Actually she is more talented artistically. That shows up to this day. But she lacked training. And something else too, perhaps: my guess is that she has lived less intensively. When she was young she cultivated herself and the objects of her love. That was enough for her. I probably had more drive. And it has been this drive alone which has made it possible for me to develop as far as possible my talent, which in itself is inferior to hers.

When I compare my drawings done at the age of fifteen with many things by Rele, Sabine Lepsius, or Liselotte Friedlaender, done at the same age, then my own things seem to me abominably amateurish—that is, amateurish in respect to taste.

Goethe speaks of the complacent conceit which makes the production of a period just past seem so odious to one. That does not really apply here. I still say that one has every reason to writhe inwardly over one's youthful works. The shortcomings are not even compensated for by technique; they lie smugly exposed in all their naïveté.

March 13, 1917

One of the most striking things about Goethe's life is his effort to get to know everything and take a position on everything. In Strassburg he associated by preference with medical men and attended medical lectures. He not only went to see the cathedral, but studied it, made drawings of it, took measurements. There it is again, the broad foundation, the need for "expanding into the universe." If—he says somewhere—we do not succeed in giving

ourselves an all around education, if we must drop one thing or another, we are glad to see what we have dropped taken up by others and carried on. "Then there arises the splendid feeling that true man is only humanity all together and that the individual can only be glad and happy if he has the courage to feel himself part of the whole." A remark which has about the same application to the present time as speaking about the beautiful view when one is standing in dense fog or in a pitch-black night. At any rate, I see Goethe as following a path of development which I have always rejected. He desires the greatest possible versatility and breadth; I have wanted limitation in everything but the one sphere which really mattered. The same with the children. I was against giving Hans a variety of lessons, for instance in music—which is what Karl wanted to do. Instead I wanted to put all the stress upon the one really strong inclination that Hans had. Peter had much more of Goethe's sort of temper; in fact he had a great deal of it. But in him it did not trouble me. I was in sympathy with it because there was in the boy an inner harmony which made everything he did seem good to me.

May 1917

After Easter worked concentratedly on the show. On the afternoon of Sunday, the 15th, I had the porter open the building and showed Karl the exhibition. Monday, the 16th, it was opened. It was a great success. From many sides I heard that it made a strong and integrated impression. Stahl's review, Deri's prefatory notes, Lise's review in the *Monatsheft,* Wertheimer's comments. Their praise is such that I almost think the last two at least would not be so affected by an artist who was a stranger to them. Fondness for me is also involved. For I can scarcely think that I have been *so* able to communicate myself or—more than that—to have been the direct mediator between people and something they are not conscious of, something transcendent, primal. Suggestion must play some part here. If my works *continue* to make such an impression—even after decades—then I will have achieved a great deal. Then men will have been enriched by me. Then I shall have helped in the ascent of man. For that matter everyone does so, but it would then have fallen to me to do so to a greater degree than others.

My fiftieth birthday has passed. Different from the way I used to imagine it. Where are my boys?

And yet the day was good, this whole period is good. From so many sides I am being told that my work has value, that I have accomplished something, wielded influence. This echo of one's life work is *very* good; it is satisfying and produces a feeling of gratitude. And of self-assurance as well. But at the age of fifty this kind of self-assurance is not as excessive and arrogant as it is at thirty. It is based upon self-knowledge. One knows best oneself where one's own upper and lower limits are. The word fame is no longer intoxicating.

But it might have turned out differently. In spite of all the work I have done, success might have been denied me. There was an element of luck in it, too. And certainly I am grateful that it has turned out this way.

Wednesday evening Karl got sick; today, Thursday, he had a very high fever early in the morning. Now he seems to be getting better. Again I feel as I used to when the children were sick, after the cause for real anxiety had passed and I stayed close by them, did everything for them, did not even think about my own work and was concerned only with being near to them, physically, spiritually. Tending them back to health. This glorious feeling then of reconquest, the profound sense of happiness overlaying the lingering tremors of anxiety: they will stay; I shall keep them. And so my Karl is now lying quietly in bed.

When I told Karl that Wertheimer may visit Peter's grave, Karl said he would like Peter to have a gravestone. I said, then I should like to make it. Today I thought about it again. I thought that the relief of the parents might be set upon his grave. Then I realized that this relief would be more appropriate for the whole cemetery. It belongs up front at the entrance. A square stone, the relief cut into the face. Life size. Below or above it: Here lies Ger-

man youth. Or: Here lie Germany's finest young men. Or: Here lie the youthful dead. Or simply: Here lie the young.

It seems to me *I must carry this out*. God grant I keep my health until it is all done for Peter and the others.

July 26, 1917

Work is still going very well. I work without effort and without tiring. It is as if a fog had lifted. Now for the first time I am beginning to understand plaster work. I know what it is all about and what one can aim at. If nothing unusual interferes, I think I shall really be finished with the woman this fall. Sufficiently so for the stone work to be done after the plaster. And once I really have one figure finished, once I have really solved one, I will be able to make the others. Possibly then I can finish the work next year.

I have seen now that plaster work is not only filing away at the plaster cast which has been made from the clay, but an independent task in its own right. This time I will not attempt to perfect my clay model of the man, but as soon as the general outlines are fixed I shall have it cast in plaster and then finish it. How long it has taken me to realize this.

August 16, 1917

Visited the Sterns Sunday. Rele was there. Very well and cheerful. I think that I must have had something of this fresh and almost provocative contentment when I came from Munich in my blue-and-white dress, my peasant shoes and my home-made hat.

August 1917

For some time now I have been in a remarkably auspicious mood for work. Am working concentratedly for four or five hours. I have the feeling that I am on the right track. Like running along behind someone you have not yet caught, but you know you can keep him in sight, you are at his heels.

Then again I tell myself that possibly what will come of it will be something almost academic. Today Lehrs sent me the head of Christ from the

Church in Northern France. That is art. There the chance face of some un-known dead man has been elevated to great art. And how the hair and beard are done! In this I am so insensitive. How am I going to make the hair? God, what enormous tasks, when I think of executing down to the smallest detail all three of the figures. Yet I cannot give it up. Nor am I discouraged. I am discouraged only when I think of my fifty years, of diminishing time and strength.

<p align="right">September 9, 1917</p>

Worked well all this week, except for last Saturday when I could do nothing. I see more clearly that this way leads to the goal, but I also see that the goal is very far away, that years will pass before I am finished with Peter's work. There is no harm in that. But probably I have not too long to live and I must refrain from trying a variety of things. If I finish this work and do it really well, it will contain much other work, will help express things which I would otherwise have had to do piece by piece. For weeks now I have been working only on the shoulders, back and arms of the mother. Using a model now and then, but mostly without one. With infinite slowness I am gradually peeling it down to what it ought to be. Sometimes I think I might be doing more important things with my time. But for me there is really nothing more important than this work, and after all, at this snail's pace I am learning so much that I hope I shall be able to solve the problems of later works more swiftly.

<p align="right">October 1917</p>

When I went to work after the vacation in Lubochin, I felt no sense of refreshment at all. On the contrary. I'd lost the conception; everything was trite. I let the mother alone for a while, took up the clay figure of the father, and then dropped it too. I just can't. Then I set to work on the relief for Roggevelde.* Perhaps inspiration will come to me in working on something new. If not, it would be best for me not to work at all.

* Roggevelde: the soldier's cemetery in Flanders where Peter Kollwitz was buried.

84

Something gave me pleasure: in the upstairs studio I saw the mother-and-child group, which I had put away. It does not seem so bad, although I did not like the left arm and hand pressed against the torso. I wondered whether I might change it so that the arm is slacker, the child's feet held with open hand.

At any rate I see that in the state I am in now I can finish nothing integral on the big work. I must resign myself to its taking years and years. Meanwhile, if I am not to petrify I must take up other things. The big work will have to be finished gradually, very slowly, by my going back to it again and again.

November 6, 1917

A very good day for me, although it began miserably. I went to the Barlach show, which is very fine. While I was looking at it I was overcome by the restless feeling that I must go to the studio and get to work. Worked tranquilly and well on the relief. Then hit upon a new idea as a result of working. Or rather the same motif, but sculptured in the round. Made a quick sketch, the man and woman kneeling in front, leaning against one another. Her head very low on his shoulder. Her left arm dangles over his right shoulder. Her right arm hangs hopelessly, touching his. His head rests on her back. He is holding his hand over his eyes.

November 7, 1917

I worked on the sketch again today. I can carry it out only if I really succeed in finding a form that is adequate to the content. It must not be realistic, and yet it cannot be anything but the human form we know. Inventing a form as Krauskopf does is impossible for me; I am no expressionist in that sense. So there remains for me only the familiar human form, but it must be thoroughly distilled. Though not the way Metzner does it, in his bewilderment. Nor even like Barlach, though closer to him.

85

Just wrote to Julius that only music and poetry can express ultimates. But then I added some examples from painting after all. Florence, early Italian sculpture, the early Greeks, some things of Michelangelo. But in modern times? Everything is horribly arid. Where does the secret lie? My own work: It is as if I stand before the door to myself. But if there is nothing in particular behind that door, then it is all not worthwhile. There is no secret in me either. And Rodin? Wonderful, yes. The prayer. But is he not also too distinct? What I now vaguely feel is the symbolism of art. To think of the things that formerly satisfied me!

Week before last I began the small sculpture, *The Parents.* Dropped the relief for the time being. Today thought out a plan for, probably, a new etching: Young woman floating in the water with child on her body. Thought of bas-relief. Not impossible. But still better as an etching. Only tones. Darkly moving water. Contours of bodies. Her head the main thing. She smiles, proudly, secretively, an otherworldly smile. The child does not smile. But goes along with the mother. Confidence. Being with her. Yes, that could turn out well. They swim like an island in the water. Wholly separated from the living.

Curious how the sluices are opening up again for my drawing. Today did the drawing of the father and mother sitting by the Christmas tree. Intended for etching. I probably made the first drawing of it in the winter of 1915. Or was it even earlier? Before Peter? Was it intended for the army newspaper? I hardly think so. Anyway, as things turned out I did not want to do it. Even now I still have a feeling of reticence about representing anything of the sort. But yet—it might turn out. Just the way I also am making the parents as a sculptural group.

I have the hope that this time something really new in drawing and etching will come into the work. It can happen only through greater simplicity.

Just as I want to make these parents—simplicity in feeling, but expressing the *totality of grief*.

Perhaps now a few other things will work out also, so that the lot will express what I have to say about the war. Perhaps "Killed in Action"—the woman crying out, surrounded by the children. Or the young pregnant woman —or the old one with raised hands looking down upon her empty lap. Or perhaps what I want to do now, the woman floating in the water with her child.

<div align="right">February 19, 1918</div>

Last night I dreamt that I was out in the street and suddenly everything grew dark. I could no longer see things clearly. Karl led me and said to me afterwards that I should probably go blind. I can remember repeating to him again and again, "But I must do my work."

<div align="right">March 19, 1918</div>

Yesterday I kept thinking about this: How can one cherish joy now when there is really nothing that gives joy? And yet the imperative is surely right. For joy is really equivalent to strength. It is possible to have joy within one-self and yet shoulder all the suffering. Or is it really impossible?

If all the people who have been hurt by the war were to exclude joy from their lives, it would almost be as if they had died. Men without joy seem like corpses. They seem to obstruct life. . . . When someone dies because he has been sick—even if he is still young—the event is so utterly beyond one's pow-ers that one *must* gradually become resigned to it. He is dead because it was not in his nature to live. But it is different in war. There was only one pos-sibility, one point of view from which it could be justified: the free willing of it. And that in turn was possible only because there was the conviction that Germany was in the right and had the duty to defend herself. At the begin-ning it would have been wholly impossible for me to conceive of letting the boys go as parents *must* let their boys go now, without inwardly affirming it—letting them go simply to the slaughterhouse. That is what changes every-thing. The feeling that we were betrayed then, at the beginning. And perhaps

<div align="right">87</div>

Peter would still be living had it not been for this terrible betrayal. Peter and millions, many millions of other boys. All betrayed.

That is why I cannot be calm. Within me all is upheaval, turmoil.

Finally I ask myself: What has happened? After the sacrifice of the boys themselves, and our own sacrifice—will not everything be the same?

All is turbulence.

October 1, 1918

Germany is near the end. Wildly contradictory feelings. Germany is losing the war.

What is going to happen now? Will the patriotic emotion flare up once more so powerfully that a last-ditch defense will start? Kerr's poem. I find in myself no agreement with it. Madness not to cut the war short if the game is up, not to save what still may be saved. The young men who are still alive, Germany must keep; otherwise the country will be absolutely impoverished. Therefore, *not another day of war* when it is clear that the war is lost.

October 30, 1918

The *Vorwaerts* printed my reply to Dehmel after all, and the *Vossische Zeitung* has reprinted it.

[Article from *Vorwaerts*]

To Richard Dehmel. Reply by Kaethe Kollwitz.

In the *Vorwaerts* of October 22 Richard Dehmel published a manifesto entitled *Sole Salvation*. He appeals to all fit men to volunteer. If the highest defense authorities issued a call, he thinks, after the elimination of the "poltroons" a small and therefore more select band of men ready for death would volunteer, and this band could save Germany's honor.

I herewith wish to take issue with Richard Dehmel's statement. I agree with his assumption that such an appeal to honor would probably rally together a select band. And once more, as in the fall of 1914, it would consist mainly of Germany's youth—what is left of them. The result would most probably be that these young men who are ready for sacrifice would in fact be sacrificed. We have had four years of daily bloodletting—all that is needed is for one more group to offer itself up, and

88

Germany will be bled to death. All the country would have left would be, by Dehmel's own admission, men who are no longer the flower of Germany. For the best men would lie dead on the battlefields. In my opinion such a loss would be worse and more irreplaceable for Germany than the loss of whole provinces.

We have learned many new things in these four years. It seems to me that we have also learned something about the concept of honor. We did not feel that Russia had lost her honor when she agreed to the incredibly harsh peace of Brest-Litovsk. She did so out of a sense of obligation to save what strength she had left for internal reconstruction. Neither does Germany need to feel dishonored if the Entente refuses a just peace and she must consent to an imposed and unjust peace. Then Germany must be proudly and calmly conscious that in so consenting she no more loses her honor than an individual man loses his because he submits to superior force. Germany must make it a point of honor to profit by her hard destiny, to derive inner strength from her defeat, and to face resolutely the tremendous labors that lie before her.

I respect the act of Richard Dehmel in once more volunteering for the front, just as I respect his having volunteered in the fall of 1914. But it must not be forgotten that Dehmel has already lived the best part of his life. What he had to give—things of great beauty and worth—he has given. A world war did not drain his blood when he was twenty.

But what about the countless thousands who also had much to give—other things beside their bare young lives? That these young men whose lives were just beginning should be thrown into the war to die by legions —can this really be justified?

There has been enough of dying! Let not another man fall! Against Richard Dehmel I ask that the words of an even greater poet be remembered: "Seed for the planting must not be ground."

<div style="text-align: right">KAETHE KOLLWITZ</div>

<div style="text-align: right">December 8, 1918</div>

Yesterday morning Hans and I went to the Freedom Celebration. I came too late, but in time to hear Breitscheid (harsh, twangy, imperious voice) and two movements of the Ninth Symphony with Strauss conducting. Divinely beautiful. The first time the Ninth has been played since the beginning of the war. And again I was carried away, swept up out of the partisan dust to heights of purest joy. Yes, in the Ninth there is socialism in its purest form. That is humanity, glowing darkly like a rose, its deepest chalice drenched

with sunlight. Divine rejoicing in existence. How I was moved when the chorus sang: "*Feelest* thou thy Maker, world!"

New Year, 1918

This year we want to go to the Sterns. The past five New Year's Eves were turned backward. Were full of grief, mourning, longing for peace. We do not want to pass this New Year's Eve alone. Hans is here. Together with him we want to be with our dearest friends, the Sterns, to greet the coming year. For now all is future. A future that we resolve to see as bright beyond the immediate darkness. We don't want to be alone today; we want to give ourselves courage, to strengthen and express faith.

This year has brought the end of the war.

There is no peace yet. The peace will probably be very bad. But there is no more war. It might be said that instead we have civil war. But no, there have been troubles, but it has not come to that. The year 1918 ended the war and brought the revolution. The frightful pressure of war that grew steadily more intolerable is lifted now; one can breathe more easily. No one imagines that good times will follow right away. But we have finally crawled through the narrow shaft in which we were prisoned, in which we could not stir. We see light and breathe air.

January 20, 1919

Essay by Gorky in the *Republik* which left me rather shaken. If only I were as full of faith as he. And why can I not be? Perhaps the reason lies in the difference between the Slavic and Germanic natures. If the Slavs have a trace of the Asiatic, we East Germans have a trace of the Slavic, but only a trace. There is a great racial difference between Tolstoy and Kant. Can people of the same origins as Kant soar as high or dare as greatly as Tolstoy's and Dostoevsky's countrymen? I think that we *must* go a different way. Perhaps, in fact surely, we are heading toward the same goal, but by a different route. Yet I almost envy the Russians who go their grand and simple way so credulously, so blind in their faith.

Gorky in his autobiography tells of how his grandmother spoke so tenderly and solicitously about the soul. God, taking a soul to himself after death:

90

"Well, my dear one, my pure one, have you had enough of erring and suffering?"

The streets have been cordoned off, putting a complete stop to all relationships with the outside, so that my days were almost entirely unoccupied. I did not have any work to do; there was an ebb again. And so the day seemed long to me and I saw how much of my time is wasted in claims from outside myself, and how accustomed I have been to busy myself with so many inessential and even trivial matters.

Another observation about work: I keep asking myself again and again what is to blame for my bad works. Today my impatience seemed to be the cause. Formerly when I worked, for example on the Carmagnole, I gave myself time to do thorough studies. Now I am prey to nervousness. If I master it, perhaps I shall yet get over this slump. Today I took the *Lament for the Dead* in hand. Formerly I would have finished drawing the individual figures. Why do I not do that now? Partly as a result of the dangerous new doctrine that everything ought to be done without nature studies. That easily produces a generalized, schematic kind of work; all the particular qualities of nature are lost. I ought to return to making nature studies the basis of my works. For nature stimulates because she is unschematic. And then I ought to give myself time. Formerly I spent months on a big etching. Now I want to do a lithograph in three days. The worst of it is that my imagination so easily gets disgusted. Like a spoiled stomach: no sooner do you begin to eat than you push the food away. No sooner do I begin to work than the further stages no longer attract me. A feeling of disgust and impatience ensues, and I stop.

I really ought to try to work in a more disciplined fashion. It is only a question of whether I can still undertake such disciplining of myself at this point. Do I still have my nerves sufficiently under control?

Early this morning I went to the coroner's chambers again and saw a man who had been shot. He was a Russian by the name of Shapski, or some-

91

thing of the sort; he was always called Leo around here. Then I went next door to the morgue. A dense crowd of people filing by the glass windows, behind which the naked bodies lie. Each has its clothing in a bundle lying upon the abdomen. On top is the number. I read up to number 244. Behind the glass windows lay some twenty or thirty dead. I imagine that when someone thinks he has recognized a person, he gives the number to the clerk in the waiting room. Then the corpse is taken to another room and there the relatives examine it closely to determine whether the dead man is the one they are seeking. This seems to be the way it is done, for now and then some of the people waiting would be led out past me to the other room, and I heard loud wailing from that room. Oh, what a dismal, dismal place the morgue is. What an agony to have to seek some beloved person there, and then to find him.

May 26, 1919

> *Whoso does not aspire*
> *To be the child of God*
> *Stays with the beasts forever,*
> *Forever is a clod.*
>
> (Angelus Silesius)

June 25, 1919

Today prepared everything for the abandonment of my big work. Tomorrow it will all be taken down. With what firm faith I set to work, and now I am stopping. As I stood up on the scaffold beside Peter and saw his sweet, smiling face, his air of devotion, and then thought of all the time I had worked, of all the love and aspiration, all the many tears that are frozen into that work, I promised him again: I will come back, I shall do this work for you, for you and the others. It is only postponed. But this promise no longer has the old intensity. I do not know whether I will live long enough and keep strong enough to finish the work. The fact that now is no time for such a memorial does not matter to me. The years pass, and what was then sacred remains. If people cannot see this now, they will see it again later on.

As I kissed Peter's face and bade good-bye to the work, I thought of Germany. For Germany's cause was his cause, and Germany's cause is lost now as my work is lost. No, not really lost. If I am permitted to live and see Peter's work done and done well, commemorating him and his friends in some beautiful place—then perhaps that will signify that Germany too has passed out of the most difficult time.

> *Although we felt for you a love profound and old*
> *We never thought its name needed to be told.*
> *Gladly we marched when the summons we heard,*
> *No cheers upon our lips, but in our hearts the word:*
> *Germany!*

July 6, 1919

What strength Karl has. At times he is tired, and then he too is unproductive and bored; but then come times when he goes through it all like a champion, victorious over his fifty-six years, over all his toilsome labors, over his illness. Then he is wonderful. Shall I have to live without him, or he without me? We will miss one another very much. He inspires, animates me. But best of all is his capacity for love. It comes out of a glad kindness which sometimes seems to me absolutely incredible. This capacity for love results in his being loved in turn by so many, so many people. Above all by women and children. . . . For example, his buying an orange for our Lene when she went on vacation.

August 1, 1919

What an anniversary! Five years ago today it started. All the horrors that now strike me as almost more incomprehensible, more nakedly frightful than they did then.

I remember hearing the departing soldiers singing as they marched past our hotel in Koenigsberg. Karl ran out to see them. I sat on the bed and wept, wept, wept. Even then I knew it all beforehand.

93

September 23, 1919

Dear Mother. She is often sick. Then she is downcast, says her head feels so confused. She does not know what to do or where she belongs. And it is so moving when she gravely and dignifiedly takes my hand and gives me heartfelt thanks because we keep her with us. Then I feel such love for her that I could make any sacrifice for her sake. Mother's hardest time is already behind her, the time when she often realized that she was wandering. Now she is usually cheerful; but it is touching to see her at moments even now when she realizes and then feels so helplessly confused.

September 28, 1919

I am trying the Liebknecht drawing as a lithograph. Today I made a sketch: the old *Sacrifice*. The young mother who is arming her child, but who can scarcely stand on her feet. Shouldn't that be possible as a lithograph in just a few lines? Lithography now seems to me the only technique I can still manage. It's hardly a technique at all, it's so simple. In it only the essentials count.

October 14, 1919

For the past three days I have again been trying to work in Siegmundshof. Leaving Mother alone in the mornings seems to be working out, and I have hope that there, where I am completely undisturbed for three hours, I can get back to working again. I looked at the two sculptures, the small parents group and the woman with the child. At first I was perplexed and did not know where to start. But now I am beginning to see my way into the big group. I've hit on the idea of putting a dress around the woman. Large, ample folds.

October 15, 1919

Once more I am wavering. A dress would be good, if a dress could express something more than a nude. The trouble is that in both I must first find my manner, my style. And both nude and dress are still foreign to me; as always only the total attitude and the face and hands speak to me. So for the present

I am groping in the dark. Still, a little light glimmers, a faint hope is dawning, and that makes me more confident and cheerful in these days of partings.

October 28, 1919

Work is going beautifully again. The figure is growing, composing. Everything closes, forms under my hands. I tremble for fear that one day it will all be over with again.

December 26, 1919

There are days when Mother sleeps most of the time, murmuring softly in her dreams and daydreaming when she is awake. Always about children. Sometimes full of care and fear that they will not come home. But mostly the scenes she sees are very pleasant. The children sleeping in their room. Then she wants to go to wake them, and comes back wondering: where are they? It is really so sweet to see how the dreams and visions and fantasies of so old a mother always return to her children. So after all they were the strongest emotion in her life.

January 1, 1920

I face the year with a dullish feeling of oppression. One has few hopes, and no illusions. If this progressive pauperization continues we shall all slip gradually into the proletariat. The strong young people will emigrate in masses. Poor cudgeled Germany.

Close up as we are, it is impossible to view the whole. May there not be ways of ascent after all?

As we thought of it, the whole thing had to be conceived as a harsh test. Our losses in the material realm would ignite in all the brighter inner life. But what is most depressing is that there is so little evidence of this inner life. The four years of war brought about a general moral deterioration, and this last year has made it worse. Undoubtedly there are people here and there, many of them, who work against this trend. But the masses have been brought so low that little can be hoped for from them. In addition, there's the

splitting up into parties who hate one another like poison, and the increasing improbability, in fact impossibility, that majority socialism will be able to bring order into the chaos.

Perhaps another great shock will clear the air. But what new dreadful times would result. If only we could get to the fresh air.

And now our personal life? It seems to me my circle is shrinking. I am no longer expanding outward; I am contracting into myself. I mean that I am noticeably growing old. Alas, alas, I notice it in everything—but worst of all I notice it in my work. Complaining does not help, praying does not help either—*it is so*.

January 4, 1920

I have again agreed to make a poster for a large-scale aid program for Vienna. I hope I can make it, but I do not know whether I can carry it out because it has to be done quickly and I feel an attack of grippe coming on.

I want to show Death. Death swings the lash of famine—people, men, women and children, bowed low, screaming and groaning, file past him.

While I drew, and wept along with the terrified children I was drawing, I really felt the burden I am bearing. I felt that I have no right to withdraw from the responsibility of being an advocate. It is my duty to voice the sufferings of men, the never-ending sufferings heaped mountain-high. This is my task, but it is not an easy one to fulfil. Work is supposed to relieve you. But is it any relief when in spite of my poster people in Vienna die of hunger every day? And when I know that? Did I feel relieved when I made the prints on war and knew that the war would go on raging? Certainly not. Tranquillity and relief have come to me only when I was engaged on one thing: the big memorial for Peter. Then I had peace and was with him.

January 12, 1920

I have been working on the poster for Vienna for a week now. I thought it would turn out well, but it is turning out only fair.

Another way to treat Death occurred to me while working. To show him reaching into the band of children. He has seized two children. One of them,

whom he has grasped by the hair, is lying quite still on its back, looking petri-
fied into his eyes. To the left sits a woman with sorrowful face. She is not the
child's mother, but the woman watching who feels everything.

I want to do a drawing of a man *who sees the suffering of the world.*
That can be only Jesus, I suppose. In the drawing where Death seizes the
children there is also a woman in the background who sees the suffering of
the world. The children being seized by Death are not hers; she is too old for
that. Nor is she looking; she does not stir, but she knows about the world's
suffering.

Sometimes it seems to me that the curtain is about to lift which separates
me from my work, from the way my work now must be. I have a sense of
something imminent coming closer. But then I lose it again, become ordinary
and inadequate. I feel like someone who is trying to guess an object being
described by music. The sound grows steadily louder; he thinks he is on
the point of grasping it, and then the sound becomes weaker again and he has
to look for another answer.

Yesterday I went with Professor Kern to the Secession shows and to the
big exhibition in order to choose a print for the Kunstverein. Then I saw
something that knocked me over: Barlach's woodcuts.

Today I've looked at my lithographs again and seen that almost all of
them are no good. Barlach has found his path and I have not yet found mine.

I can no longer etch; I'm through with that for good. And in lithography
there are the inadequacies of the transfer paper. Nowadays lithographic
stones can only be got to the studio by begging and pleading, and cost a lot
of money, and even on stones I don't manage to make it come out right. But
why can't I do it any more? The prerequisites for artistic works have been
there—for example in the war series. First of all the strong feeling—these
things come from the heart—and secondly they rest on the basis of my previous
works, that is, upon a fairly good foundation of technique.

And yet the prints lack real quality. What is the reason? Ought I do as Barlach has done and make a fresh start with woodcuts? When I considered that up to now, I always told myself that lithography was the right method for me for clear and apparent reasons.

In woodcuts I would not want to go along with the present fashion of spotty effect. Expression is all that I want, and therefore I told myself that the simple line of the lithograph was best suited to my purposes. But the results of my work, except for the print *Mothers*, never have satisfied me.

For years I have been tormenting myself. Not to speak of sculpture.

I first began the war series as etchings. Came to nothing. Dropped everything. Then I tried it with transfers. There too the results were almost never satisfying.

Will woodcutting do it? If that too fails, then I have proof that the fault lies only within myself. Then I am just no longer able to do it. In all the years of torment these small oases of joys and successes.

October 1920

. . . I simply should have been left alone, in tranquillity. An artist who moreover is also a woman cannot be expected to unravel these crazily complicated relationships. As an artist I have the right to extract the emotional content out of everything, to let things work upon me and then give them outward form. And so I also have the right to portray the working class's farewell to Liebknecht, and even to dedicate it to the workers, without following Liebknecht politically. Or isn't that so?

April 1921

Low. Low. Touching bottom.

I hope to get through it anyhow. Finish the woodcuts by the time of the Jury. Then the Jury; then a week's rest in Neuruppin, and then it may go better. But no. Poor work right along recently and no longer able to see things right. Then I was ripe for illness and fell ill, and at the same time everything slid and dropped and collapsed with a thoroughness I have not experienced

98

for a long time. Now my work disgusts me so that I cannot look at it. At the same time total failure as a human being. I no longer love Karl, nor Mother, scarcely even the children. I am stupid and without any thoughts. I see only unpleasant things. The spring days pass and I do not respond. A weariness in my whole body, a churlishness that paralyzes all the others. You don't notice how bad you get when in such a state until you are beginning to rise out of it. One horrid symptom is this: not only do you not think a single matter through to the end, but you don't even feel a feeling to the end. As soon as one arises, it is as though you threw a handful of ashes on it and it promptly goes out. Feelings which once touched you closely seem to be behind thick, opaque window panes; the weary soul does not even try to feel because feeling is too strenuous. So that there is *nothingness* in me, neither thoughts nor feelings, no challenge to action, no participation. Karl feels that I am strange—and nothing matters at all to me.

In the theater yesterday. Saw Barlach's *Die echten Sedemunds*. A deep sense of envy that Barlach is so much more powerful and profound than I am.

However, I did have one fine experience in these dull, dead weeks. That was before I fell ill. At the Tiergarten I saw a nurse with two children. The older boy, about two and a half, was the most sensitive child I have ever seen. As the nurse put it, like a little bird. For this reason she did not like him. But the boy was utterly charming. On his little face and in his thin body impressions from outside were constantly reflected. A great deal of fear, oppression, hope, almost blissful joy; then again anxiety, etc. Like a butterfly whose wings are constantly quivering. Never have I seen a baby more moving, more affecting, more helpless and in need of protection and love.

June 28, 1921

Went to the theater with Karl; saw *The Weavers* at the Grosse Schauspielhaus. The inflammatory effect of the mass scenes. "Let Jaeger come out, let Jaeger come out! Let Hoelz come out!"

I was overcome by something of the same feeling I had when I saw *The Weavers* for the first few times. Of the feeling that animates the weavers, the

desire for eye for eye, tooth for tooth, the feeling I had when I did the weavers. My weavers.

In the meantime I have been through a revolution, and I am convinced that I am no revolutionist. My childhood dream of dying on the barricades will hardly be fulfilled, because I should hardly mount a barricade now that I know what they are like in reality. And so I know now what an illusion I lived in for so many years. I thought I was a revolutionary and was only an evolutionary. Yes, sometimes I do not know whether I am a socialist at all, whether I am not rather a democrat instead. How good it is when reality tests you to the guts and pins you relentlessly to the very position you always thought, so long as you clung to your illusion, was unspeakably wrong. I think something of the sort has happened to Konrad. Yes, he—and I too—would probably have been capable of acting in a revolutionary manner if the real revolution had had the aspect we expected. But since its reality was highly un-ideal and full of earthly dross—as probably every revolution must be— we have had enough of it. But when an artist like Hauptmann comes along and shows us revolution transfigured by art, we again feel ourselves revolutionaries, again fall for the old deception.

October 3, 1921

Saturday evening we rode out to Lichtenrade and stayed there overnight. I was surprised and overjoyed by little Peter. He has gained weight and made much development. He moves his little head so cleverly; his fine, clear, wise eyes look at everything; his laughter and his soft, crowing sounds are charming. Wonderful the way he lay in bed beside Ottilie. Now he is not only a healthy, but a delightful baby also. Soon after he had been fed I took him into bed for a while; he lay beside me with his warm little feet kicking me and his sweet, soft voice forming all imaginable sounds. But his laughter was loveliest of all. Then he wetted me.

October 23, 1921

The day of Peter's death has come round for the seventh time. It is Sunday. I sit upstairs in the room that Hans and Ottilie occupied and where I

now sleep, where Peter's cupboard with his stone collection stands, with the Narcissus head. I am writing at Mother's desk.

Day before yesterday I was reading my diary of 1916. Even then I was already complaining that I was no longer in tune with Peter. Now seven years have passed. And his image is dissolved, even as his body has become wholly earth. The pain has vanished. I am glad to be alive, intensely glad when I can work.

But when I compare the present with the past, the present seems to me not so full. At that time I lived deep inside myself; now my life turns outward too much. The brief morning is devoted to work, the afternoon to everything else, household, letters, seeing people, things in general. The days rush on faster and faster; time for introspection grows shorter and shorter. I feel like a person whose breathing is shallow and fast, though he ought to be taking quiet, deep breaths. All that must be changed.

Today, October 23, is Gaul's fifty-third birthday. Yesterday we buried him at the village cemetery in Dahlem. On the coffin lay a gilded wreath of laurels and flowers from his wife and three children. Surrounding the coffin were wreaths of glorious fall flowers. Liebermann spoke at the bier, spoke warmly, as a friend. Scheffler spoke even better at the graveside. I stood beside Barlach who told me he had visited Gaul only recently. And he had been terribly moved, he said, to see Gaul sitting there in his studio, among all his works, before the great unfinished anthropoid ape; unable to lift a hand, Gaul had kept on working with his eyes.

Dear August Gaul, I was very, very fond of you. Of all the artists I have known for twenty-five years, you alone were always dear to me as a friend. Always kind to me. Rarely have I seen in others the friendly light that shone always from your eyes. You were modest, good and as sweetly kind as Francis of Assisi.

End of October, 1921

A lovely, happy period of work. The *Mothers* is making progress day by day. How wonderful life is at such times.

Karl had a pleasant experience recently. He lectured to a group of women and young girls. I did not wait up for him, but went to bed. Around

eleven o'clock I heard young voices singing, moving past our house and then fading away. The girls had accompanied Karl home, singing.

Karl is blithe. How good it is for me when I sometimes complain about too little time, and so on—the way he unsentimentally and yet with the greatest kindness thrusts my nonsense aside.

November 9, 1921

On the way to the studio something very amusing. A little band of Communist children marched down Weissenburger Strasse, a banner before them carried by a tiny little chap: "We demand freedom on all playgrounds." Then the piping childish voices sang the Marseillaise: "Shall we fear the hosts of hireling foes?"

January 3, 1922

I have just read Annie's letter and instantly felt this staleness vanishing. *I was able to feel again.* I cannot write about the letter. When someone opens his heart so truthfully and without reserve and lets you look into the pulsating, loving, quivering heart, it is no time to bandy words about it.

February 1922

Today is the sixth of February, our Peter's birthday. Today he would be twenty-six years old.

I wanted to go to work this morning, but it was impossible to get anywhere by subway. Then it occurred to me to go to the Kaiser Friedrich Museum. I spent a rich and solemn hour. He was close to me once more. I saw a beautiful Filippo Lippi—Mantegna—van der Goes, and a painting by an unknown of around 1440: the Trinity. To the right you see the meeting of Mary and Elisabeth. They stand facing one another, dressed in wide mantles which enfolded the whole into one group. They are holding their mantles open, and in their swollen abdomens you see the coming children, Jesus and John. The faces are earnest and dedicated.

How beautiful it all was. It lifted me out of the daily dreariness of politics. I was in Florence again, in the Franciscan monastery with the old fres-

102

coes. I saw that divine landscape, felt the air, had such a longing to get away from the present back to the past when I lived with joy and fullness. Peter was there too. At that moment I could have worked very well.

Now life really is not easy. Not easy physically and equally difficult spiritually. Sometimes when I sigh, "God, give me a new and sure mind," I know only too well that what is necessary is first a sure body—and that is gone forever.

April 21, 1922

Good Friday passes without arousing many thoughts about this special day. But in the evening we heard the Matthew Passion together at the garrison church. The weather has suddenly turned very warm, and in the intermission all the people went out into the tranquil dark street, walked up and down and ate their sandwiches. I remember again Hans' astonishment that according to this Gospel Jesus' last words were: "My God, why hast Thou forsaken me?" When just before he has said his proud: "Or thinkest thou that my Father cannot send me more than twelve legions of angels, etc." And in Gethsemane: "If this cup may not pass away from me except I drink it, thy will be done." That is, at the beginning he showed complete acceptance of destiny because it must be so. Perhaps something similar to what I experienced in my petty human relationships when I gave Peter and he died. Then I too could not manage to say everything had to be so, but rather: My God, why hast Thou forsaken me? In my secret heart I had probably expected that I would not be forsaken. And perhaps Jesus was not prepared for his Father's refusing to send the legion of angels; and I too secretly expected there would be provided the ram for the sacrifice. Why was Abraham just taken at his word; why was it enough for him just to show he was willing? Jesus was willing enough. But when he hung on the cross: "Why hast Thou forsaken me?"

April 30, 1922

Plans for woodcuts which are going along with the series on war. Reworked the Vienna poster of Death reaching into the band of children. The more I work, the more there dawns upon me how much there is still to be done.

103

It is like a photographic plate which lies in the developer: the picture gradually becomes recognizable and emerges more and more from the mist. So these days I no longer think that I shall soon be able to return to sculpture. Since I have been doing woodcuts I find the technique full of temptations. But above all I am afraid of sculpture. I suppose it is an insuperable problem for me; I am too old ever really to conquer it. It is not impossible that I shall gradually move from woodcut technique to woodcarving. But that is still very nebulous. I toy with the thought of doing the mothers standing in a circle, defending their children, as sculpture in the round.

November 1922

On All Souls' Day Karl and I went together to the Reichstag memorial meeting for the dead of the World War. At such moments, when I know I am working with an international society opposed to war, I am filled with a warm sense of contentment. I know, of course, that I do not achieve pure art in the sense of Schmidt-Rottluff's, for example. But still it is art. Everyone works the way he can. I am content that my art should have purposes outside itself. I would like to exert influence in these times when human beings are so perplexed and in need of help. Many people feel the obligation to help and exert influence, but my course is clear and unequivocal. Others must follow vague courses. Pl., for example. In the spring he wants to clear out, go around wandering and preaching. He wants to preach *action*, but inward action, a turning away from the outmoded forms of life that have proved wrong. Preparing the soil for a new life of spiritual liberation. And then there are all the groups preaching a new eroticism ("religious bohemia"). It is reminiscent of the Anabaptists, of the times when—as now—the great turning point in history is proclaimed and it is announced that the millennial kingdom is upon us.

Compared with all these visionaries my activities seem to me crystal clear. I wish I might go on working for many long years as I am working now.

December 1922

Yesterday I was out to Lichtenrade again. Ottilie sat at the table under the

lamp, doing needlework. Peter on the high chair, also at the table, with his back to me. All around his head the fine white hair, shot through with light. It so reminded me of our own children. Afterwards, when I held him on my lap, he kept pointing at me and saying, "Here, Gandmother." A pause between "Gand" and "mother," and then the word "mother" slipping out quickly, carelessly.

December 13, 1922

Again I am not yet finished with the war series. Reworking the "parents" plate. At the moment it seems to me very bad. Much too bright and harsh and distinct. Sorrow is all darkness.

August 5, 1923

At last got out to Lichtenrade Sunday. I went from the studio and came too late for lunch. Everyone was taking an afternoon nap. In the room I found the baskets with the twins and sat down between the two little baskets. Both babies turned their heads toward me and watched me. Both looked pale, because both have diarrhea. Joerdis' and Jutta's faces are just the same, except that Joerdis' looks as if seen through an elongating mirror, Jutta's through a mirror that makes everything wider. She has a broad nose, wide little mouth, her head is wider, her eyes large and very beautiful, but with a grave expression. Joerdis' eyes have that look too. Then, when Hans and Ottilie awoke, and little Peter too, I brought out the little linen suit which Julie once made for our Hans. Hans wore it when he was at his sweetest age. When Peter had it on he looked almost exactly like Hans, especially since he has had his hair cut. For me it was moving and beautiful to see my little Hans again in his baby. But how much more loving the boy is than Hans was. He throws himself into your arms again and again. He can't kiss properly yet, but he lays his little round head against you and cuddles.

October 1923

I am reading Emil Ludwig's account of Goethe's last years. How he gathered his forces and shut away all alien influences in order to fulfil him-

self in his work, to produce it out of himself to the last, to bring the pyramid of his life to its ultimate apex. What a splendid figure, this very old Goethe: wrathful, powerful, essential, concentrated to the utmost. How he presents the justifications of violence and all that follows from it. He is full of irony and impatience and intolerance. He overcomes Age, which in kind and thoughtful people usually produces tolerance, an attitude of "children, love one another." Leaving that state far behind, in his great age Goethe begins to blaze anew. He says of Death: "My conviction of our continuance after death springs from the concept of activity. For if I go on indefatigably doing my work to the end, nature is obliged to assign me another form of existence when the present form is no longer able to contain my spirit."

October 1923

A great response from my show. How happy I am!

January 11, 1924

We were in Neuruppin over New Year's, because I felt jangled. No desire to draw up my usual summary of the year, because I have been in such a slump, and it has not yet passed. Today in the studio I accidentally uncovered the head of the mother on the fireplace; I looked at it again for the first time in years and had the joyful feeling that perhaps I may be able to finish the sculpture for Peter after all. But how? When? Here I am almost fifty-seven, and declining so physically. Probably I couldn't do it in the form I originally conceived. I don't think I could carry that off. Perhaps in a variant form. I have the idea of a large entrance gate to the cemetery in Roggevelde. To either side, on the right and left, kneel the parents. Larger than life size. Above this the text: Here lie the finest of Germany's youth. Or: Here lies the flower of youth. The figures would be conceived as figures in high relief. Simpler and more cohesive than they now are. They let visitors pass through between them. Or perhaps not relief. But very much larger than life. In that case the figures must affect by contour. Or without gates. Only the blocklike

106

figures, Egyptian in size, between which the visitors would pass. Perhaps that would be the really beautiful way. The words, "Here lie the finest of Germany's youth," could be cut into the floor between the two figures. That would bring out the tremendous gravity of it.

April 1924

Once when I was talking with Karl about Mother I said ruthlessly that after all her life is now worthless. A little later I was alone with Mother. She was standing in her room, casting a troubled and loving look upon me. She took my hands, pressed them and said, still with the most loving of expressions, "My good daughter." It was terribly touching. She is rarely vehement and stubborn nowadays, mostly gentle. *What* she says is usually confused, but in the way she says it there is all the old civilized atmosphere of my grandparents' home, the inner dignity, the peculiar composure, definiteness and courtesy that prevailed there. But besides all that there is something in her tone which is not altogether love and kindness, but rather loftiness. When for example she says goodbye because "I want to go now," or the way she takes my hand in hers, presses it repeatedly, then gives it back to me and turns around—when she behaves this way, then in spite of all her confused talk she is Mother as she used to be. No hardening of the arteries can affect this in her.

May 1924

A little chap runs to meet his father, who comes home at evening in his car. It happens that once the father comes an hour late; he is not met by the boy. The boy is nowhere; he has disappeared, has perhaps been killed. This sweet, affectionate little fellow who went to meet Father as he did every day.

No, thank God, he has not been killed, nor abused and tortured, but he has been drowned; the little boy was fished out of the river. When his father did not come he probably went to play, perhaps went chasing a butterfly. Perhaps, in the middle of his play, his little soul filled with joy, he slipped into the water and suffered only the briefest of frights. Sweet, affectionate boy.

107

The first day of Whitsun, a joyous and happy day for me. I went out to spend it with the children. Magnificent weather. The Goeschs were there again. We sat on the ground in the big, open, polygonal arbor. Hans and Heinrich read aloud from Morgenstern, but it was not that that mattered. I am vegetatively happy looking on at it all and watching the children crawl all around. Karl and I are the oldest. Then Heinrich and Gertrud, then Hans, Ottilie and Gerda. And then the wild scrambling of the children. And all the colors! Ottilie white, Gerda bright yellow, Hans white linen, Manon pink, Veronika pale orange, little Peter white and particolored with cheeks flushed red with happiness, and the twins in flaming red dresses. The twins are precious. Sturdy, droll, innocent little white heads. Babbling their own language. When Ottilie sits between them to feed them and gives each in turn a spoonful of pap, the one who doesn't have her turn clenches her fists and her face turns red at having to wait, while the other opens her mouth for the spoon with the smuggest air of contentment. It is wonderful to see. Happy Ottilie, who is so thoroughly maternal. Whatever comes later on, these three years of work with the babies will always give her a kind of satiated feeling. She is a mother through and through, much as she sometimes rants against being one.

Little Peter has given me a pink.

When I entered Mother's room today to bring her down to supper, I saw a strange scene. Like something out of a fairy tale. Mother sat at the table, under the lamp, in Grandfather's easy chair. In front of her were snapshots she was looking through. Diagonally across her shoulders sat Frau Klingelhof's big cat.

Mother used to be unable to stand cats. But now she likes to have the cat on her lap. The cat warms her hands. Sometimes it seems to me that Mother thinks the cat is a baby. When it wants to get down, Mother clasps it anxiously, as if she were afraid the baby will fall. Then her face is full of concern. She actually struggles with the cat.

In the picture Helmy Hart took of Mother, which shows only the head,

Mother has a strange expression. The wisdom of great age is there. But it is not the wisdom that thinks in thoughts; rather it operates through dim feelings. These are not the "thoughts hitherto inconceivable" that Goethe had, but the summation of eighty-seven years of living, which are now unclearly felt. Mother muses. Yet even that is not quite it, for musing implies, after all, thinking. It is hard to say what the picture expresses. The features themselves do not definitely express one thing or another. Precisely because Mother no longer thinks, there is a unity about her. A very old woman who lives within herself in undifferentiated perception. Yes, that is right; but in addition: who lives within herself according to an order that is pure and harmonious. As Mother's nature always was.

It seems more and more evident to me that Mother does not recognize the cat for what it is, but thinks it is a baby. Often she wraps it up in a blanket and holds it just like a child. It is touching and sweet to see my old mother doing this.

April 1925. After a sea voyage.

Madeira, Funchal. In the morning, on our arrival, the crazy spectacle of the naked brown boys diving for the penny. Their challenging gestures. The peddlers who brought their embroidery on board and spread it out. Funchal, the first non-European city. Broad pier for disembarking. The first palms. Wide, colorful, open, plazalike streets full of idlers, automobiles. The big corner cafe where we often sat. Young men dominate here. Boys so beautiful you want to kiss them. Utterly shameless beggary. Fantastic impressions of the first hours: Procession. "Angels" with wings. Riders on horses decked with broom. The beautiful riverbed road running upward, shaded by plane-trees. On the right the artisans' shops closed for Easter. Ox-drawn sledges. *Beautiful* people. Carrying everything on their heads, of course.

We walk at random up the street between walls. Flowers incredibly beautiful and plentiful. On the flat rooms and at the windows girls who return greetings with dignity and friendliness, often throwing flowers. The splendid plaza, shaded by live oaks, in the broad, ravine-like riverbed. There Frau Schnirlin and I waited for our husbands. They came thundering up to us on

ox-drawn sledges. We rode out to the Mount. The wild sled-ride back. I felt sure we would smash up, but we descended safely. The drivers, who run along side, were done in when we reached bottom; they kept coughing. It seems to be terribly hard work. Then they carry the small sleds back up on their heads. All of Funchal is paved with the small, round lava stones set on end. Awfully smooth and difficult to walk on. Magnificent gardens with all sorts of palms, banana trees, orange trees, cacti, etc. We drove by motorcar with the Schnirlins to the fishing village of Connara. Tremendously picturesque and horribly wretched. The children frightful to look at. Dwellings cut into the rock cliffs.

<div align="right">October 13, 1925</div>

I am with Peter only when my plans for the soldiers' cemetery in Roggevelde are stirring again. Recently I once more set to work on the big sculpture with relatively fresh vigor, with the thought that I should have it ready by spring and be able to show it in the Academy. Once I have done that, I can go back to the Roggevelde figures. This time I want to make them half life-size at most, and then have them enlarged.

The mother is to kneel and look out over the multitude of graves. The unhappy woman spreads out her arms over all her sons. The father kneeling too. He has his hands clasped in his lap.

When I am making such progress in sculpture I do not care that our planned trip to India is falling through.

<div align="right">November 1, 1925</div>

In an essay on Stifter, Bahr expresses very well what seems to me to be the essence of a work of art. He says: Stifter's endeavor as a painter was always either "to intensify experience to where it reveals its immanent idea; or, when he felt that he had grasped an idea with his inner eye, not to let it affect him as a mere stimulus. Rather, he had to satisfy the profound longing of the idea to be converted into reality."

110

Recently I began reading my old diaries. Back to before the war. Gradually I became very depressed. The reason for that is probably that I wrote only when there were obstacles and halts to the flow of life, seldom when everything was smooth and even. So there were at most brief notes when things went well with Hans, but long pages when he lost his balance. And I wrote nothing when Karl and I felt that we belonged intimately to one another and made each other happy; but long pages when we did not harmonize. As I read I distinctly felt what a half-truth a diary presents. Certainly there was truth behind what I wrote; but I set down only one side of life, its hitches and harassments. I put the diaries away with a feeling of relief that I am safely out of those times. Yet they were times which I always think of as the best in my life, the decade from my mid-thirties to my mid-forties. A great many things were very confused in those days. Then came the war and turned everything topsy-turvy. Knocked one down flat on the ground. Half alive and half dead, one crawled in silence, living a humble life drenched with suffering. One rose to one's feet very slowly indeed. New happiness came with Hans, Ottilie, the babies. Karl was always at my side. And that is a happiness that I have fully realized only in these last years—that he and I are together. Now we are wonderfully fond of one another. He is no longer the same man he once was, as I am no longer the same woman. He has left many things behind him, has grown out of and above them. What has remained is his "innocence," as Sophie Wolff calls it. He has a really innocent heart, and from that comes his wonderful inward joyousness.

March 11, 1925

Today I have finished the small figures for Roggevelde. Twice I had an accident with the figure of the mother; it fell down. When this happened the first time, I was not terribly downcast. I began over again and found a formulation which seemed to me better than the old one. The mother kneeling, leaning forward, hands laid one on the other below the face in an attitude full of life, head tilted slightly backward. With her eyes she embraces all the graves, smiles gently, loves them all. I worked a long time on this, and

at last it seemed to me I could stop. Day before yesterday, in the morning, I wanted to move the turntable in the studio into a different light. It struck somewhere, slid, the figure fell to the ground, and it was all gone. I did not know what that was an omen of. That I shouldn't do the work? And yet nothing seems to me more necessary than this. I was terribly upset and depressed. But next day I reworked it, differently. For I could not reconstruct what had been destroyed. Gradually my painful agitation cleared up—I was able to work. Is this last version better than the others? Was that the reason the others got smashed, so that I should do better?

When God burdens you, thank Him then,
And thank Him when he lets you go again.

May 1926

A wonderful birthday party for Joerdis and Jutta. Magnificent weather. I went out to Lichtenrade in the morning and found them all out in the sun in the field, the seesaw set up. The children radiant in their pink dresses, then naked. Gloriously healthy and blooming, all three of them. A joy, such a great, rich joy. And Ottilie, young, vigorous, healthy Ottilie with all her great charm and her inadequacies. And Hans—a bit, but only a bit, abstracted, more far-seeing, his face so good, so dear.

October 12, 1926

Have not yet begun the work for Roggevelde. Unhappily I have used up many weeks' strength turning my head to matters of sculpture. I keep keying myself up. It is getting better daily, but never good. Stopping altogether would be best, but I am too obstinate.

October 22, 1926

Saake built up the scaffolding and clay for the "mother" in my studio. It is beginning. I feel as if I now stand directly before the last stage of my

work. I think it so important that I can't imagine I will fail at it. Everything must hold up—health, mind, eyes, money—until I have done the work for Roggevelde. Both figures, father and mother. Afterwards I don't care what happens.

December 21, 1926

A long time since I last made an entry. A sweetish-sour condition, physically and mentally. In the work, which I began naively, so to speak, I have reached the first stumbling-block. I do not know what to do about it. I keep my hands timidly in my lap and evade the issue. The obstacle is the clothing. Once again I confront the great difficulty of having to do something that isn't in me, for which I have no talent. And yet it must be done. The naturalistic folds disgust me and the stylized folds disgust me, and if I try to do it in Barlach's manner, that too disgusts me. To get across what I want—so that only the silhouette matters—takes a great deal of technique. More than I possess, working in this material.—I am not afraid of the head, but the big, clothed mass worries me.

On top of all that, for some time now I have been haunted by the thought: Sixty years old—how can I manage to do anything important any more? In addition I am physically dragged down. Christmas coming, with its multitude of trivial, wearisome concerns.

January 1, 1927

The melancholy of age is slowly taking hold of us all. Georg, Lise, Konrad, dear Karl. I have long been its victim. We go on running ahead, from one week to the next, one month to the next, and then hop, skip, jump, clasp hands and over into the next year. Which of us knows whether he will live through to the end of it? Last year I got started on the important work for Roggevelde. It would not be altogether inconceivable that I may finish it in the coming year.

113

Yesterday Heinrich Braun, seventy-two years old, died of pneumonia. Much loved, a cavalier who looked like the Landvogt of Greifensee. Always chivalrous, noble, Lily's husband and Otto's father. I do not know much about his intellectual attainments. But how charming his laugh was when I used to telephone him in Paris. Of his voice Lily says, "Only a man of the world has such a voice." When he smiled at you, you felt beautiful, loved, surrounded by knightly courtesy. He was a man who ought really to have been carried to his grave by women, for he made women radiant and beautiful.—He was married four times, and there is little doubt that he made his last wife, Julie Vogel, happy.

He contributed the profits from Otto's diary to poor students.

He was always helpful—as indeed he helped Konrad. I knew that he could also be very mean—that is, I have heard so, but I never experienced this. Whenever he saw me he smiled that wonderful smile that spread over his whole face. I remember his visiting me in Munich when I was twenty-two— Marianne Fiedler was there too. He introduced us to socialism.

February 13, 1927

Another Schnabel concert. How peaceful and sacred the largo of the E-flat Major Sonata, Opus 7, is. Then I grew tired and could not follow. After the intermission Schnabel played the B-Major Sonata, Opus 106, one of the very late sonatas. I was alert and able to listen, and for the first time in a long while I was stirred through and through.

I can scarcely imagine another art which penetrates so deeply into you as music does. Plastic art is concrete; you are confronted by something definite. But here in the adagio it is *sheer soul*. What I always vaguely envision when I want to do a woman "who sees the suffering of the world." Only looks. No words. Goethe was one who could find the words. The "labyrinth of the breast" or "the blessed yearning." Or many others. He had words to stand beside Beethoven's music.

I feel a tremendous urgency to rally all my forces. I shall never approach those great ones, but still I *must* pull myself together once more for graphic

work, if I am ever to get Roggevelde done. And I must do the prints on Death. Must, must, must!

The last Schnabel concert today. For finale he played the Beethoven Sonata in C-Minor, Opus 111. I was able to follow it again, as with Opus 106. The strange, glittering tones shot flames—a translation into the spheres; the heavens opened almost as in the Ninth. Then a return. But a return after Heaven has been assured. Clear—consoling—good—that is what this music is. Thank you, Schnabel!

August 1927

. . . Early next morning the departure on the steamer. The three children: "Grandpapa, Grandpapa, Grandmamma."

My feeling of love for these five is often so strong as to be painful. And of the three children it is always Peter who is closest to our hearts. I do not know quite why it is that Karl and I often tremble with concern over the boy. His face looked so sweet as he walked holding Karl's hand and listening to stories. The white hair, the red cheeks, the frail little hand laid in ours. The beautiful naked little body.

New Year's Eve, 1927

The year 1927 was very good to both of us, to Karl and me. Not only that we are still together at the close of the year; we are also physically better off than we were a year ago. Both of us have been able to work very well. Naturally *everything* is not perfect—our trouble is that we have become somewhat duller toward one another. But the melancholy, last year's melancholy of age, has lifted. That is a result of the fine experiences we have had together. Ascona in the spring. Then my sixtieth birthday, with all the joys that came with it. Then Hiddensee with our beloved family, and then Russia. Moscow with its different atmosphere, so that Karl and I came back as if we had both had a good airing. We have been permitted to experience all that together—

and in addition the many good times with friends, the many hours when we felt so close and united. Much happiness.—Thanks, thanks!

The feeling of indifference is often bad; it deadens one's attitude toward life. But if any really heavy burden fell upon me, at least the feeling of indifference would be gone.

There have been a great many outward events this year which have kept me tied up in somewhat distracted activity. Not much time or desire for probing into myself.

Our dear children in Lichtenrade!

March 1928

Joy in others and being in harmony with them is one of the deepest pleasures of life. Love or infatuation need not have anything to do with it. I know that in recent years I have been fortunate enough to have this splendid feeling several times, and I have been quite conscious of what a blessing it is; but curiously enough I can no longer recall exactly the people who aroused this feeling.

I am very seldom so disposed toward young people. In fact I cannot think of a single case. I have to work to sympathize with them. Here the difference in generations becomes apparent. Their experiences are not interesting to us. Perhaps they would be if these young people opened themselves, but they do not do that.

April 1928

I had asked Lise to sit for me a while, for the head of the mother. I thought I now knew exactly what was needed. But nevertheless I did not make any progress. Suddenly I recalled my self-portrait in plaster, which had been standing in the studio for three-quarters of a year, and which I had not even unpacked. I unwrapped it, and it was as if scales fell from my eyes. I saw that my own head could well be used after all, and that I can work from this oversize study.

116

In the beginning of January I decided to look again at the long-covered figure of the mother, to get an idea how it will look after the basic changes of enlargement and so on. I was afraid of it. But then I felt calm and in good spirits, for it is really four-fifths finished. However, what remains to be done *I* must do. The head is not yet quite right. I must go at it some time when I am in a good working mood. For the time being I contentedly covered the figure again and went to work on the father figure, which I expect to master more quickly.

I was going along very well. Then I caught a bad cold and had to stop again. Today, February 6, Peter's birthday, I so wanted to work. But I can't.

October 22, 1929

I have had the father figure standing covered for a long time. Saturday I uncovered it. It was not good. It was more or less technically finished, but it had no soul. Only dexterity where I wanted an impression of disciplined firmness. I was much alarmed and at once began redoing it. I cut off the head and the arms. Tried crossing them over the chest, which I had tried before and repeatedly rejected. Then came Sunday. Monday I could not get to it either. It was not until today, Tuesday, that I uncovered the figure again and went on reworking it.

So I have been with you on the 22nd after all, Peter.

February 1930

Saw Barlach's Magdeburg war memorial. Only a photo. *Very strong* impression. He knew what he was about.

February 1930

For the cremation of our friend Heinrich Goesch:

Others have taken note of Heinrich Goesch's intellectual achievements. I want to speak of him as we knew him, as a friend.

He came into our circle when he was a very young man. He was perhaps twenty-two at the time, and both handsome and remarkable. Even then, in fact, he had all the qualities which we recognized in their fully mature form in his fiftieth year. Above all there was the urge to communicate and to influence other men. At that time he was a teacher, as indeed in his talk he has always been a teacher; but his teaching sprang from the need to communicate his inner experiences. A deep, swift and constant stream of experiences poured into Heinrich Goesch. And he always overflowed with ideas and perceptions he wished to share; he always sought recruits, and as long as I knew him, people followed him. His power over people often seemed dangerous, for those who accompanied him could rarely keep up with his tempestuous development. They thought they were at his side when he was already somewhere else, farther on, and then they had to find their way back to the point where they had gone astray.

There was genius in this man; everyone who crossed his path felt that. Yet how was it that in spite of his genius he could never bring anything to fruition? It always seemed to me that only a small door need be opened and his wonderful gifts would have shaped something lasting. Now that his life is closed and we see it whole, I realize that the significance of his genius lay in scattering seed, in giving, in fructifying, in largesse.

Our long conversations with him are unforgettable. Unforgettable one night spent in talk in the Christmas room. The lights on the tree burned and burned down, the last shadows of the twigs swayed on the ceiling. We sat and talked and talked. What perspectives opened up, what prospects looking out upon things unknown or only guessed at. For there was nothing arrogant about Heinrich Goesch. When he talked to you, you felt your own intellectual powers enhanced, you felt a sense of your own value. He gave everyone a keener sense of life.

Like a colorful woven tapestry the hours we spent together unroll before me. We were far away from each other and did not often see each other. But that did not seem to matter—we were assured of his coming again, assured of his bounty. We felt him ageless. His drive to keep finding new experiences, new perceptions, would lead him into new lands. When the wanderer returned, he would enrich us anew. It was characteristic of Heinrich Goesch that at the last he should say he had the feeling that he was about to enter

upon a great transformation. This last great transformation was death. But for Heinrich Goesch the word death had lost the meaning we usually attribute to it. There are people whom we would grant unconditionally the peace of death—of being done with everything; and there are people for whom death can only mean a new transformation.

"A new day lures us on to newer shores."

April 1930

Igor Jakimov and his wife visited my studio. I took heart and showed them both figures. The figures seemed to make the impression I had hoped for. That excited me tremendously. The thought that I shall really be finishing this work in a few months is agitating. Until recently I worked toward a goal far in the future, and now suddenly completion is upon me—that is, by fall. I was in a state of euphoria, but now it is beginning to give way to dull indifference.

April 22, 1931

Today was the opening of the Academy show in which I am exhibiting the two sculptures—the father and mother.

This is a great divide, a highly significant period. For years I worked on them in utter silence, showed them to no one, scarcely even to Karl and Hans; and now I am opening the doors wide so that as many people as possible may see them. A big step which troubles and excites me; but it has also made me very happy because of the unanimous acclaim of my fellow artists. I am thinking mainly of the sculptures. These past weeks have been very strenuous. But now that the works are delivered to the world, I am calmer. In June I will start on the finishing touches. In the fall—Peter,—I shall bring it to you.

April 16, 1932

A good day. Richter, the state architect, came to the studio in response to a letter I had written to the cemetery board in Brussels. He looked at the work

119

and thought it very good. He told me that the construction of the pedestal and the laying of the foundation will be undertaken by the cemetery board. He will also take care of getting the works put through custom-free and of the freight charges in Belgium. The German national railway will probably provide free transportation.

Where should I exhibit the figures here in Berlin? I don't want them in the Academy—it is too academic. Nagel proposes the Schiller Park, but there they would have no relationship to the surroundings. I dislike the idea of having them *inside* the Memorial Hall because it has been so taken over by the Right. Left outside they would not be guarded and might be scrawled over with swastikas or damaged. So that problem is still unsolved. But in any case the affair is progressing and I am happy.

Easter 1932

For a short time I have once more had that glorious feeling of happiness, that happiness which cannot be compared with anything else, which springs from being able to cope with one's work. What I've had in my best periods— and how short-lived these were. How long were the stretches of toilsome tacking back and forth, of being blocked, of being thrown back again and again. But all that was annulled by the periods when I had my technique in hand and succeeded in doing what I wanted. Now only a faint reflection of all that is left.

And then the unspeakably difficult general predicament. The misery. People sinking into dark wretchedness. The repulsive political hate-campaigns.

June 1, 1932

Things are going along. Tomorrow the stone figures will be exhibited in the entrance hall of the National Gallery.—Justi offered it to me, since the figures were not to stand inside or in front of the Memorial Hall. Today the last finishing touches in Diederich's studio.

120

Empty day of waiting.

Saturday I have to be at the gallery again from ten until two-thirty because of the press.

What a strange feeling it is when the benches are set up around the figures, the floor swept and the figures gone over once more with a dustcloth. *Finished!* Even to the dusting.

Saturday we drove to the cemetery (Herr Schult, young Lingner, Karl and I). The first impression of the cemetery was strange, because it has been changed since I last saw it. It has been leveled. And it seems smaller because the unknown soldiers have all been buried in pairs. Now it has been turned into a regular rectangle. The small tin crosses have been replaced by somewhat larger wooden crosses. The rows run with perfect regularity, but the space between the crosses is not always equal. A small stone bridge leads across the highway. The stone wall is higher on the highway side. Inside, it is lower, convenient for sitting. The wall is made of laid stones between which varieties of moss are growing. Now the cemetery seems more monotonous than it did. Only three crosses are planted with roses. On Peter's grave they are in bloom, red ones. It is nice that the whole area is now planted to grass. The space in front, which has been reserved for the figures, is smaller than I thought. It too is in lawn.

In the right corner of the cemetery the granite stones are still lying packed up. The workers from the graves' committee were there. The stone pedestals, already cut, were lying in readiness, and the provisional wooden pedestals. The dummies were being set up. First the woman, then the man. Long discussions on how much space to leave between; finally everything was settled. So that the whole will combine and the parents will have crosses in front and all around them like a flock, Lingner persuaded me that six more graves

should be brought up, so that there would be no gap between the figures and the crosses. There are still many remains not yet put in rows. . . .

The British and Belgian cemeteries seem brighter, in a certain sense more cheerful and cosy, more familiar than the German cemeteries. I prefer the German ones. The war was not a pleasant affair; it isn't seemly to prettify with flowers the mass deaths of all these young men. A war cemetery ought to be somber.

The day before, Schult visited the cemeteries in Northern France. At Arras there is one that holds 30,000 graves. It has one large mass grave which contains 2000 soldiers. Schult's companion said that you can scarcely see the limits of the cemetery; you have the impression that it goes on to infinity.

The following day the figures were set up. The workers were already waiting, the blocks were in place. It took long, hard work before the figure of the woman was raised. It turned out that the figure had to be raised somewhat to get the proper forward view, because the gently rising terrain emphasized the lean of the figure. Then the man. The great trouble with him, which at first upset me terribly, was that his line of vision is not high enough. He is not looking out over the whole cemetery; instead he is staring down, brooding. The hours of work were very tiring. When we left I was sad rather than happy.

Friday morning it rained and I packed. In the afternoon it cleared. Van Hauten came with the car around four o'clock and we drove out there once more—for the last time. And the depression of the day before lifted. I was able to see it all in the right light. We said goodbye.

August 14, 1932

Looking back upon the time in Belgium, my loveliest memory is of the last afternoon when van Hauten drove us out there once more. He left us alone and we went from the figures to Peter's grave, and everything was alive and *wholly* felt. I stood before the woman, looked at her—my own face—and I wept and stroked her cheeks. Karl stood close behind me—I did not even realize it. I heard him whisper, "Yes, yes." How close we were to one another then!

122

Age remains age, that is, it pains, torments and subdues. When others see my scant achievements, they speak of a happy old age. I doubt that there is such a thing as happy old age. Hauptmann, too, so highly lauded, only keeps up a façade of happiness.

July 1933

On July 4th Hans and his family went to the Baltic for their vacation. We saw them off. The boy bubbling with excitement and the joy of going some-where. Ottilie's face had the expression I like best to see, her clever, kind, humorous maternal expression.

August 1934

It is curious the way I am working during these summer months. As with the spring procession, I always keep making a few steps forward—and a few back. I had intended during this period when I cannot work in sculpture to carry out my old plan of doing a series of prints on the theme of death.

First of all I have to accustom myself to my new workroom. The balcony room is very small, but on the other hand that makes it intimate. Since I have moved the group down to the floor, there is space enough. But in the hot summer the sun shines in almost every day. Anyway, this wonderful weather is not conducive to work on the theme of death.

It is very laborious. Although I don't think my imaginative faculties are failing, the work I am doing does not satisfy me at all. "It's all been done before." When I worked it out for the first time it may have been no better, but it was more necessary for me. That is after all the crux of the matter.

I thought that now that I am really old I might be able to handle this theme in a way that would plumb depths. As old Goethe said, "Thoughts hitherto inconceivable . . ." But that is not the case. The period of aging is, to be sure, more difficult than old age itself, but it is also more productive. At the very point when death becomes visible behind everything, it disrupts the imaginative process. The menace is more stimulating when you are not

confronting it from close up. When it is upon you, you do not see its full extent; in fact you no longer have such respect for it.

In any case, so far I have done nothing *essential* in that direction. At the same time I have a curious doubt about the technical aspects. Decided on lithography, but when I started the work itself I no longer felt sure. Continually vacillating between stone and transfer. Formerly I could properly say, I carry a job to completion. Now it is no longer *I* who carry out *my* idea, *my* plan. I start off indecisively, soon tire, need frequent pauses and must turn for counsel to my own earlier works.

That is not a pretty state of affairs. But strangely enough it does not sadden me as much as it might. The simple fact is that nothing is terribly important to me any more.

November 23, 1934

Konrad's birthday and the anniversary of his death.

Among the drawings for the Death series is one in which Death passes by Konrad, as in the child's game: We're going to Jerusalem, who's coming along? Konrad stands up. Wearily rising. In his face sadness, resignation and dignity.

Easter 1936

I was recently at the Kronprinzenpalais museum. Found out from Hanfstaengl that there were objections to the exhibition of my group at the autumn show of the Academy. (The day after, there was an article in the *Schwarzer Korps* attacking Hanfstaengl.) In the lower rooms—not open to the public—I saw Barlach's Magdeburg war memorial. I knew it only from a reproduction. It is as good as I had thought from the reproduction, in fact better. There the war experience of 1914–1918 has really been fixed. Impossible for adherents of the Third Reich, of course, but for me and many others it is *true*. When you look from one figure to the others—this silence. Where mouths are ordinarily made for speaking—here they are shut so firmly, as though

124

they have never laughed. But he drew a drape over the mother's head. Good, Barlach!

November 1936

I am gradually realizing now that I have come to the end of my working life. Now that I have had the group cast in cement, I do not know how to go on. There is really nothing more to say. I thought of doing another small sculpture, *Age,* and I had some vague ideas about a relief. But whether I do them or not is no longer important. Not for the others and not for myself. Also there is this curious silence surrounding the expulsion of my work from the Academy show, and in connection with the Kronprinzenpalais. Scarcely anyone had anything to say to me about it. I thought people would come, or at least write—but no. Such a silence all around us.—That too has to be experienced. Well, Karl is still here. I see him every day and we talk and show one another our love. But how will it be when he too is gone?

One turns more and more to silence. All is still. I sit in Mother's chair by the stove, evenings, when I am alone.

September 1938

War has been averted! Thank you, Chamberlain!

In the debate on the imminent danger of war, someone in the British Parliament said: "There is nothing in the world important enough to justify unleashing another world war." *I agree absolutely! Nothing* in the world. God knows, not Deutschland, Deutschland *ueber* alles!

October 1938

Barlach died on October 24th in the hospital in Rostock. The following Thursday there was a funeral ceremony in Guestrow. I went. It happened that I arrived at his house before the others and went into his studio. I entered through a side door and came upon his work table with its assemblage of tools, and back of it a wall with some of his works standing against it. As I

turned to one side, toward the studio room proper, I saw Barlach lying in the open coffin. The coffin stood in the middle of the room. His bier was solemnly and expensively fitted out. A black drape, and white satin shrouds. Barlach is very small. He lay with head turned fully to one side, as though to conceal himself. The hands, outstretched and lying side by side, very small and thin. All around against the walls his silent figures. Behind the coffin a heap of pine boughs. Above the coffin the mask of the Guestrow cathedral angel. His small dog kept running around the coffin and sniffing up at it.

The ceremony was held over the closed coffin. Pastor Schwarzkopf, who spent eight years in Guestrow and was close to Barlach, delivered the sermon. A good one, and very grave. He began with Julius Raab's aphorism: "Eternity is still." Then passages from Job, passages from Barlach's letters and books. The struggle, the search, the cry for God.

Then a friend spoke a farewell in low German, then another friend, and finally Gerhard Marcks spoke for the younger artists: "Let your star be our guiding star."

The younger men carried Barlach's coffin out to the adjoining house, his living quarters. The day after, he was buried in his home town.

December 1939

On December 14 at three-thirty in the morning Frieda Winckelmann died in the Hedwig Hospital. In February this year, about the same time that Karl was so terribly sick, Frieda Winckelmann had a new attack of her cancer, which was supposed to be cured. Her strong will and the inspiration she received from her Catholic faith, as well as the support of her friends—especially Father Krajewsky—enabled her to do her best work during this period. When I was at her studio on September 20th I saw her Pietà. Akin to mine only in that the mother is holding the dead hand of the son. But mine is not religious. Frieda Winckelmann's is distinctly religious, Catholic. And because of that it has more power and weight. Mary's face is not empty, as Hans said; it is an exalted face, that of the Saviour's mother. My mother is musing upon her son's failure to be accepted by men. She is an old, lonely, darkly brooding woman. The Winckelmann mother, however, is still the Queen of Heaven. In the son her work and mine are more alike. But hers is better there

too. Frieda Winckelmann undoubtedly thought so, although she did not say it. This work of hers is noble and good. It is her best.

Just a year ago Karl got so sick I thought he would not pull through. . . . Often, during the worst of it, when I no longer had any hope, I wished the end would come for him. I was all prepared for it, and when he seemed to improve I took it for a temporary postponement of the inevitable end. Now I am thankful that his tolerable state of health looks as though it will last a while. Yet when the end does suddenly come, parting will again be very hard.

I am working on the small group in which the man—Karl—frees himself from me and withdraws from my arms. He lets himself sink.

June 6, 1940

Since April 12 Karl has been seriously ill again. He has become much weaker, lies in bed almost all the time. In the early morning hours he often looks very sad and grave. He picks up a little in the afternoon—is able to speak for at least a while with a visitor. With Pastor Schwarzkopf, for one. One time he had a long conversation with Hans and told him about his childhood. He expressed the wish that Hans would write it down. Now he has dropped it again; he is rarely strong enough for dictation.

Recently I thought of the words of Novalis:

> *Gib treulich mir die Haende,*
> *Sei Bruder mir und wende*
> *Den Blick vor deinem Ende*
> *Nicht wieder weg von mir.*
> (Put your hands faithfully into mine, Be brother to me, and before your death do not turn away your gaze from me again.)

Karl thought this verse wonderful, and at night before I say good night to him he always asks me to repeat it. Then he says good night and "thank you."

On his birthday Karl sat up in the chair by his bed. On a small table before him stood flowers and three burning candles made by Faasen—the very large one with small pictures of Karl and me, and the two large red ones with reproductions of the Roggevelde figures. These red ones have never been lit as yet.

In the afternoon the folks came from Lichtenrade. Kathrine and Paula were the only other visitors. All stayed with Karl only a short time. Karl looked very pale. For a while Jutta stayed in his room with him. In the evening he had a high fever. But he has recovered again and no longer talks so much about death. Once he walked about the room a little, supported by Klara and me. It was very moving to see him beginning to sing in his feeble voice. On June 15th Pastor Schwarzkopf stopped in to see him once more, before the pastor leaves on his trip. Karl is very fond of him and has considered asking him to say a few words at his grave, after Hans. The best thing would be for him to omit the usual things pastors say and talk only about how deeply the patients are attached to Karl—many of these patients are also in Schwarzkopf's care.

Karl has died, July 19, 1940.

Recently I dreamed that I was together with the others in a room. I knew that Karl lay in the adjoining room. Both rooms opened out into an unlit hallway. I went out of my room into the hall and saw the door to Karl's room being opened, and then I heard him say in his kind, loving voice: "Aren't you going to say good night to me?" Then he came out and leaned against the wall, and I stood before him and leaned my body against his, and we held each other's hands and asked each other again and again: "How are

you? Is everything all right?" And we were so happy being able to feel one another.

My days pass, and if anyone asks me how things are I usually answer, "Not so good," or something of the sort.

Today I thought it over and decided that I am really not badly off. Naturally I cannot say that things are good—no one could say that. For we are at war and millions of human beings are suffering from it, and I along with them. Moreover, I am old and infirm. And yet I am often amazed at how I endure it without feeling altogether unhappy. For there are moments on most days when I feel a deep and sincere gratitude. Not only when we hear from Peter, or when one of the family from Lichtenrade comes, or Lise; but also when I sit at the open window and there is a blue sky or there are moving clouds. And also when I stretch out in bed at night, dog-tired.

Where do these random sensations of happiness come from? After all, I certainly do not have a sanguine temperament.

The fact is that I am still pretty well off. I do not yet have any constant pain; my eyes are holding out; I am living with Klara and Lina, who are so sweet about taking care of my food; at least once a week my dear Hans comes; pleasant people visit me. I have not been able to work for months, but this too I do not take so hard as I formerly thought I would. Yes, at intervals this weighs on my mind and makes me very sad. But on the other hand, it is an adjustment to the order of things. It is in the order of things that man reaches his peak and descends again. No sense grumbling about it.

It is of course bitter to experience it. The old Michelangelo drew a picture of himself in a kiddie car, and Grillparzer says: "Once I was a poet, now I am none; the head on my shoulders is no longer mine." But that is simply the way things are.

Yes, I must still say as I always have, that when a certain measure of suffering has been reached, man has the right to cut his life short. I am still far from that measure of suffering, in a physical or spiritual sense. And I also feel a timidity and fear of bringing death upon myself. I am afraid of dying

129

—but being dead, oh yes, that to me is often an appealing prospect. If it were only not for the necessity of parting from the few who are dear to me here.

October 1942

Hans has been here. On Wednesday, October 14. When he came into my room very silently, I understood that Peter was dead. He fell on September 22.

May 1943

The last diary entry.

Hans has reached the age of 51. Air-raid alarm the night of May 14. It was the loveliest of May nights. Hans and Ottilie did not go to sleep until very late. They sat in the garden and listened to a nightingale.

After work Hans came, then Ottilie and finally Lise. The four of us sat together. On his birthday table, below the grave relief, I had placed the lithograph *Death Calls*, the print of which I worked over. Then there was a drawing I had made of Karl one time when he was reading aloud to me. We were sitting around the living room table at the time. This drawing is a favorite of Hans'. And there was also the small etching, *Greeting*, which is closely connected with his birthday.

We lit Josef Faasen's large candle.

Early next morning, Hans came again and brought a great bouquet of lilies from the garden. What happiness it is for me that I still have my boy whom I love so deeply and who is so fond of me.

Goethe to Lavater, 1779: "But let us stop worrying our particular religions like a dog its bone. *I have gone beyond purely sensual truth.*"

The Letters

Florence, May 1907

Dear Lise—I want to write you a proper letter for a change. Sometimes I get homesick for my family, but also for all of you. Especially now, with Hans' birthday coming, I am often on the brink of tears. But then the mood passes. Lately I had the same dream I once had in Paris, that out of homesickness I went home sooner than I was supposed to and that after the joy of welcoming was over I clapped my hand to my head and thought I was mad to have come home earlier than I needed to. So of course I want to stay here until the time is up; but I shall leave here with a lighter heart than I left Paris. Because when it comes down to it, everything here is really alien to me. Perhaps I shall feel more at home in Rome, but I hardly think so.

Since Peter left I have really been studying Florence for the first time. Doing it thoroughly, however, is out of the question. I think you could spend half a year here and not see everything worth seeing. The enormous galleries are confusing, and they put you off because of the masses of inferior stuff in the pompous Italian vein. And so I have been trying the churches, with

better luck. There are magnificent frescoes in the churches. They produce a completely different effect when you see them where they belong. I've made a pilgrimage through all the churches and monasteries—today I was in San Marco, in Savonarola's cell.—Then there is the Bargello, with all the Donatellos—splendid things, some of them. I am not so fond of his Annunciation in St. Croce's; it strikes me as somewhat too soft. But his boys and young men are splendid, the David very beautiful. And finally I again ventured into the Pitti and Uffizi Galleries. There are beautiful works here and there in them, but only here and there, it seems to me. It is odd about Botticelli; now and then he has figures in his paintings which are gloriously beautiful in conception, coloration and draftsmanship, and then again I can't stand him; he seems to me so un-naive and decadent. The look of ecstasy reminds me, among other things, of the Salvation Army; the facial expression is dully stupid, as after a drunk, and at the same time affected. But there is one splendid Annunciation there. So far, what has gotten deepest inside me is a fresco of Masaccio's in Santa Maria del Carmine, where a naked boy kneels amid an assemblage of stiff men; and then a Mary who has the child on her lap and is herself sitting on the knees of St. Anna. These are two very fine paintings. Do you know, by the way, that Botticelli fell so strongly under the influence of Savonarola that he refused to touch a brush again?

As far as the architecture goes, my experience is almost like little Peter's, who impertinently declared that the Palazzo Vecchio is "awful." All these palaces affect me as hostile, sulky. They may have been first-rate citadels during many civil wars, but it is an architecture without charm. And to me the Pitti seems only massive; you cannot get a proper general view of it. It is simply too large. As for the churches, almost all of them are dressed up in black and white marble, which Peter again thought awful. The façade of the Cathedral, which was finished in its present form only recently, struck me also as much too bright-colored and restive. With Santa Maria Novella, on the other hand, age has entirely erased all the restiveness. The façade of Santa Maria Novella, and the plaza before it, are among the finest things here.

The ancient baptistery is also beautiful. The Brunelleschi dome of the Cathedral is splendid.

On the whole, the inside of Florence seems gloomy. The other day I had gone out for some supper and was coming home through all the narrow

streets when I encountered a funeral procession. For a moment I had the sensation of being actually in ancient Florence. The funerals are held after sunset, and the coffin is carried by the fraternity of the Misericordia, which was founded during the great plague. The brothers go about dressed completely in black, with hoods that cover the face and only holes for eyes—a costume dating from those days. They carry torches and walk in total silence.

Now that the hot weather is starting, however, Florence seems very different. In the first place you see so many flowers, roses everywhere. And then the singing. Evenings I usually dine at Lapi's, a sort of artists' café, an old bistro. There are always a guitar player, a singer and a castanet player making music. When I have finished my supper and go home through the streets, which are very dark compared to Berlin's, there is music everywhere. I think all Italians have tenor voices, and their tremolos are so heartrending that you can scarcely bear it. Recently I saw three men standing on a bridge in front of a house, thrumming a guitar and singing to a window above. Suddenly a lovelorn woman's voice began singing a solo; it was one of the men. Whether or not he was a eunuch, I don't know; he did not look it to me. As I stood for a while enjoying it, someone else began singing on a neighboring bridge, and then more and more voices joined in, from right and left, until finally I strolled on home. And then fat Annina, who is still up, says under her breath with a pitying shake of her head, as she always does: *"Sempre sola, la signora."* Yes, now I am really *sempre sola*. For a while I liked it, but it is getting to be too much for me.

Lore's friend—her name is Harding-Krayl—and I are planning to take a walking tour over San Gimigneon and Volterra into the coastal region; but we intend to be very careful on account of the fever (though this isn't the season for it). Then cross-country along Lago Trasimeno past Perugia and Assisi. And then perhaps northward to Gubbio, which Hesse has so praised. Then south to Orvieto. Siena on the way back. I am looking forward tremendously to this walk. And am rather curious as to what I'll look like when I finally reach Rome. Now I have my usual summer appearance, but how shall I be in July?

The roses are blooming now—in such masses. On the street you are offered roses for next to nothing. If you don't want to have them, the vender says, you ought at least to smell them, and he keeps walking along at your side

holding the bouquet under your nose. Finally you burst out laughing, and he does too, and then you buy them.

Dear Peter! You industrious little farmer! Is the elderberry already blooming? It's wonderful that you are working so hard in the fields, my boy. Too bad I cannot eat some of your rhubarb and your peas. Not even some of the strawberries, when they ripen. But send me a pressed forget-me-not or daisy when you write to me.

And that you are able to swim for ten minutes and can dive from the diving board is very good and makes me happy. You know, if you want to be as good as Fritz Goesch you will have to practice hard. Swimming will be very useful to you in Fiascherino, and I'll do my best to learn how to swim also. The Mediterranean is so warm in the summer months that you can stay in it for hours without getting cold. Mr. Krayl, who has been there too, says that when it becomes unpleasantly hot you can go swimming in a grotto where it is always shady and the water is so shallow that it reaches only to your knees. You can set a table in it and read and write. It will be wonderful there, but I must learn to swim; otherwise you three will swim away from me and I will sit like deserted Ariadne on the shore. And the sea is so *blue*, believe me. In the afternoon hours it is often an absolutely wild ultramarine blue.

Just imagine, Mrs. Krayl and I wanted to buy ourselves a little donkey for this trip. The donkey was to carry our packs and sometimes us too, and at the end of the trip we thought we would sell it again. It would have been great fun if we had done it and ridden into little towns sitting on the donkey, which of course would have had to bray.

But yesterday at any rate we rode on a donkey cart. We took the wrong road and were out of sorts at having to walk all the way back. Then a man came along in a little donkey cart that was going back the way we had come. He said we poor pilgrims ought to take a ride, and so we clambered up on the sacks and sat there, eating our cherries and spitting out the pits to the right and left of the cart. And the sweet little donkey, whose name was Nina and who had a very big, thick head, trotted along, pulling us.

134

Goodbye, my sweet boy. Keep healthy and happy, and I will see you again at vacation time. And work hard in school too. Love and kisses from your mother.

<div align="right">

January 16, 1911

</div>

My dear boy! . . . In the evening we went to see *Everyman*. I was terribly sorry you did not have the chance to see it. I thought it excellent, and Moissi especially acts with a charm and vivacity that quite carries one away. I can now understand why all the young girls are so crazy about him. Except for his Hamlet, I have never seen him so good. Of course people say that this role is virtually made for him. As Hamlet he acts, but here he *is* the spoiled, handsome, charmingly weak young man who finds dying so horribly hard. When he finally realizes what dying means, and that *none* of his earthly pleasures remain to him, he takes off his heavy golden chain and his rings and throws them away with the expression of a sweet, spoiled boy who thinks he has been treated unjustly and is on the point of crying. It was marvelous, all of it, absolutely marvelous.

And in this naive play with its skeleton figure of Death, its angels and devils—as though, God knows, we were not at all living in the twentieth century—one is so gripped (I was at any rate) by the horror of inexorable death. Incidentally, the Devil, who of course gets the short end of the stick and is made fun of, was played in a magnificently comic vein by Biensfeldt. Too bad you missed it.

<div align="right">

[For Hans' birthday]
May 14, 1911

</div>

My dearest boy! Your bust stands before me. When I look up I see your dear face, which I know so well in every mood. Dearest boy, you know how often you are in our thoughts these days. We always think of you with love, but at this time we are more conscious of it than ever. When you were born nineteen years ago, the lilacs were already blooming. I had great masses of lilacs in my room, where I lay with you who had just come into the world. Even then you had such a serious face.

And then, from your first birthday on—when a single little candle burned, with the life light beside it—to the present one, all these many years. Only once before was I unable to be with you on your birthday. That was when I was in Italy, and it was very hard on me then too. There was just one thing during the whole time of your growing up which worried us—that was your tendency toward melancholy, toward depressions. But we can no longer do anything about that; we can only wait and hope that you yourself will overcome it. You have so much strength, Hans—you will fight against this tendency toward sadness. I always remember that for me too the years of youth were harder to bear than later years. The praise of life, such as old Goethe sings in his song of Lynceus, is natural only in age, I suppose. The selfsame Goethe harbored thoughts of suicide in his youth and, to recall only one of his poems: "Now the heart is sad always./Sorrow's what youth feeds upon,/Tears are the young man's hymn of praise."

Dearest boy—push *through* into life—it is worth living after all. With exceptions, of course; but why should these exceptions, these things that are really unendurable, be your fate?

May 15, 1911

Dear Hans! You ask about my sculpture. On Saturday I shall be finished. Then Frau Naujoks is leaving, and I should not like to spend any more money on it. I have done a great deal more with it than with the first group, but of course it is still far from what I want it to be. Perhaps I shall keep it wet over the summer and then set to it again in August with fresh vision and, I hope, with fresh money also. Whether it will keep that long, whether it won't "come" as Lobach says, is the question. A crack started diagonally across the legs, and the whole heavy back part threatened to collapse over backwards. Now I have drilled a stout piece of wood into the back, and it has enough support for the present.

May 20, 1911

My dear boy! I must tell you the sad news that Pitti was put out of the way yesterday. It was hard for us all, especially Peter. But the poor beast was

completely changed and took no pleasure in life; it *had* to be done, and now that it is done I am glad of it.

I myself took him to the Society for the Prevention of Cruelty to Animals, and it was very hard for me to leave him there. He was put to sleep right away. The saddest part of it was the night before, I think. I had a talk with Peter about why it had to be done, and then we heard Pitti scratching at the door. Peter let him in and took him on his lap. For a while we went on talking about him. We are both convinced that Pitti had an inkling of what we were talking about. He acted so strangely. Nothing, not even luring him with meat, would persuade him to leave us. He followed Peter into the bathroom and into the bedroom until Peter was in bed, and then he came back to me and lay down with his head on my feet. It was very late at night before I could get him out. We'd seldom seen him so attached and mournfully affectionate. So it was all the sadder for us next day. As soon as Peter left, I hurried off with him.

Incidentally, I went to the Old Museum yesterday. The depressing amount of half-good stuff, even in sculpture, was such a letdown that I told myself I'd run over to the National Gallery and see something really good for a change. And it really was very nice. Since the lower rooms are being redone, they have pretty much assembled the elite in the big hall upstairs with its overhead light. Menzel, Boecklin, Feuerbach, Truebner, Thomas, Liebermann. Then I went up to the French artists, and in the very first room—which holds the famous Rodin bust—I began to regret my having signed Vinnen's protest. For here I saw French art once more represented in really good works and I said to myself that come what may, German art needs the fructifying Romance element. It is simply that the sensuous nature of the French makes them that much more gifted at painting; the Germans lack any color-sense and left to herself Germany would produce the type of painting represented by the Dresden school, which I despise. Of course I said something of the sort to myself before I signed, but at the time I was so angry about the latest presentations from Paris that I just went ahead and put down my name. I ought rather have told myself that the whole Matisse craze will sooner or later come to an end; the thing to do is simply to wait patiently.

While I was standing there and thinking about these matters, I became aware of a conversation between a museum attendant and a young woman

painter who was doing copying. I suddenly realized that they were talking about me, and the museum attendant was praising my work to the sky. But he had no backbone, for when the painter took issue with him, he became more and more timid, and finally said, "Yes, that's so, of course; women ought to stick to their households."

<div align="right">October 15, 1911</div>

My dear boy! . . . Yesterday was a happy day. The "juryless" show opened, and there was a frightful rush of people. A wild crowd swarming through all three floors. The show made a very good impression. The boring things were cleverly grouped together and the better ones hung in worthy company. As far as I have seen, there seem to be a great many good and interesting things. The poster is of a newborn child being raised into the air by two hands, crowing with great pleasure and apparently a very husky baby. In the evening a big banquet was given in the Artists' House, and they kept telephoning me to come over. Finally I did, but not until nearly ten o'clock, by which time they were all dining at long tables. Imagine the shock to me when, as soon as I came in, Sandkuhl spied me and proposed a cheer for me. The band played a fanfare and everybody cheered. I was so embarrassed I didn't know where to turn. Luckily I discovered Lene Block and managed to get to her side and sit down quietly. There were so many acquaintances of ours there, not only artists, that I hurried to telephone Father and he too came. It was very nice, but lasted terribly late. Today I'm sleepy as can be.

<div align="right">October 22, 1911</div>

My dear boy! . . . But I have just had real pleasure in something very beautiful—that is *Wilhelm Meister's Call to the Theater*. You are filled with something like reverence when you begin reading this book, which dates from Goethe's best period—before Italy—and was not worked over or filed away at later on. He probably worked on it for some eight years; the date of the beginning is only three years after *Werther*. But you can convince yourself of that on every page. Everything is written with such freshness, concreteness, naïveté. I like it ever so much better than the later *Wilhelm Meister*. Now too

I understand what it was in *Wilhelm Meister* which has always baffled me—
the differences in the language. Goethe, when he undertook to rework the
book later on, left large parts of the first version almost unchanged. This was
so with most of the sections dealing with Marianne. The wonderful letter Wil-
helm writes to her, beginning "under the sweet mantle of night"; the part
where he takes the musicians under her window and spends the night on the
bench—all these wonderful passages are taken word for word from the earlier
version, except for minor changes he made where the first version may have
seemed excessive to him, although in all cases the earlier passages were
superior. For example, he says later (of Wilhelm hearing the music of clar-
inets, French horns and bassoons), "His breast quivered," while in the first
version he says, "A quivering ran all through him." Inserted into the later
version were Wilhelm's story about the puppet theater and Wilhelm's en-
counter with the unknown stranger who asks him where he may find an inn.
Both seem to me inferior. In the original version the puppet games are re-
counted in the first chapters in a far more lively fashion. In the revised version
the encounter with the stranger comes right in the middle of an integrated
description of Wilhelm's being in love, and makes for a great letdown. There
is nothing of the kind in the original version. I have not read any further
than Wilhelm's starting out on his journey. In the revised version this takes
place before the break with Marianne; in the first version he sets out on this
journey much later.

The copy I am reading was intended for Lise, but I cannot tear myself
away from it and have got another copy for Lise.

January 26, 1912

My dear boy! . . . Now I want to tell you about our darling Anatol. He yelps,
drags his ham bone into his basket and lies down beside it with a menacing
look. It is wildly funny, like a Lilliputian trying to play Goliath. He is no-
where near housebroken yet. He has been given a very handsome tin tray
made for the purpose by Klempner. We have put sand in it and he is supposed
to use it. He does so when he is in the mood, but usually he is not in the
mood. Even at night I can't say he behaves himself. But all his sins are for-
given when we see what a pretty little beast he is, getting darker all the time.

He sits stretched out full length, legs wide apart, snout alert and ears marvelously expressive. When you call him he tilts his head to one side, just the way Pitti did, so that you sometimes think he is going to dislocate his neck. He still doesn't at all like to jump down from the sofa, although he can do it perfectly well. He makes a terrible fuss about being asked to do anything of the sort. Yelping loudly, he jumps around on the sofa until he finally gets up his courage. It always makes me think of Fiascherino and the rock cliffs there.

<p align="right">For July 8, 1912</p>

My dear boy! I hope this letter will reach you by my birthday. It is strange to be alone with Father on this day—this is the first time that's happened since you were born. The four of us have always been together, or at least three of us, as last year. But I am not sad, although when I realize the changes that have taken place I become thoughtful. How fast the time has gone by, really, from the days when you were still a baby and belonged to me. Now it is very different. But let me say again, Hans, I am not complaining about it. The goal of parents, after all, is to make their children independent. The love between parents and children does not cease, never ceases, but everything changes and takes on new forms. If you would rather not have me share in what you are experiencing at this time, I completely respect that wish. I think about you so much. I have seen so many things in life go awry and turn out unhappily; and often the unjustified feeling comes over me that even a grown child is still a child who must be guided. That is nonsense, of course. One must have confidence in one's child; one must trust that he will be strong and wise enough to settle everything for himself. And I do have this confidence, my boy.

<p align="right">December 19, 1912</p>

Dear boy! . . . Peter will not get to writing today. He is sitting upstairs devouring Wedekind's *Spring's Awakening.* I took the book with me on the streetcar today; it must be nearly ten years since I read it. Today, too, the impression it made was enormous. The younger Wedekind is powerful and full of life. I don't like his later things, but *Spring's Awakening, Earth Spirit,*

Pandora! When I read them now, I once more recover the sensation I used to get from them, namely, that life in its violence, burdensomeness and inexorability is almost unbearable. The naked quality of his writings, the brutal nakedness, the passionate magnifications, the crudeness—I used to try for the same thing in my work, but with a different slant. I do not believe I now see life more mistily; on the contrary. But I see it more from a distance now. I take a broader view of it, and it now seems to me more meaningful, too. In those days it seemed as though you had a colossus directly in front of you, as though you were bumping your nose right up against it and yet could not at all make out its structure. It was all confused by crude illumination, by glaring lights and pitch-black shadows. Now I have moved farther away from this monster; I have begun to familiarize myself with its contours, and it has partly lost some of its frightfulness. But when I read Wedekind these twenty years of my life vanish again and I am once more caught up in that passionate feeling of having to defend myself against the monster.

But enough of this. I really would hardly wish to live through my youth again, but I should like to relive the years when I pulled myself out of the state of suffering and came to a clear sense of my own powers. The process is after all like the development of a piece of music. The fugues come back and interweave again and again. A theme may seem to have been put aside, but it keeps returning—the same thing in a somewhat changed and modulated form, and usually richer. And it is very good that this is so.

February 2, 1913

Dear boy! . . . These days there is one Secession meeting after the other. And I really have not escaped my destiny; they've saddled me with a horrible job, that of second secretary. Which means that when Baluschek is absent I have to take minutes, and so on. I protested that I couldn't do it, but Cassirer said I ought to try and if I really couldn't they would replace me. And so I now have that on my back. To give you an idea of how much this job has disturbed me: the following night I dreamed that the Secession had given me the task of pasting a quantity of red stickers on the advertising columns. With a pail of paste hanging at my belt and a large brush, I ran breathlessly

from column to column, pasting on my red stickers and trembling for fear I was doing it wrong. But aside from this matter, I find the meetings extremely interesting. Cassirer is full of plans; he has so much energy that I am in awe of him.

Wonderful that you already are out in the country, even when it is still winter. I too often have such a longing for the country, for an expanse of sky, clouds, the smell of earth, flocks of crows, for all the things one can have outside of Berlin. But as it is, I take my daily trot over to the studio. Barlach has rented a place in a village in Mecklenburg, but I could not do that. For all my romantic feeling for the country, I suppose I need the city.

So long, old fellow. What about Easter? I suppose you will be going out to the country again?

If only the Secession board, instead of making me secretary would send me to Duesseldorf to arrange the exhibition affairs there. So long, keep well.

June 2, 1913

My dear boy! . . . For a change Peter was not out with his hiking club; he wanted to paint something for Father's birthday. So after dinner we both went out to Stolpe. We stopped at a pretty place on the way to Hohenschoepping. Peter started to paint, and I lay in the grass and took in the wonderful fragrance of pines and blossoming grass. It was so lovely and still and peaceful. The thought eats away at you that the wonderful summer is passing while you smell nothing but motor busses and dust in Berlin. The temperature in the studio is eighty degrees from early morning on; that makes for lassitude, and yet I cannot and will not take a vacation now. I must stick out the two months.

Koenigsberg, July 8, 1914

Dear boys! The way I feel about nature around here—it is like seeing again someone you love dearly, only to find that he is wearing his hair so differently that you scarcely recognize him. You are sad, missing the familiar face. But at odd moments it shows up again.

Dear boys! . . . Then we go out to eat and then usually take a walk up or down to the sea to watch the sunset. Here there are proper sunsets once more. The sea spreads out below one, so broad and vast, and then the sun in the cloudless sky sinks slowly into this undulant bosom.

I have received your presents, boys, and thank you warmly for them. It would have been far nicer had you been here to give them to me yourselves. As it is I must "manage for myself," as Peter says. It has not been very hard for me. Nevertheless—to start with Peter—I do think he has chosen to walk on the bumpiest sort of corduroy road. You know that well enough, Peter. What I'd like to see in you is the beginning of thorough study. As you yourself said, as soon as you start on color, that's the end of studying. I am happy about your way of seeing forms; I think you see what is organic. But your color is an emotional outpouring. And one can allow oneself emotional outpourings only after strenuous intellectual labors. If the emotional outpourings come first, you soon get a fluttery feeling in your stomach; you have a hangover. And then a feeling of dilettantism. We shall be quarreling over this point time and time again. But for the present we agree that training is necessary. If one only knew what training first, and where. I have not seen your self-portrait in its earlier stages. As it is now it strikes me as tortured. It would have been better had I not always conscientiously looked the other way whenever I came into your room.

(November 1914)

Dear Frau Schroeder and dear Dora! Your pretty shawl will no longer be able to warm our boy. He lies dead under the earth. He fell at Dixmuiden, the first in his regiment. He did not suffer.

At dawn the regiment buried him; his friends laid him in the grave. Then they went on with their terrible tasks. We thank God that he was so gently taken away before the carnage.

Please do not come to see us yet. But thank you for the sorrow we know you feel.—Karl and Kaethe Kollwitz and Hans.

Dear Erich Krems! . . . Six weeks ago Walter Koch brought us the first news. Then we went to see Hans Koch at the hospital and he told us how it happened. Your letter has told us too, and what Hans Koch did not say was in your letter—love and sorrow for Peter. You are dear to me, Krems, because you love Peter and he loved you. You have lost your friend. There is in our lives a wound which will never heal. Nor should it. To give birth to a child, to raise him, and after eighteen precious years to see his talents developing, to see what rich fruit the tree will bear—and then to have it cut short . . . !

I have in mind a sculpture in honor of Peter. That is one goal for living.

You write that you will keep faith with Peter. You will, I know. Here is a picture of him that Regula Stern once took. Until we meet again, Erich Krems.

January 4, 1915

My dear boy! Some days ago the children around here were playing war and a little boy was taken prisoner by a superior force. He pleaded for his life in these words: Oh, please let me live, I am the father of a large family and my wife's only son.

January 28, 1915

My boy—We had a long wait this time, but today your letter came at last. You sound healthy and in good spirits.

But I am troubled that the fountain pen has not arrived. I know I sent six packages to you, two containing just woolen things, one just sweets, one with the *Wilhelm Meister* and one with the volume of Hesse's poems and the fountain pen. Let me know how many of these things have arrived.

Our life is quiet, but curiously enough, where formerly I suffered from ennui, that seems to have disappeared entirely. I am almost entirely alone, but I always feel that there is a great deal to do in this solitude. A new turning of the soil. Peter is always present.

I suppose it is the same with Father. We do not talk much, but we help one another nevertheless. We are coming close to one another in a new way. And then there is the day-to-day work that I have to do again. Since I have

not yet received a reply from the local union, I am utilizing the time to get ahead with my old big work. You know it; you were both up in the studio with me and we talked about it. In all this Peter and you are present. Loving and having to give up what one loves most dearly, and having it still—always the same. How is it that for years, many years, the same theme was always being repeated in my work? The premonition of sacrifice. But one is enough —Hans—one is enough.

February 6, 1915

My dear son—Today I heard lovely music. Beethoven and Schumann and Reger at the Opera House.

A young, blinded soldier was there. He was led to his seat. There he sat very stiffly, without stirring, his hands resting on his knees. His head erect and tilted back somewhat. On his chest hung the Iron Cross. I had to keep looking at him—it cut me to the quick. Lise was here and brought flowers— white tulips.

February 7, 1915. Sunday.

My dear Hans! Yesterday we wanted to go out to Buch. But Father had so much to do that when he finally got away we could no longer make the train. So instead we only went to the park in Pankow. A winter wind whistled in the trees and the ground was frozen hard. Today there is a heavy white snow cover over everything.

Do you recall how we said half jokingly that when you two went to war, I should sit with my big horn-rimmed glasses and read the Bible like an old grandmother? I am reading the Bible now, but not the way the old grand-mothers did. I am reading it from the beginning and for the very first time in my life, and I am altogether overwhelmed by its greatness. What a people they were! When King David has the Ark of the Covenant brought to Jeru-salem "David and all the house of Israel played before the Lord on all man-ner of instruments made of fir wood, and on harps, and on psalteries, and on timbrels, and on cornets, and on cymbals. And David danced before the Lord with all his might." His wife looked through a window "and saw king David

145

leaping and dancing before the Lord; and she despised him in her heart."

And then the chapter about Bathsheba and her husband Uriah, to whom David gives a letter to take to the commander: "Set Uriah in the forefront of the hottest battle and retire ye from him, that he may be smitten and die." It is all written with deep earnestness and grandeur. There are treasures of beauty in the Bible. The wonderful book of Ruth.

Sunday, February 21, 1915

My dear Hans! Very slowly and gradually I have been getting to the work for Peter. During these past weeks of working I have again realized what I spoke of to you months ago, but what in the intervening time became so obscured that I almost ceased to believe in it.—Shortly before the news about Peter came, we both had gone out to Potsdam. I have already told you of the new insight that this period gave to me. That egoism was dying out, and that the right to voluntary death, even beyond the deaths of you boys, was no longer a right possessed by the individual, as I formerly thought. For back of the individual life, I said, stood the Fatherland, and as long as one could be of use to it, one had to live. That was how I thought then.

Why does work help me in these times? It is not enough to say that it relaxes me very much. It is simply that it is a task I may not shirk. As you, the children of my body, have been my tasks, so too are my other works. Perhaps that sounds as though I meant that I would be depriving humanity of something if I stopped working. In a certain sense—yes. Because this is my post and I may not leave it until I have made my talent bear interest. Everyone who is vouchsafed life has the obligation of carrying out to the last item the plan laid down in him. Then he may go. Probably that's the point at which most people die. Peter was "seed for the planting which must not be ground."

If it had been possible for Father or me to die for him so that he might live, oh how gladly we would have gone. For you as well as for him. But that was not to be.

I am not seed for the planting. I have only the task of nurturing the seed placed in me. And you, my Hans? May you have been born for life after all! You must have been, and you must believe in it.

146

My dear boy—Today I returned from Alt-Ruppin, tanned and looking well. I distinctly feel that the ten days have done me good, and I only hope the good effects do not vanish too quickly.

I have no idea when Father will be able to relax. He has so terribly much to do.

Do you know the poem Dehmel wrote to his beloved Rhine? On the last day there I saw the Rhine as beautiful as he describes it. I had gone out alone. Through a high, wooded area I came to a clearing where the view down into the valley suddenly opened out. Then I saw it again winding blue as a cornflower through the meadows of the valley. And always above, the hawks.

In Alt-Ruppin what pleased and hurt me at the same time were all the soldiers. They would begin their field maneuvers at dawn, or sometimes toward evening. Then we would hear them marching back at night, singing all the time. Sometimes I could make out every word of the song.

Sunday, January 16, 1916

My dear boy—You keep us on short rations with letters. I am always afraid that your not writing indicates that you are having a period of unhappiness. So your not writing troubles me, simply as a symptom. But if you cannot do anything about it, at least write a card now and then—as you did recently when you sent me that terse note that you are well. You will, won't you, my boy?

Today is once more my day for correspondence—a Sunday. And a sunny day for the first time after weeks of storms and downpours. The sun shone into Peter's room.

I am growing more and more fond of sitting here with Peter, where it is so quiet and shut off. After I have opened the old desk and placed the lamp on the hinged top, the three compartments confront me. In the four small drawers to the left are all the pictures of you boys. In the open compartment on the right are a few books which I like best and read oftenest. In the center open compartment is a picture of the two of you as children. You must have been about seven at the time, Peter about three. You are standing arm in arm, and you are much bigger than your brother.—Here is also a picture of

Peter before his departure. Along the back wall of this compartment there is just room enough for another picture. A fine Bellini now stands there: the lamentation over Christ. When I look up I must look at this picture; it makes a lasting impression. But I intend to change it, to place other pictures there too.

The hours pass very quietly here now. During my working hours it is also quiet, as far as the absence of other people goes, although the quiet is of a different sort, being active. But my work on the jury puts me in contact with plenty of life. Yesterday the jury session began at three in the afternoon. We sat together until six, and the general meeting was to be at half past eight. In between I went to the Sterns. And just during this interval my sculpture was delivered—while the other people were still around. I was as a matter of fact glad not to have to be present. When I returned I heard the others' verdict. It sounded favorable. I still do not know how the work will look to me among all the others, in a strange environment and with strange lighting. I hope it will hold up.

I have resumed reading the Bible again. As soon as you open it, no matter where, you find something full of savor and power. Listen to what God says: "I would thou wert cold or hot. So then because thou art lukewarm, and neither cold nor hot, I will spew thee out of my mouth."

February 22, 1916

My dear son! We are daily expecting the news that you have left Spa. Going where? West—East—South?

Now that it is so and must be so and there is no choice, I cling to this: If you come back, life will have another meaning for you. Right now it seems to you a good which you know has value, but whose value you do not quite understand. But later—if it is granted to you to live—you will feel what living means. Then you will strike roots. May it be so, my boy—my dearest child.

Rohrbrunn, 1916

My dear boy—We would have been happy had we got there in time to see you, even though I do wish you would at last move ahead. On Friday we will

148

be at home. Today is St. John's day. During the night it clouded over and rained again; today there is a sultry west wind.

The meadows in front of our window are now mostly mowed. Everyone who could crawl helped with the haying. Frau Foerster, Babette, a younger brother of Babette's, and a worker whom they finally managed to obtain, were at work from five o'clock in the morning on. I awoke when it was still dark and heard the rustling sound of the scythes. Father, too, mowed until he was running with sweat. These are glorious days; we lead an ebulliently healthy life in the country day and night. A real St. John's time. But as soon as one tries to throw oneself wholly into it, the war leaps into one's mind.

For two days we went on an extra trip. We walked along the Main. It was lovely, lovely. When we arrived at Miltenberg, flags were hung out everywhere. We thought they were for a victory, but it was for Corpus Christi Day. We stayed in the ancient Gasthaus zum Riesen. Luther once stayed there, and God knows who else. When we looked out of the window in the morning, we were enraptured. *That* is how peace will probably be celebrated. In the narrow streets the long, gently waving flags, blue-and-white and black-white-and-red. From window to window swung garlands of the greenest pine boughs. The streets were strewn with grass and many-colored field flowers, and more and more were being scattered. All the small stoops leading from the houses down to the street were decorated with roses and pine boughs. And people were already going to church in their finery, the little girls—right down to the absurdly tiniest of them—in white dresses with wreaths of clover in their loose hair and carrying baskets of flowers. We watched the whole procession from our window. At the "Riesen" the street widens out somewhat. A picture of the madonna had been placed here, and the procession paused somewhat. All of it was so beautiful—the men's singing and the women's singing and the candlelight in the spring sunshine. But loveliest of all was the small troop of men in field gray who marched along, some leaning on crutches. One of them carried a skyblue flag with the inscription: Our German homeland. Then in my deepest heart I knelt with them and prayed and said thanks.

On the same day we passed through other small villages. Everywhere the same charming decoration. In one village they had placed birch branches along the whole stretch down which the procession passed, on both sides, so that it was like walking through a lane of tiny trees.

The evening before this we crossed the Main on a ferry and climbed up to Engelsberg monastery. Along the way the stations of the cross were cut into sandstone. These were all fairly new. On the top was a scene from the life of Christ. Below was the inscription: To the memory of —— who fell at Ypres in October 1914. On one monument was inscribed a sentence from the Bible: He opened not his mouth, for he wanted to be the sacrifice. The reference was to Jesus, and possibly to the fallen soldier as well.

All the days here have been lovely. But these two days of walking were best of all.

September 1916

My dear Hans! . . . I have sent Julius Hoyer a little volume of Moerike's poems. He wrote a long letter which must have been directed as much to Peter as to me. There was nostalgia for his happy friendship with Peter, and a longing also to go forward, a nostalgia for life. When he was a child—he wrote—he wanted to make a forest for his mother. There she would sit quiet and happy and he would sit in a tree and sing songs to her all day long. After reading the letter I thought of a passage from Moerike:

> My soul stands open like the sunflower to the sky,
> Leaning and longing and loving and hoping.

Then I dug up the volume of poems and sent it to him. If only he may be permitted to live to sing his songs and paint his pictures, the beautiful ones he imagines. You must hear him singing. He really sings like a bird in the woods—it all bubbles right out of him.

Oh, my boy, if only the war were over and you were here again and could live your life.

I have just reread your letter of August 28. Yes—memories! You in the barracks on Belle-Alliance Strasse and Peter in Neuruppin. Peter and Erich and Walter Meyer—all of them dead. When I sit here in his room, at his desk, and my memory of the boys is so vivid (I see their young faces, hear them laughing), I often feel very strange. Death and youth—the association is still incongruous.

And now the year is coming around to it again. For the second time. Our Peter—our beloved Peter.

And so I am back where I always am—with the war. The war and those who lie silent.—My dear child, goodbye.

September 1916

My dear Hans! . . . Now I also use *du* with Julius Hoyer and Richard Noll. To Erich I always said *du* in my thoughts, but that dear, familiar word never actually passed between us. Of all Peter's friends he was closest to me. But now I want to keep those who are still alive, and to love them. Since he went, I have not again seen Hans Koch. He is coming Monday and promises to tell us a great deal about a new league that is to be a continuation of the old one. He is very young and adaptable. That is good. Richard Noll is different, partly because he is six years older than Hans Koch. I'd like to come closer to him, too. You know that I am not especially attracted to boys like him. But that is not what counts. When I say *du* to him, I indicate my wish to come closer to him. I know I can abide by that wish. It is different from being faithful in a love affair when one is young; it is often hard to be that and one can scarcely promise it. The sort of faithfulness which I feel inwardly prepared to give him is something else again. He was a friend both of yours and of Erich's, and he will remain a friend. And so I shall be very thankful if he is trustful and open with me. He knows that no third person can ever be to me what you—my children—are. His own mother is still living and he loves her.

As for Julius Hoyer? I love him because he is so alone and remembers Peter with such a deep devotion. The fact that I try to be more to him than "my dear lady," which is what he always called me, gives him a feeling of warmth and of being at home. He lost his mother early, and the first person who ever offered him love was Peter. He is a profoundly modest person, shut up within his own emotions, solitary. I am happy that he will no longer need to feel so abandoned.

I wanted to tell you about this, my dear child. It seems to me nowadays that the most important task for someone who is aging is to spread love and warmth wherever possible. Life is so terribly hard now. Good-bye, my beloved, my son.

Yesterday, a Sunday, we were at the zoo with a little girl. A few weeks ago at night Father was called to a woman who had just died very suddenly. This little nine-year-old girl, and an even younger boy, were sitting beside their dead mother, quite helpless. Their father is at the front. Neighbors took the children in at first. The husband was sent for, and Father told the neighbors to let the man know that we would take the children for a while if he had nowhere to place them. The husband took the boy to relatives in Silesia, the girl to his mother-in-law here in Moabit. Then he had to return to the front. Shortly before he left he came here and begged us to take care of the child if he did not come back. We promised him we would, and half told him that we would take the girl in any case. But we have not done so yet and perhaps will not, because it is a very serious decision which must be considered with great care. I thought I could take care of any sort of child, because I imagined the factors of sympathy and antipathy no longer counted for much with me—although in the past those factors would have counted for a good deal. At the same time it seemed to us a sign from fate that the forsaken little girl's name is Trude Prengel. I should not have dared to take into our grave and quiet house a boy or a strong, lovely girl. But I thought that a pale little Berlin violet like this one, such a good, quiet little girl, would not miss much in our home.

But now I have seen the child. She really is a good, quiet, precocious little Berliner with pallid face, blonde braids and bright blue, somewhat sad and worried eyes. I recalled what Frau Kautsky used to say all the time: "I'd rather take care of three boys than braid one girl's pigtails." All the traits which belong to little girls and which have always been rather alien to me, are to be found in this little girl. I wavered, wondering whether she would not be and remain so foreign to me that I would be unable to feel any real love for her, in which case it would be no happiness for the child to be with us. For the present we have arranged it so that she comes here every Saturday afternoon and stays until Sunday after lunch.

She has a long way to go and so cannot return home alone on Saturday evening, and Sunday afternoon I like to be able to go somewhere with Father. I think this will work out best. In this way we keep an eye on her, which is

what her father was principally concerned about, and in the time which I keep free for her, I can really be helpful to her. I shall be writing you more about Trude Prengel soon.

<p style="text-align:right">Sunday, October 15, 1916</p>

My boy! What magnificent music I heard this morning. The *Missa solemnis!* What power! The *Credo* with those rocky, unshakable first notes and the mysterious *et incarnatus est de spiritu sancto ex Maria virgine et homo factus est.* Then the wonderfully resolved *Sanctus* and the close: *dona nobis pacem.* I read recently that Beethoven used to wander around the outskirts of the city like a madman, singing aloud, and once walked straight into a wagon and was given a good bawling out by the driver. I believe it. In spite of the painstaking work a musician must do, only two arts, poetry and music, give one the impression of direct divine inspiration and revelation. Has any picture or sculpture ever affected me like *Faust* or the *Ninth Symphony?* In music, too, the road from first conception to completion is a long one, the effort is at least equal. But the effect upon the audience is incomparably more intense.

On the thirteenth we had wonderful weather. Warm, springlike and sunny. I was on my way to the studio when it occurred to me that I would rather ride out into the country. So I did, and visited the Schildhorn heights again. Yes, that is really the place where my work must stand; I can scarcely think of another place for it. The old pine trees rustled. I sat there and thought about everything.

And imagine, I found the tiny, rose-red fringed pink blooming. I gave one like that to Peter when he went away. It was the only flower I could find in Wuensdorf. You see, there are always visible tokens of connections.

It was a year and a half ago that I began the work. After months of laboring over it, this summer I had spells of great weariness, and for the first time there came the thought: May I be unable to do it after all? Now that period is over. It was a sad time for me. I *will* be able to do it. A work which is meant to last for many decades cannot be done in a short time. I do not know whether I shall be able to show it in plaster at my big show. I am afraid not. But the big show will nevertheless prepare the ground for it; it ought to demonstrate that such a work is within my range. And then to go quietly

ahead and finish it. Of course I want to do more besides this work; I should be grateful if I were permitted to. But above all I must do this. I do not want to be called away before it is finished. I suppose that sounds very gloomy to you. But no—I feel well and strong. But you know: "It is still time . . . the night will come when no one can do aught." Alas, you make better use of your time when you do not take it for granted that everything will go on for countless years.

This year Reinhardt is giving a cycle of plays dealing with the soldier's experience. He began with *Soldiers*, by Lenz. The Lenz of the Storm and Stress period. It was interesting, but I did not really like it.

I am reading Tycho Brahe. Everything concerning Tycho and Kepler is very fine. How wonderful is this pure masculine love which Brahe feels for his "Benjamin." The rest strikes me as somewhat diffuse and does not interest me very much.

Good-bye, dear, dear boy.

<div align="right">

October 24, 1916

</div>

My dear boy! . . . Your letter of the 23rd. You speak of seeing his image before your eyes, wonderfully clear. It is so much harder for you, and for Father too, to keep him in mind. For all your work in the world takes you away from him. My work leads me back to him all the time. But he often recedes from me too. The best times are when I see him as you describe it.

Once we stood by his bed and I asked you whether you could believe in reunion. You said: Yes, as in *Faust*, as Faust is reunited with Gretchen.

After the terribly painful process of giving up hope for a reunion in the flesh, this remains. That we who love one another here will sometime be remolded into different forms. May there be a communion, a being together, then! And may there be—best thought of all—a sense of being together, a feeling of reunion, of having come home, of at least having one another again.

A verse by Silesius:

> *The spark is there in thee,*
> *Make room and give it air—*
> *By holy love and longing*
> *Thou canst make it flare.*

154

Burst forth, you frozen soul,
For May is on the way
And you'll be dead forever
Unless you bloom today.

My dear Hans! I want to sit down in peace and write you a good letter. . . .
The Eysoldts gave an evening of readings at Cassirer's. Not public; just for
invited guests. Father and I were invited. The program more or less centered
on the war. The first readings (Kolb and Daeubler) did not affect me. But
then Madame Durieux read a story by Leonhard Frank: *The Waiter.* In 1894
an only son is born to a waiter. The old story of working solely for the sake of
this child. The son goes to secondary school, is planning to go on to the uni-
versity. Then comes the war. The son falls. The father receives the slip of
paper with the familiar words. "On the field of honor" seems to him a phrase
out of a foreign language. Work becomes meaningless to him; he falls more
and more to brooding. And then, one day while he is waiting on the guests
at a trade-union dinner, or something of the sort, he finds speech. He begins
to talk, to clothe in stammering words his horror of the war. The people, all
of whom have been struck hard by the war, grasp his meaning. A wave of
excitement goes through them. As a body they leave the restaurant; others
outside join them. Soon there is a procession, a stormy group of people car-
ried along by passion. Someone cries, "Peace!" and the cry is taken up. A
vast shout for peace fills the street.

Madame Durieux read this with mounting passion and excitement of her
own. It was almost unendurable. I could scarcely keep control of myself,
and I felt that I was not the only one. When she had finished and her last
word, "Peace," faded away, someone in the audience called out aloud, as
though overpowered by a tremendous emotion: "Peace, Peace," again and
again. It was as if we were all swept up on the same wave. Then the light was
turned on and Frau Eysoldt came forward and read something else—but I
think no one listened.

There you have a peep behind the scenes. There you see the true feelings
of people who to all appearances are bearing the war well. And how about

those who have been utterly crushed by it? That is how all Europe feels. Everywhere beneath the surface are tears and bleeding wounds. *And yet the war goes on and cannot stop.* It follows other laws.

<div align="right">Sunday, March 11, 1917</div>

My dear Hans! I do not know whether Hauptmann's *Te Deum* is performable or not. Reading it alone is almost torture on account of the power, hardness and dissonance of its effects. Hearing it read aloud was maddening. At home I read some letters of Goethe. The fact is, I shrink from such painful impressions—I don't know what this new timorousness of mine bodes. But I think it arises from the instinct for self-preservation. I know and you know too what the war and all it has brought has done to me. If one wishes to live and work, it is only possible by fending it all off. I want to live and work while the daylight lasts. That is why I seek escape from the unbearable pressure. No, perhaps escape is not the right word. I do not want to shut my eyes, but to create a counterpoise to the horror, the pain. Even so, many times come when sadness weighs me down like lead. I must fight my way out of this grey despair and find purpose and calm in the daylight of work. There will be joys too—serious joys, but joys nevertheless.

<div align="right">April 16, 1917</div>

My dear Hans! The show is open. There was a preview from three until five. Two minutes before three I pasted labels on the pictures in insane haste. Then I fled. I have already heard some reactions from those who were there. This show *must* mean something, for all these prints are the distillation of my life. I have never done any work cold (except for a few trivial things which I am not showing here). I have always worked with my blood, so to speak. Those who see the things must feel that.

<div align="right">April 22, 1917</div>

My dear Hans! . . . You know how at the beginning of the war you all said: Social Democracy has failed. We said that the idea of internationalism must

156

be put aside right now, but back of everything national the international spirit remains. Later on this concept of mine was almost entirely buried; now it has sprung to life again. The development of the national spirit in its present form leads into blind alleys. Some condition *must* be found which preserves the life of the nation, but rules out the fatal rivalry among nations. The Social Democrats in Russia are speaking the language of truth. That is internationalism. Even though, God knows, they love their homeland.

It seems to me that behind all the convulsions the world is undergoing, a new creation is already in the making. And the beloved millions who have died have shed their blood to raise humanity higher than humanity has been. That is my politics, my boy. It comes from faith.

May 1917

My Hans—Perhaps this issue of the *Monatsheft* will reach you exactly on the 14th. I am sending it to you because there is an essay on my show in it. An essay by Lise which I like very much. That's all I've looked at in the magazine.

She makes a point which is for the most part ignored when people assert that my one subject is always the lot of the unfortunate. Sorrow isn't confined to social misery. All my work hides within it *life itself,* and it is with life that I contend through my work. It is difficult to express oneself clearly about one's work. At any rate I felt that Lise's conception is very close to mine. Which is after all natural.

July 9, 1917

My Hans. Among all the birthday greetings yesterday there was nothing from you. But today it came. Hans—thank you. What you say, what you write about my work, makes me deeply happy.

Yes, the day was a holiday. Different from what I earlier imagined it would be—since our fourth is missing. But I feel him nevertheless, see his dear, friendly smile. Father is here, and he stands beside me, firm in his love. And you, far away though you are, are here too. Ever-present to us.

And now the friends are coming. I never knew I had so many. So many

157

people who want to shake hands and say that I have meant something to them. My boy, you cannot imagine how many letters, flowers and telegrams there were. What an overwhelming response to my work, which I had done so quietly. Oh yes, Hans, I am deeply grateful for all that, and it restores strength to me. I still wish very much for the chance to say what I have not yet said. I consider it important. If only that chance may be granted me. But really, when does one stop and say: now there is nothing more to express? If only I may at least properly finish those works which are now so dear to me. I hope so, and am cheerful. But not to lose another one of you whom I love! And yet—even were it so, I should still have my work.

God grant we may stay together. In this world, for a while yet. As you write, we are always together, we four.

Father had forgotten the Gundolf book. I had unpacked the parcel, seen the book, but had not picked it up because I had a feeling it might be something for me. When your letter came today I ran up at once and brought it down in triumph. I am very happy to have it, my boy, and thank you from my heart. Now I shall read again, read, read. Goethe is a never-failing spring for me, always enriching. How much I owe to him!

July 20, 1917

Dear Frau Hasse! Of all the letters I received for my fiftieth birthday, your letter stands out. My heartfelt thanks. When you wish that all the good spirits of creative joy, love and peace of mind may be at my side, I must say a hearty Amen to that. Such wishes bring new strength, and I need strength. Everyone needs it. And people can help one another a great deal through their sympathy, through their thinking of one another.

I dearly wish that my health may stand up for a long time to come. Primarily in order to finish the work—to finish it well—which I am doing for my boy who fell in battle. But beyond that I have in mind many other things still to be done. Growing old is fine if one keeps strong and well. Today we celebrated Liebermann's birthday. At seventy he is wholly unbent; his last works are perhaps his best. May the same be granted to me.

But not to grow old and be an invalid.

Will you be coming to Berlin soon? If you do, you will certainly come to see me, won't you? Your Hanne is a joy to you, isn't she?

Your life is hard, I know—you have given me some glimpses of its bitterness and difficulty. But I think other times will be coming for you, when life will give you happiness as well as work and the satisfaction that brings. Let me return that one good wish to you.

With cordial regards.

For your birthday, 1918

Dear Hans! You were here three weeks and we talked over a great many things. And yet I have the feeling one always has at partings, of not having taken full advantage of the wonderful presence of those we love. Often my heart was full of the desire to say a great deal more to you, but the things remained unsaid. Yet the feeling underlying it all, my love for you, you certainly felt. And we also felt your love for us.

Your birthday. All the years past come to mind. You and Peter. The years of childhood—so simple; and then adolescence. Cares came. How could we advise you or help you? How many things one should have done differently. It is difficult to be an educator, because parents are never fully able to cope with themselves or are done with their own education.

And then the war years. The death of Peter and his friends. You going your own way alone—and not an easy way. Seeing us remote, far from you. We follow your progress with our eyes and our hearts, but still you must go alone. I am upheld by the feeling that you will be guided by a good star. Perhaps it is Peter whose loving eyes watch over you. It is not only the feeling that your life will be preserved, but also that your life will some day give you deep happiness.

The time is coming, my boy. My beloved boy, may it come soon. May you find someone to whom you can give yourself fully and who will love you fully. We—your father and I—love you as our child, our only child now. We would have laid down our lives for yours, and would have for Peter, if that were possible. But love of parents is one thing, conjugal love another.

159

I hope you may find a girl. Oh, I have many other hopes for you. For you and for us. Come again and live, then life will be open to you.

Till we see you again, beloved Hans.

<div align="right">September 17, 1919</div>

Dear Frau Hasse! Your card from Nidden reminded me that I did not write you at the time I learned of your husband's death. I tried to, but I was unable to. You know me better than some people who may see me more often, and you will be able to understand that. It is so terribly difficult to find words, the right words and truthful ones which help and do not hurt, in such matters and situations which involve the innermost core of two people's relationship. That is why I did not write—and only for that reason. Now you have come to Koenigsberg to recuperate. If only you were able to! Yes, the sandbar islands along the Baltic are terribly sad—someone who is already sad can scarcely bear them.

You use my professional title on your card—happily only in the address and not in the salutation. Please leave it out. It is something I never wanted to accept—I am opposed to all titles. But I was away while the matter was being settled and there were all sorts of delays in the mail, so that as it turned out I could not decline it without a great fuss, and the whole affair was too unimportant for that.

If you should pass through Berlin again, please come to see me.

<div align="right">Flinsberg, September 2, 1920</div>

Dear old boy—Welcome home!

Today we received your long letter from the Lofoten Islands. How good, my boy, that you've been seeing such wonderful things—how very good. Have you also found the clarification which was the trip's main purpose? Does one find that—when one goes out to find it—even though one travels through the whole world? On and on? Dear, credulous, silly boy! Believe me, believe old Goethe—how can one learn to know oneself? Never by introspection; probably only by action.

How will Berlin strike you? Probably as things strike me after we have

spent some weeks in the mountains: stale and attenuated and talky. But perhaps not. By the time we're back home you will have told Ottilie and Rele all about everything, and there won't be much left over for us.

Half of our stay here is already past, and we have had almost nothing but rain, so that we can scarcely get out. But it has rested us, and we make the best of every fine day. Yesterday we roamed around in the area for eight hours. It is beautiful here, but somewhat melancholy too. The paths along the crests of the mountains are lovely, with grand views. There are not so many tourists here; the bad weather has driven them away and we have it all to ourselves, which is what we wanted.

We will see you soon, dear Hans. We are happy to think of that.

For May 14, 1921

My dear boy! . . . Before I close I must tell you something about the landscape. Gronau nestles into this Central German hill country which you both know so well. It is fertile and serene, unbelievably serene. Often I am reminded of the hills around Florence. Take one of the many winding paths and you go uphill through a vineyard, or walk under walnut trees, and it is a joy to see how many things this same soil bears. Below us are grainfields, and amid the grain, fruit trees. And these flowery meadows make you want to burst into laughter. Everywhere the land rises and falls. To the West you see the Rhine plain, with the Cathedral at Worms swathed in mist, and uphill are the heights of the Odenwald, beautifully clothed in dense forest.

You know, it is best described by Goethe in *Hermann and Dorothea*—the part where the mother goes to look for Hermann.

Of course there are no snow-capped mountains here, but every segment of nature is perfect in itself and one does not miss the beauties of other regions.

August 23, 1921

Dear Hans! . . . Today I received a card from the Wentschers, from Greece. Frau Wentscher is simply in ecstasy. I wonder whether Father and I will ever get to take such a voyage. You know I don't really believe it, nor do I long

for it as intensely as I once did. My desire for external experiences has great-
ly diminished of late. It used to be that I thought such experiences might
help my work. Now that is no longer the case. Whether and how I am able to
work is altogether independent of this kind of experience. The readiness
forms in waves inside myself; I need only be on the alert for when the tide
at last begins to rise again.

[*no date*]

Dear Herr Bonus! Stolterfoth's essay has given me the greatest pleasure. The
man puts into words everything I have tried to embody in my work. It makes
me very proud to have been able to bring out things so clearly after all. . . .
I am very happy about the essay. He thoroughly grasps everything I had in
mind when I did the work. And I am also glad that he feels that *Trampled*
and the Women's Industries poster are sentimental. As far as *Trampled* goes,
I am still fond of the left part, where the man holds out the cord to the woman.
The poster I now find odious. But when I did it I was infatuated with it. If I
had had greater technique at the time, the print probably would have been
far more adequate. I was often in despair over how unsatisfactorily a good
drawing turned out when it was transferred to the copper plate. But please
tell Herr Stolterfoth this: The particular prints of the Peasants' War series do
not derive from any literary source. I had done the small print with the flying
woman, and the same theme occupied me for a long time. I hoped that some
day I should be able to represent it, to get it out of me. At that time I read
Zimmerman on the Peasants' War. He tells about "Black Anna" who incited
the peasants. Then I did the large print on the uprising of the peasant mob.
This one brought me the commission for the cycle. The rest were built around
this already finished print. Six prints are now finished. . . .

[*no date*]

Dear Herr Bonus! . . . My attitude toward it [a proposed introduction to a
book on Kaethe Kollwitz which was to be published by Reissner Verlag] is
negative from beginning to end. You are right about the parts you object to—
but the rest is awful too. My mind just goes blank when I hear such a string

162

of empty phrases. Couldn't you yourself write a few simple words? Why must people always talk in superlatives, or, as you say, grow rhetorical about the problems of humanity? And on top of it all the quotations of poetry! It's all much too much, and much too high-flown. I would be extremely thankful if you would stop the publishers. . . .

Third Day of Easter. Snow flurries.

Dear Herr Bonus! It was really at the last moment that your wife and I started to talk about Julius Rupp. By then it was too late for a thorough discussion. . . .

My grandfather died when I was seventeen, so that I knew him well and have a lively recollection of him. I respected him, but was intimidated by him also because I was a bashful child. Therefore I never had a personal relationship with him. My elder brothers and sisters, especially my brother, did have such a relationship. I had lessons in religion with him, along with the other children of the Congregation. I imagine his teaching went way beyond the limited horizon of most of the children, including myself. The instruction consisted of religious history, discussion of the gospels and of the Sunday sermon.

Not much was made of "our dear Father in Heaven." "God is spirit," and "I and the Father are one"—such of Jesus' sayings formed our religious sense. I did not love God—He was far too remote—although I suppose I felt reverence for Him. But it was Jesus I loved.

When I left home and came up with materialism, I revolted against everything that went by the name of religion. Heine's: "Here on the rock we build the church of the Third New Testament, for suffering, the suffering is spent" —you know it—became my creed.

For years at least. Although I thought that Grandfather's religious force did not live on in me, a deep respect remained, a respect for his teachings, his personality and all that the Congregation stood for. I might say that in recent years I have felt both Grandfather and Father within myself, as my origins. Father was nearest to me because he had been my guide to socialism, socialism in the sense of the longed-for brotherhood of men. But behind that concept

163

stood Rupp, whose traffic was not with humanity, but with God. He was the religious man.

To this day I do not know whether the power which has inspired my works is something related to religion, or is indeed religion itself. I am curious to see what you make of it. I know only that it actually is a power, or at least was one. As in everything else, I find that age is not good for much, that one becomes deafer and less sensitive. Alas, the higher up the mountain you climb, the less of a view you get. A mist closes in and cheats you of the hoped-for and expected opportunity to see far and wide. . . .

When you say that Peter enriched me—that too is true. I always had the feeling that he was helping me, especially in the past when I was working on the sculpture for him.

When he was seven years old and I was doing the etching *Mother with Dead Child*, I drew myself in the mirror while holding him in my arm. The pose was quite a strain, and I let out a groan. Then he said consolingly in his high little voice: "Don't worry, Mother, it will be beautiful, too."*

March 20, 1925

Dear Frau Hasse—Yes, you are right, it is a glory and a privilege just to live. And if your work goes badly, you need only remind yourself of Goethe's: "In times of slack do not drive yourself, for fullness and strength are never far off. If you have rested during the bad day, the good one will prove doubly good." I am used to long involuntary halts which drag on so wretchedly that I often think fullness and strength will never come again. And yet they do come, although in the measure that is the due of age. And *when they come*, I say as you do: how glorious, what a privilege!

With the warmest regards.

Mariakerke-Ostende, June 11, 1926

Dear children—Today is Georg's birthday. This afternoon we intend to have our coffee at Ostende.

* The letters included in this volume to Arthur Bonus and Beate Jeep-Bonus are taken from the book *60 Jahre Freundschaft mit Kaethe Kollwitz,* by Beate Bonus (Karl Rauch Verlag).

Day before yesterday we spent the whole day trying to get from Dixmuide to Ostende. We had given up Bruges for the present and wanted to leave by the street-car lines, but we had repeated bad luck with them. So we used the time to look up a nursery in Dixmuide and arranged with the man to plant a wild briar shrub on Peter's grave. The day of our arrival in Dixmuide we had ridden by railroad to Zarren. We were told that Roggevelde lies between Zarren and Eessen. Probably some village to one side of the railroad has that name, but the cemetery is close to the highway. We came to an intersection and asked the way, then turned to the left and had already gone past the cemetery when a friendly young man called after us and told us. The entrance is nothing but an opening in the hedge that surrounds the entire field. It was blocked by barbed wire which he bent aside for us; then he left us alone. What an impression: cross upon cross. Some of the graves originally had largish wooden crosses which the weather had ruined, and these had fallen over; but on most of the graves there were low, yellow wooden crosses. A small metal plaque in the center gives the name and number. So we found our grave; it is situated where I have placed the dot. We cut three tiny roses from a flowering wild briar and placed them on the ground beside the cross. All that is left of him lies there in a row-grave. None of the mounds are separated; there are only the same little crosses placed quite close together. That is what the whole cemetery is like, and almost everywhere is the naked, yellow soil. Here and there relatives have planted flowers, mostly wild roses, which are lovely because they cover and arch over the grave and reach out to the adjoining graves which no one tends, for to the right and left at least half the graves bear the inscription *allemand inconnu*.

Where I have made a circle in the drawing there is a kind of memorial. A short round column on a square pedestal, without any inscription at all. In itself it looks all right, but I would rather it had not been there. We considered where my figures might be placed. They could not go among the graves; the rows are too close together. There are two small unoccupied areas, but I do not think they would do there. Right at the entrance would be a possibility, but since the ground drops somewhat toward the highway and the cemetery extends out as far as the roadside ditch, you stand somewhat lower at the entrance and therefore do not have a good view over the whole cemetery. That would not be a good place for the figures. What we both thought best was

to have the figures just across from the entrance, along the hedge. A kind of garden plot has been laid out there, but it could easily be moved. Then the kneeling figures would have the whole cemetery before them. I am marking the place with small circles. The little square on the right marks a sort of memorial placed there by a regiment. It is a fairly high columnar affair. Fortunately no decorative figures have been placed in the cemetery, none at all. The general effect is of simple planes and solitude. Except for two small farms there is no house in the vicinity; it is situated in the midst of fields. Everything is quiet, but the larks sing gladly.

As we went on, we probably passed the very place where he fell, but here everything has been rebuilt. A short distance beyond the cemetery the highway drops toward Eessen; you can recognize the large area that was flooded at the time for defense purposes. Everywhere there are traces of the war, and there are more dugouts. In Dixmuide itself, along the Yser Canal, two places have been left just as they were. One is the Minoterie, where the Germans entrenched themselves; the other is the *Boyau de la morte*, the Belgian position. The Minoterie is where the mill stood. Now the ground is hollowed out by countless shellholes, and thrifty grass grows in the rises and dips. Goats and sheep graze there. It is horrible to see how the yard-thick walls of the dugouts are shattered. In this place alone the Germans are said to have lost 200,000 men in the course of the four years. Their trenches and the Belgian trenches were sometimes separated by only twenty, even ten yards. They have been closed up now and life goes on; only the Belgian dugouts and trenches, those bowels of death as they call them, have been preserved and are a sort of place of pilgrimage for the Belgians. As I've already written, the people have been kind and pleasant to us, but if you get into conversation with them about these four years, during which the town became a rubble heap, they blaze up and tell you with passionate gestures how the positions were fought over continually. "In and out—in and out."

On the ride to Ostende the picture is always the same. Dugouts, and here and there a cemetery with the monotonous rows of soldiers' graves.

Tonight I dreamed there would be another war; another was threatening to break out. And in the dream I imagined that if I dropped other work entirely and together with others devoted all my strength to speaking against the war, we could prevent it.

166

Dear Frau Sella Hasse! My warm thanks for your letter. Yes, you are right, I have been privileged to experience a great deal of happiness; and the burdens I have had to bear have been light compared with those of others. But Goethe says: Expect trials to the last. My life is not yet over.

What you have had to endure during the illness of your only child is frightful. I am terribly, terribly sorry about it. That is really all I can say. Yes, keep up your courage and smile when you are with Hanna. She must get well. I hope so with all my might. Let us clasp hands on that.

Sunday, July 28, 1928

Dear Hans—You and I are a couple of prize fools. We ordered a cupboard without measuring the doors. And so the cupboard comes along in a small truck, and it immediately becomes apparent that there is no way to get it upstairs, not even by taking it through the Hauffs' apartment. It will not even go into Ottilie's bedroom.

So we decided to place it in the room where the piano stands. But the only way to reach that room was through the locked door, and you have the key with you. None of the keys around, neither the Hauffs' nor the Fechters', fit this door. Sabine ran off to the locksmith who came and with the help of Dietrich opened the door. But then the passage was blocked by the stove, which projects out about three centimeters too far. I was in utter despair and suggested that the cupboard be taken back to my studio and I would have the small cupboard with the Academy mark on it brought out to Ottilie for the time being. The new one could be marked with the A and used for the Academy stuff until the day comes when you get an apartment with wider doors.

Then the carpenter hit on the idea of taking the doors off the hinges, which would give us a few extra centimeters. And that did it. The cupboard went through the other door too. Now we have moved the small cupboard away from the piano and put it in the children's room. The new cupboard stands between the piano and the wall, a veritable Greek gift. And now, Ottilie, you can scold to your heart's content. The language I used about Hans and myself wouldn't bear writing down.

During all this agony I escaped into the garden for a while, ate some berries and saw that everything needed watering. So I went out to your place again yesterday. The children had a grand time watching me struggle with the tap and the two hoses. Sometimes I got water in my face, sometimes in my shoes, but in the end I watered everything thoroughly, and shall go out again to do that in a few days. A small fruit tree had been pulled off its stake but not broken; I tied it up. Another tree ought to be propped. Some of the kohlrabi are already very large. Frau H. thought they would be turning woody and I told her to try them and to take them for herself rather than let them spoil. On your balcony the Polygonum is wrapping itself around everything like the Sleeping Beauty's briars. The little sour cherry trees are laden; the tree in front of the door has all the fruit eaten off.

I don't think it a good idea for you to have deadly nightshades right by the door. Or aren't they nightshades?

Glion. April 24, 1929

Dear children—Don't worry about us! In spite of cold, fog and even snow flurries not a day has passed without bringing something gloriously lovely. But today, ever since early morning, we have had real sunshine, and of the loveliest kind; not so that the mountains are suddenly exposed to glaring sunlight, but with the mists being drawn up and condensed into clouds or evaporated. The mountains are still unveiling, mysteriously and hesitantly; you still cannot tell whether some spots are snowy peaks or white clouds. And below, in the curious veil of mist which seems to hang over it almost always, is the wide, wide Lake of Geneva. Yes, we are very happy here in Glion. Below, in Montreux, I did not feel that I was in rapport with nature. Everything was beautiful, but proud and remote and arrogant. Here there are roads into lateral valleys with views of mountain meadows (Les Avants lies in a broad, open, grassy valley). Then, suddenly, a turn in the road and you find yourself once more looking up at glistening, snow-capped peaks. The view from up here is more limited, which is absolutely a comfort. The fog of the past few days hemmed the view in still more. Today, when its whole splendor lies uncovered before us again, it seems to me, I might almost say, more bearable, more intimate than it did at first. Rarely have I felt as I did at first here, that

I had no sympathy with nature; and the incapacity to feel nature makes one unhappy. It may be that nature here is too indubitably first rate. Too famous. Just once during the first few days in the Rhone Delta did I really feel close to it; but perhaps that had to do with the familiarity of the miles of flat plains there. Then, if you looked up and saw the white mountains shining down all around, it was wonderful.

Last night, to our joy, the mail brought the snapshot of our three school-child grandchildren. We are so very pleased with it, and thank you.

Here is a picture postcard which is fairly good. We see these mountains from our balcony, but they seem much lighter, not so heavy and oppressive.

This afternoon we intend to drive up to Caux and then walk back down to Glion, swinging in a wide arc. Keep well, all you whom we love. Heartfelt greetings.

Malcesine. For May 14, 1931

My dear boy—It is very nice that your birthday falls on Ascension Day. You will be having a merry time at home all day long, and in the evening, I imagine, you will have a bowl of punch out on the balcony or in the arbor. I can see all of you, and it makes me happy; I send you all the greetings of a cheerful heart. It was so good of you to send us the snapshots. How changed we will find the little fellow, Arne. And Peter's dear boy's face as he bends over the cart. It is good that there is so much to look forward to in coming home. . . .

What can I tell you about this place? As far as landscape goes, it is one of the most beautiful places I have ever been to, indescribably beautiful. For example, I open the door of my room—the open window is right opposite, and when I open the door the whole window is filled with blueness. Blue, blue, blue. Or when one of the large barques passes by and unfolds its ochre-yellow sails, the whole small room is bathed in yellow light. As you know, beauty can never be described, only felt by the fortunate soul who is able to see it. There are reminders here of Lago Maggiore and of Lake Geneva, but Geneva has more grandeur. Sometimes the lake is so turbulent that the waves roar like the waves of the sea. Even yesterday afternoon as we strolled down along the lake shore, walking now among olive trees, now over white stones (as at Fiascherino), although it was a perfectly windless day, the water surged as

169

high as the sea on quiet days. This pounding of small waves, this low gurgling and roar—it is all so beautiful.

For the rest, both of us are learning together how to ask for less and less in the way of activity. Ever less and less.

Whenever I see the roads climbing ever higher into the sunlit mountains, climbing on and on, the old cravings awaken. Formerly we could satisfy them. Now such things are no longer for us. Neither Father nor I can appease our longing, and in a sense it is fortunate that one of us has not remained vigorous while the other grew old. We are both old. But how lucky we are that we have been able to see this too. Together.

On the small terrace outside my window a party of Italians has settled down amid an incredible din to drink wine. Autoists, like people off the Kurfuerstendamm, loud and impertinent. But they are not talking in Berlin dialect and so their noisiness is amusing. Our greetings to you once more, dear boy—to all of you together. We think gladly of you; think gladly of us.

My wobbly handwriting is due to the awkwardness of my writing table.

February 1933

Dear Jeep! Has the Academy affair reached your ears yet? That Heinrich Mann and I, because we signed the manifesto calling for unity of the parties of the left, must leave the Academy. It was all terribly unpleasant for the Academy directors. For fourteen years (the same fourteen that Hitler has branded the "evil years") I have worked together peacefully with these people. Now the Academy directors have had to ask me to resign. Otherwise the Nazis had threatened to break up the Academy. Naturally I complied. So did Heinrich Mann. Municipal Architect Wagner also resigned, in sympathy with us.—But they are allowing me to keep my position until October 1, along with my full salary and the rooms I use. I am greatly relieved about this, because I have a largish group in clay over there and would have had no place to put it if they had evicted me straight off. . . .

1933

. . . Believe me, Bonus, when the author says that the souls of countless members of the working class were on fire for me, he should add that they un-

170

doubtedly would cool off if I were once more "restored to honor." I want to and must be among those who have been slapped down. The financial loss you mention follows as a matter of course. Thousands are going through the same experience. It is nothing to complain about.

<div align="right">1933</div>

Dear Jeep! . . . The Academy show has opened here meanwhile. That is, it has not opened, rather it has been ready to open for two weeks. But Goering, the second man in the State, has no time to open it right now. I was admitted after all and was delighted with the exhibition. You will see it in the winter. It is only sculpture—one hundred and fifty years of sculpture, down to the present. You know I wanted to have my group there, but they refused it. Instead they wanted the Mother figure that is in the Kronprinzenpalais museum, and the small bronze gravestone relief. At first I was angry that they did not want my new work; but it is just as well after all. It could not possibly have been ready in stone, and in the cement cast, as it is now, it would not have done at all. It is far from dry yet and looks horribly mottled.—

Yesterday, when I came into the old rooms and saw my own works among the many others, and that they held up, I was very glad after all. Participation is good and vital, and it is sad to be excluded. For one is after all a leaf on the twig and the twig belongs to the whole tree. When the tree sways back and forth, the leaf is content to sway with it.

The day before the opening of the show my two works, the Mother from the Kronprinzenpalais museum and the gravestone relief, were taken out. So were three works by Barlach. From this and from Rust's speech I could not help concluding that both pieces were going to be put away in the warehouse of the National Gallery. That is for outdated trash. In fact, I began to fear worse things. I was afraid they would remove my figures from the cemetery in Belgium. But with a curious lack of consistency, although the works were removed from the Academy show, they are to be on exhibition in the Kronprinzenpalais again. A sequence of decisions which is hard to understand. If only the sculptures may remain in Belgium in the place for which they were made.

<div align="right">171</div>

My dear, dear boy—I have taken your letters along to the studio where it is quietest. It is wonderful that you are in our old home and writing from there. No—Rauschen as it was you will never find again; that really belongs to the past. But the coast is mostly as it was, and the sea is indestructible. How much the sea meant to me. Lise and I were close as twins, and yet each of us made her first trip to the sea alone. After my marriage and your birth, when I went back to Rauschen again, I went down to the sea the first night. First on the ridges above, and then down, and I took off my shoes to feel the cool sand on my bare feet. I heard the roar of the sea and sat down and wept. Probably I would weep again if I went there; yes, I am weeping now, at this moment. It is not sadness, but even in memory the sea moves me so. Nothing else that I saw later on ever moved me so much; only Rauschen, the Samland seashore. Grandmother too went on dreaming about that in her later years. And the sunsets there!

Reinerz, for July 15, 1937

My dear Ottilie! Our practical presents, the two handbags, are lying on your birthday table. This post-birthday present that I am sending now, the cast of the group, unfortunately has not turned out well. For some time I have had the idea of giving you a very good reproduction of the group, and inscribing it: "The Mother—to the Mother—from the Mother." For there is a close tie between you and me and the work itself. I was working on this theme even before the war. Then everything else intervened. When I transferred from Siegmundshof to the Academy, I had a mold made and the piece cast along with the work for the soldiers' cemetery. But the piece had to be totally changed. For in the meantime the twins had come into the world, and ever since seeing you with a child in each arm I knew that I had to extend the work and have a child in it. And so the whole grew slowly until now, when it is finished at last. Now you know how intimately you are a part of it.—You Mother! I thank you from the bottom of my heart for all that you have given Hans and us. Not to speak of the children.

So for the present, until a really good reproduction of the group is made

—possibly in stone—take this one, and with it the print of the soldiers' wives beckoning.

And all my blessings for you and yours.

How you both will miss the two children today.

Now, after all this, I come to my thanks for your presents to me. I took seven of the best of Faasen's beautiful candles with me—he had sent them to me beforehand, to Reichenhall. With it the large life light which we have lit ever since July 8, 1931. In my room Father set up a table heaped with flowers. And there lay your presents. Ottilie, your beautiful warm woolen chemise for when more days come such as we had last winter; your lovely scroll on the motto of "Freut euch des Lebens"; Hans, your drawings of the children; Peter's absolutely marvelous carousel and the girls' equally marvelous quilt. And besides all that the Mediterranean book and your dear letters—so much beauty, so much work embodied in it all. I thank you from the bottom of my heart!

On the previous day Father and Katta walked down to town together and came back with very mysterious airs. Now two bottles of wine stand shining in their splendor, and a fountain pen that Katta gave me, with a merry bit of verse along with it. Katta, when she came over in the morning with Lise, had put on that beautiful long silk dress with the big flowers and the famous low-cut back. The four of us celebrated in my room with a wonderful meal (soup, trout, roast chicken and ices) and the bottle of champagne.

Then we rested, and then came the time for Lise's gift: We drove in a handsome automobile up to the Hindenburg hut in the mountains, taking the cake and the accordion along. It was glorious weather, the views down into the valleys and the endless woods so beautiful.

Then in the evening we lit the candles again—actually seventy of them—which Faasen had insisted on sending. A round plaque with a large seventy in the middle and all around it tiny holders for the tiny candles. We burned them on the balcony; they burned up at tremendous speed. In less than a quarter of a hour all the bright flames were gone. Then we were all tired and went to sleep, and when I awoke next morning I had a feeling of contentment: there, now I've leaped over the seventy mark!

I haven't mentioned all the letters and telegrams yet. So far some 150 have come; I stand and look helplessly at them. Among the telegrams are

ones from Hauptmann, Breker (Munich Memorial), Schmidt-Rottluff, Fech-ters, Jolbe, Leo von Koenig. Among the letters some wonderful ones. I am en-closing the letter from Owlglass—please save it for me—of the old *Simplicis-simmus;* also his poem to Hermann Hesse. That is actually the basic note of all the letters, and I am very happy about the deep and wide response my life work has had in Germany, and outside of Germany also. God knows, I can be happy about that.

Now I must close so that this letter will go off. Love to all of you, includ-ing the absent girls.

I hope you will enjoy the box of sweets. They were a birthday present, but we contented ourselves with looking at them.

For October 14, 1940

Dear Lise—I am not in favor of putting off birthdays, for they are *unique* days when one was "given to the world." And so I remember the fourteenth of October—your birthday and the day of Konrad's death—and send you my sisterly kiss. And thank you from the bottom of my heart, not only for how much you have helped me during these past weeks, but for all you have meant to me in this long life, in which we have gone through so much in common. And my wish for you is that you may master the seventies better, alas, than I seem to be able to do.

And here I am sending the magnifying glass. It was often useful to Karl and me, but I have another and I am glad that this one will be in your pos-session.

May 10, 1941

Dear Frau Hasse! Thank you! To begin straight off with my account: I have reason to be grateful for the way things are going with me. Naturally, that does not mean *well*—but passably. My health, which often is quite shaky, has somewhat steadied again, and since at the beginning of June I am going to Feldafing on Starnberg Lake for several weeks, I shall once more experience the joy of bombless nights, moonlight and starlight, and blooming nature. Of course, for the time being I am still here.

174

I am living along on the fringe of life. Since the fall I have moved my studio from Klosterstrasse back to my apartment. That more befits my present situation. Since my strength is greatly reduced—I can walk along the street only with the aid of a cane, and so on—I was able to go out to the studio only now and then. But here at home, where my working room is also my sleeping room and where I have everything I need all crowded together and handy, I can work whenever I feel strong enough to do so for an odd half hour. There are still so many things to be completed.—My sister visits frequently. About twice a week my son Hans comes, talks everything over with me and helps me in all business affairs.

All that is fine. From my eldest grandson, Peter, I have had good news. He was fortunate and came out of the Aisne campaign last year unhurt. For the present he is in his garrison at Frankfurt on the Oder. The two twin girls— now just turned eighteen—are also in a relatively happy period. Their parents have obtained permission for them to go on with their education for another year. One of them is working toward her apprentice's examination in the Karlsruhe school of hand weaving; the other is attending normal school in Wuerzburg. The youngest boy, who is ten now and a darling little fellow, has been moved with his whole class to Reinerz on account of the bombings.— So far, you see, all is well with me. Sometimes these days seem intolerably dreary. I miss my husband and at night often feel utterly miserable, as if I were about to follow him immediately. But there is nothing surprising about that.—Yet think of me as sheltered, more or less. My life has been long and rich enough, so that I am thankful to have been granted it.

Thank you again for what you have written me. Whether or not we see one another again—my heartfelt greetings.

July 9, 1941

Dear children! Now it is Peter's turn, and that is why I want to send you these greetings today. Yesterday was a fine day for me, with your letters and presents, many, many roses, and in the evening your telephone call. We drove out to Tutzing and sat and ate in a very pretty little inn down by the lake, where curiously enough we got very good baked fish. On the way home there was a full moon in the sky. The night before it had been even lovelier. The

moon has occasionally an unpleasant effect on me, but I am cured of that now, once and for all. I walked along the road that slopes gently upward from Feldafing to the forest. Where the sun had set the evening sky was aglow, and if you turned around you saw the full moon hovering in inexpressible calm and peacefulness above the last farmhouses. It was so beneficent; it gave one such peace, in the sense of Claudius' poems. And then, when I came to the Ruestov garden, the fireflies hovered silently around me.

[To her grandson, Peter Kollwitz]
New Year's Eve, 1941

Dear boy! Yesterday when Father rang up and told me that you were in the hospital with a light case of jaundice, I can't tell you how I felt. You are living and for the time being safe.

Keep your jaundice just as long as you care to.

Now, today, your letter of December 7 has reached me directly. You had a different Christmas from what you anticipated. With us it passed pretty much as we expected. Your parents, sisters and Arne were together. I sat with Kathrine and Fraeulein Lina by my little tree, with the candles burning quietly. The thoughts of all of us were somber. On the first day of Christmas your family came over from Lichtenrade to visit us, and once more the candles were lit and your little brother with his shining face and his chatter about the youth group helped us to be gayer.

Now your letter has come and has moved me very much.

My dear boy, how much they have meant to us, the Christmas Eves spent out in Lichtenrade with all of you. With what gratitude Grandfather and I always returned from them. Every word you write I thoroughly understand, and it proves to me that there is some factor beyond physical presence that goes on affecting people and developing them. Even during the times when alienation, a failure to understand, seems to have set in. How your grandfather loved you. How he worried about your coming back. Once I wrote to you that you must always think of him and of me together. If, fate permitting, we see one another and embrace one another again, you must think then that through me your grandfather embraces you—you, our beloved eldest grandchild.

176

So may it be—my wish is *that we see one another again,* and that the new year may bring progress.

<div align="right">

January 1942
</div>

Dear Jeep! Yesterday I had a joyful day. First, early in the morning came a note from Peter in Russia. He is well. Unfortunately we must reckon with his probable discharge from the hospital this week. There is no way of knowing whether he will be sent homeward first, or right back to the front. I still keep hoping it will be home. Then I have given the plaster relief to the stone sculptor and he can now begin his work. And today I have finished my lithograph, "Seed for the planting must not be ground." This time the seed for the planting—sixteen-year-old boys—are all around the mother, looking out from under her coat and wanting to break loose. But the old mother who is holding them together says, No! You stay here! For the time being you may play rough-and-tumble with one another. But when you are grown up you must get ready for life, not for war again.—The stone will be sent to the printer tomorrow, and if it turns out well, that will be one more thing off my chest.

<div align="right">

June 13, 1942.
Karl's birthday
</div>

Dear Lise—Yes, Georg and Karl, and in between the thirteenth of June, which we so often spent happily together. Life was good—you write—and in spite of all is still good! Well, yes—is it still? Certainly it has its good hours—for example today. Arne had a kind of intestinal grippe accompanied by only a slight fever, but with palpitations of the heart, so that I was much concerned for him. But now that is over, and seeing him today, again so absorbed in his games, in the little canoes he has carved, manned by Mohicans molded out of plastics, completely concentrated on his enjoyment of this free playtime, always singing—yes, then life is good again.—And that you are able to be over there, Lise, that's wonderful too. The little wooden cottage where Hennes slept is splendid, isn't it? I realized some time ago that I would not be able to go. Even here in Lichtenrade life is almost strenuous compared to my room in Berlin. Here, too, there's the constant wind blowing, and my leg exercises

<div align="right">

177
</div>

give me trouble. Nothing much comes of it any more; but here at least I can enjoy the sight of early summer. The cherries have set beautifully; the strawberries are beginning to ripen; the air is pure and much more rarefied than in Berlin. But above all it is lovely to have the children around. Ottilie is looking very well now. She works like a horse, and even in between whiles finds moments to work on her woodcuts, and makes good progress. How she has developed in the twenty-one years of their marriage.

Hans, when he comes home, almost always goes straight to the garden; Traute, the girl from East Prussia, is working in the garden too, so that there ought to be plenty of vegetables and fruit this year. Unfortunately they are having a dreadful plague of grubs. And really, what an enormous amount of work compared to the harvest. This young East Prussian girl is very nice. When she is wondering about something—and she is always wondering—she uses that long-drawn-out *mein Je* we used to hear in Koenigsberg. She's likely to be fetched back any day, but as you see she is still here.

From the girls we hear good news of hard work, but also fun. Only from Peter have we heard nothing yet. But the children think he can hardly be at the front already; probably he is in the process of being transferred and the silence is due to that.

Yes—I feel very good here, even though it is not the same as if I were at the lake together with you. Hennes told me that Frau K. has made up a nice package for me. That is so very good of her. Please give her the enclosed note. She is a person with such a practical bent, with no interest at all in theory, but a bright, sharp mind and a great deal of originality. I am very fond of her.

So, keep well, dear Lise. Give dear Katta my regards, too. And enjoy to the full everything that the lake offers you. Stay as long as you can; remember the kind of winter we are moving toward.—Your old Kaethe.

For October 14, 1942

Dear Lise—As we sat together in our stove corner yesterday and spoke of your birthday, I said I would write to you. And now I don't really know what to write. It was like this when we were one another's best playmates; we knew

178

each other so well, knew all about one another, so that we had little to say. Now too. Our sorrows, our wishes and our hopes are common to both of us. Yours are mine and mine are yours. When one or the other of us is gone, the other will feel a good deal poorer.

Lise, we will hope that we can remain together for a while yet, and experience a few more things that will be a joy to our hearts. And regards to Katta.—Your old Kaethe.

[To Georg Gretor, who was seriously ill]
Berlin. June 22, 1943

My dear Georg! Hans was just here and told me about your last letters and how he hoped to get permission to go out to see you. If only he can.

Georg, what you wrote about me moved me very deeply. Dear Georg, I too have been and am so very fond of you. You have always belonged wholly to us. Do you still remember how I came to get you and Peter at the Friedrichstrasse station, and how you slept that first night in the balcony room with Hans and Peter, on the green sofa? I know you cried that first night.

Do you remember how you once said to me: Frau Kollwitz, can't I take care of your household for you? And the time we were together in Voels and when we came to a road to Schlern and my husband said that tomorrow we would walk up to Schlern? You three were walking ahead of us with your long alpenstocks, and when you heard that you swung yourself up on your stick and swung your feet in the air for sheer joy. And once we went through a village and saw an open window and a peasant woman weaving at the loom. When she saw my husband and me, surrounded by the three of you and the Stern girls too, she said, "Brats enough, the darlings." Oh, Georg, what happy times we have had together. And our theatricals! Schiller's *Love and Intrigue* and the *Lower Depths*—it went on forever. And the dogs Pitti and Anatol! When you sat around the oilcloth-covered table, each of you with a book in front of him, and Pitti would sit beside one of you, his head peering out from under one of your arms and resting gravely on the table beside the book! And how we worried about Pitti when he was picked up by the dog-catcher again and you went to bail him out. And how afraid I was when you

179

two did not come home from Burg. You had missed the train. Woertherstrasse was quite dark, and I walked up and down it, terribly nervous, until at last I saw the two silhouettes, yours and Peter's.

Oh, Georg, how good it all was, and how the group increased later on. Heinrich and Gertrud and Hans Prengel's first wife. Yes, dear Georg, we all belonged together; we lived and enjoyed the good life.

For me the end is approaching, very much so. I have spells of melancholy, but the fullness and richness of our lives overwhelms me again and again with feelings of gratitude. Let us tell you once more how we all have loved you. If Hans can arrange to visit you, he will embrace you for me.

Do you still remember how it was said a comet was threatening to collide with our earth? Then each of us had to say what, in his opinion, was the most important thing for the last days, and you said that one ought to feel love more strongly than ever.

Warmest greetings to you, dear Georg. Thank you for what you wrote. Give my love to Esther, too. I am your old, faithful Kaethe Kollwitz.

July 13, 1943

Dear Nagels—Your news makes me happier than I can say. She has come, your little Lotte (I suppose that will be her name) and Wally is well and you are out of the witches' cauldron. And life will somehow take care of what comes next for you. On towards a better future. Clara, too, is overjoyed. I am off head over heels also. All four of us. . . . A wonderful, charming woman. Did not rest until she had us here, and we are as well off as it is possible to be. Otto, let us hear from you again soon. My best, my very, very best regards and good wishes to all three of you.

[After hearing that her house was destroyed by bombs]
Nordhausen, November 30, 1943

Dear children! I had already heard from Clara, whose card came astonishingly soon. Your letter did not come until today, Tuesday.

Yes, it was a hard blow to me at first. After all, it was my home for more than fifty years. Five persons whom I have loved so dearly have gone away

180

from those rooms forever. Memories filled all the rooms. And yet, Hans, you are right: the fate of one is merged in the fate of thousands. . . . What must Berlin look like now? Is Hennes' house still standing? These days one can expect only news of disasters. If only I could see all of you once more—that is my great prayer. . . . But there is also some good in the total annihilation of the past. Only an idea remains, and that is fixed in the heart.

Now I want to look again. I am going to set to work right away sifting through and signing the prints. Margret herself, Lise, Katta—they are all so good and capable and loving. If only I could see all of you once more. Yes, my dear boy, you too have lost your boyhood home with all its innumerable memories. But something new has been built, with everything in it except for the one loved one who will never return to you. I think of you, of the past and the present, with infinite love.

[Upon learning that our house in Lichtenrade had been destroyed]
Nordhausen, December 1943

Dear children! I hold Hans' letter in my hand, open it and find the news. Ah yes, such is our life; our fates are so entangled with one another. What is left now? Love that grows firmer and firmer. You must go on living. I too want to go on living in order to see you again. At least once more. Oh God, life is hard. Keep up your courage. And Ottilie, keep your studio. Courage!

Nordhausen, December 15, 1943

Dear children! I am glad you were able to salvage those few smaller things from the house—your table, the lovely rainbow picture, the lamp and the potatoes. Have the rabbits been rescued? Or was your comment on them only from memory?

No, I have dropped the curtain over the past, although sometimes I feel choked up when I think of all the things that are gone: all the pictures, the one picture of my grandparents I had, the picture of Mother with her firstborn in her lap—so much, so much. But I mean to look forward.

One more good thing. I was secretly appalled at the thought of Christmas. Now, without asking me, Margret has arranged my bedroom so that

the room will be quite mine. She has taken out the big double bed and re-placed it by a smaller one, put in a comfortable chair for resting and a good lamp for reading and writing. So now I have a room entirely to myself. I am sitting in it now as I write to you. Isn't that lovely of her?

Day before yesterday as we sat at lunch talking as usual about the short-ages and the difficulties of getting food, the sealed package from your Erna came—with butter and a fine chicken and such a sweet letter from her. You can imagine our joy. I am writing to her at once.

Nordhausen, January 1944

Dear Hans! Clara promised to let you know when I was not well. She wanted to keep her promise, but I objected so strongly that she had to obey me. Don't be angry, it was not her fault. Now I will give you a truthful report on my sickness. The night Lise went to Schwarmstedt with Regula, I had a spasm of the great artery which was terribly painful. But here too a kindly fate watched over me. Clara, who ordinarily sleeps elsewhere in the house, happened to be sleeping in the next room because the train had come in late, and so she heard my groans. She seemed like an angel to me when she suddenly opened the door. Then I felt protected. Next morning Doctor Brill came right away, and she has been giving me intravenous injections every other day.

Today I was taken to the armchair twice and sat up for a while.

February 4, 1944

Dear Otto and dear Wally! I am so very happy about your Sybille, who looks at me with eyes just like Otto's. How good that your child is in a safe place. Berlin is devastated. My own home went up in flames, after my principal works had been rescued with difficulty. Ten days afterward my son's house went too. Everywhere is the same boundless misery. Gerhard Marck's work has been completely destroyed.

Keep well and guard your baby.

Your old, no longer well and terribly weary Kaethe Kollwitz.

182

My dear children! We are sitting here—Lise and I—at my desk, a lamp beside us, writing, and now I should like to tell you a little about things here. Above all I should like to advise you very strongly to start Arne learning Russian. It is the hardest imaginable language to learn and he will have a big headstart if he begins now. Later on, no matter how everything turns out, he will have this headstart. Here the people are already preparing themselves for the Russians. Once Arne has a grip on the language, he will have that advantage at any rate. With the two countries bound to be so linked, knowledge of the language will be a great asset. So let him learn the language while there is time. He is still young enough to learn it with ease. Later on in life, it is said, it is virtually unlearnable.

I have heard an aphorism of Stehr's which I think very good. He says: Why, dying is only like turning over on the other side. That is good, isn't it? That is what it is: you just turn over on the other side. . . . I am *still* with you.

Nordhausen, February 21, 1944

My dear Ottilie! Your return trip must have been really frightful. Thank God you reached home at last. Hans must have been very upset; we are too far from the world out here. The airline still seems closer, but train connections now are terrible. And you have just had another bombing. . . .

The strength Gerhard Marcks has summoned up remains almost incomprehensible. Not only has his son fallen, but all his work has been destroyed; everything is gone and yet the man starts a new life. Where does all this strength come from? It is almost incomprehensible to me, what degrees of endurance people can manifest. In days to come people will hardly understand this age. It must have been like this after the Thirty Years' War. What a difference between now and 1914, when the severest blow of my life struck me. Then I thought I had the right to go on living for the sake of my Roggevelde sculpture. That was why the father and mother figures were done. Now, so few decades later, all that once more appears in a different light. People have been transformed so that they have this capacity for endurance. Germany's cities have become rubble heaps, and the worst of all is that every war

already carries within it the war which will answer it. Every war is answered by a new war, until everything, everything is smashed. The devil only knows what the world, what Germany will look like then. That is why I am whole-heartedly for a radical end to this madness, and why my only hope is in a world socialism. You know what my conception of that is and what I consider the only possible prerequisites for it. Pacifism simply is not a matter of calm looking on; it is work, hard work.

Whatever my old head works out is very fragmentary and unsatisfactory.

Nordhausen, February 29, 1944

Dear children! How pleasant and homelike it must be at your house when all three of you sit together and Hans reads Lenlein's lovely *Heiligenhof*—you know Lenlein was born blind. The *Heiligenhof* is a very fine book. I read it when it was first published in the *Rundschau*. And now Hans is reading it aloud, and your dear boy is still with you. The news from here is that I need less and less help from others when I go out, leaning on two canes, and I am keeping at it. So now on to March. It will bring severe cold, for from tomorrow on we have no more heating, but I will probably feel it least of all since I spend the greater part of the day in bed or in the armchair.

Nordhausen, March 1, 1944

My dear Hans—Of course it will be cold for us here, but not unbearable. We still have a stove with which we can heat. Anyway, what is most important is that before long we hope to have a room free.

I am sorry to hear that poor Leo von Koenig is so ill. He must at last be feeling his seventy years and more.

I have looked into the book by Agnes Miegel. I know that her ballads are said to be good, but I am somewhat annoyed at what she writes about Samland. To find everything so smooth and beautiful, as though only innocently beautiful and joyful things were subjects for poetry, when all of us together are on the brink of starvation and Germany will soon be in a state like that after the Thirty Years' War (see Grimmelshausen).

I have just been reading more of her book, and it is different from what

184

I thought after all. The landscapes are very beautiful; perhaps I have been doing her an injustice. In any case I shall soon return the book to you.

Lise and I are now reading the Zelter-Goethe correspondence. Goethe is remarkably reticent in this book. Zelter seems to be the really creative personality; and at the point we have come to now, where he is all taken up with the singing academy, he is again oppressed by his longing for Italy. It is remarkable that even such men as Duerer and Breughel could not free themselves of this longing. It was different with Goethe; for him it was a conscious flight and necessary to his development. But what did Italy have that was so important for Breughel? A queer phenomenon of the times.

I personally am well, as you can see from the fact that I am able to write again. The increasing brightness of the days revives one. Now goodbye, my dear children; my greetings to all of you.

P.S. I must come back to Miegel again, and take back all I said. I do not know why I had such a prejudice against her. The content too is good, much, much warmer than I thought. So do not be annoyed with me for closing my mind against her; I repent it now.

A few days later. Tomorrow the children will be going to Suhl in the Thuringian forest. Hans too will be going away in the next few days, so that it will be much quieter. No, I take back everything I said about Miegel. She loves East Prussia as we have loved it, loved our Rauschen. I still remember how we rode toward it on vacations; we would all stand up to see who would be the first to catch sight of the sea. The day of the declaration of war I bathed in the sea there for the last time. Soon after that Peter was dead, you came back. From then on there began, with comparatively brief interludes, war, war and always more war. For all of Europe, in fact for the whole world, for each new war gives birth to another. Until, as it says in Revelation, a new earth and a new heaven shall come.

A sweet postcard from Arne arrived today; I answered it at once. He says that the teachers are very decent and he can't complain. He is learning to iceskate. That is nice. . . .

You need not worry about me; I am under Lise's faithful care. Lise, the

indefatigable, still accomplishes wonders. She is everywhere at once; without her this place would be unthinkable.

April 1944

Dear Hans! I have just received the news that Leo von Koenig is dead. Someone else to whom I have written too late, although I knew he was very ill. The older he became, the better his work; his portrait of Hans von Marees in sickness, of his parents, of his father on his deathbed, and his portrait of me too, are all masterpieces. I can still hear the sound of his voice when he spoke to me over the telephone. After the split he was a member of the Secession under Corinth. A fine, steadfast personality. I remember one time when prizes were being distributed and how he could not stand Liebermann's way of declaring dictatorially that so-and-so would get the first prize, so-and-so the second, and so on.

Barlach would go hide himself around the time the train from Berlin came in. He would peep out and if there were any people parading up and down before his house in a suspicious fashion, he would duck back into his hiding place until the visitors had left. But Leo von Koenig was always welcome and spent many an evening with him. Then Barlach would bring up some wine from the cellar, and his dog Boll was always with them too. Von Koenig would certainly have been at Barlach's funeral, but he was traveling at the time. He never wearied of encouraging Barlach. Now this brave and honorable man is gone too.

For Hans on his birthday
Nordhausen

My dear Hans! I looked forward so to having you when you were about to be born. It is true that when you boys were small I did not have a "way" with children, as Ottilie has; but when your intellectual life began we got along pretty well. Especially when you yourself began writing—*Crambambuli* and suchlike. Didn't you once write a *Genoveva* also? I recall standing at the stove while you improvised away and I copied it down as fast as I could.

186

Dear children! Kollwitz week is now in full swing. The missing one stands before me, in that wonderful picture of him between the two of us—the picture you sent me, Ottilie, and which I love so dearly. He was close to his majority then, as the girls are now.

Ottilie, I am again delighted with your new woodcuts. How excellent the golden bridge is. With what fine technique, what a sure aim, it is done. And how wise of you to have built a roof over you which now protects you. . . .

I have just read your letter, my old boy, my dear firstborn. How I thank you for everything we have lived through together, and how I thank you, dear Ottilie. What great happiness we have had the fortune to experience together. Life has meant very well by me. Although, as Storm says: "If the heart should whimper now and then, raise your glass and drink your fill. For well we know it, you and I, that a sound heart no pain can kill." So my greetings to you, all my loves.

My dear children—Hans' letter has just come and Josef Faasen has just left. Do not misunderstand what I am writing today and do not think me ungrateful; but I must say this to you: My deepest desire is no longer to live. I know that many people grow older than I, but everyone knows when the desire to lay aside his life has come to him. For me it has come. The fact that I may or may not be able to stay here a while does not change that. Leaving you two, you and your children, will be terribly hard for me. But the unquenchable longing for death remains. If only you could make up your minds to take me in your arms once more, and then let me go. How grateful I would be. Do not be frightened and do not try to talk me out of it. I bless my life, which has given me such an infinitude of good along with all its hardships. Nor have I wasted it; I have used what strength I had to the best of my ability. All I ask of you now is to let me go—my time is up. I could add much more to this, and no doubt you will say that I am not yet done for, that I can write quite well and my memory is still clear. Nevertheless, the longing for death remains. . . . The desire, the unquenchable longing for death remains.—I shall close now, dear children. I thank you with all my heart.

Dear Ottilie! Thank you very much for the long letter. It is such a pleasure to me to picture young Arne, always whistling, always laughing, always in good spirits. It is natural to his thirteen years to surmount all difficulties like a kind of Robinson Crusoe. Later on the memory of these times will be of an adventure happily survived. But you! For you the words of the sonnet will remain in memory: "And armies of beggars kneel at shabby altars."

For life is so unspeakably hard now. Faasen writes that in spite of his unhealed wound he wants to return to his old group at Vitebsk, so that he can be with his comrades when they need him. Also he loves the sky there, the expanse of Russian sky. I hope he comes back.—Yes, Ottilie, cling to the rainbow. This year *must* bring the change. Frightful as Germany's fate will be, for the war to go on for still more years is the worst of all.

My thoughts are always with you, whether or not we have raid alarms here. But I am glad that Heaven has had mercy on poor tormented humanity and has sent us a few such lovely days. You too must enjoy them. And regards to your sisters.

Nordhausen, June 16, 1944

Dear children! The thought that I shall be able to see Arne once more makes me happy, and yet I do not know whether I ought to say yes to your plan. I almost think it is better for young people like Arne not to carry around the memory of a declining human being like myself. They will never shake off that impression. How differently he will keep me in his memory if he does not see me in my decrepitude. I wish I could give you an idea of my present condition. My memory is transparently clear. I can think back much more than fifty years and recall every person, every event. Every name comes to me, even names of people who passed casually through my life. Beginnings of poems come into my mind, and I can finish them, sometimes purely by rhythm. There is only one poem, by Matthias Claudius, which I cannot reconstruct. It is the lovely poem: *"Empfangen und geboren vom Weibe wunderbar . . ."* and ends: *"Dann legt er sich zu seinen Vaetern nieder und kommet nimmer wieder."* It is one of the most beautiful poems I know, in its profound, devout solemnity.

And then on the other hand there is my physical being, which grows more decrepit from day to day. For I am after all so old. Of course some people get even older, but I am near my 77th year, and that is old enough to give one the right to long for complete rest.

<div align="right">For Ottilie's birthday

[Nordhausen, July 1944]</div>

Yes, Ottilie dear, we had the boy between us, you and I. My thoughts are so much with you, and yet nothing comes of them. Were you able to save any of the things he made, from later on? We too had so many things of his, like the charming carousel, and nothing remains but a memory. All has become the past. And once I was able to give you a real present, like the little volume of Thoma; that too no longer exists. How can everything come to be past like this? It was a great joy, having Hans here. And in the not-too-distant future I shall see you again too. I am looking forward to that. So take only this greeting from me. It is little enough.

<div align="right">Nordhausen, July 10, 1944</div>

Dear Ottilie—Well, perhaps this birthday greeting will reach you properly. What a great joy it was, that you were here! And now Peter's day has come too, the Peter who used to be with us. The first cold winter out there, and then the summer flowers. How closely he was linked with you. You always said that he felt everything along with you. Oh, cling fast to whatever of goodness life still has to give you. For it still gives, and not only to youth, but to you, Ottilie, gives you greater and greater perfection in your work. How I love your beautiful prints. As always, I come to you with empty hands. But, after all, you now possess everything which is no longer mine.

<div align="right">Moritzburg, October 17, 1944</div>

Dear Hans! Have you reached home safely? Your visit, which took me completely by surprise, made me so happy that it helped me through the whole

night and banished the evil anxiety dreams. Give my love to Ottilie. How charming Arne's little note was.

I have not ventured out, even though it has become sunny once again. But soon I shall try again, and gently start to hope that I shall once more get better.

Greetings to all you whom I love!

Moritzburg, October 19, 1944

Dear Lise—What you have written me today about my work is so practical and good, and I am grateful to you for the impulse. Then I want at least to make the attempt to do some work on my own. Of course my eyes are getting pretty bad now; it is simply as if sight itself were gradually fading. What I cling to is the distant horizon; that does me a great deal of good. So I sit at the window and doze, looking out.

Perhaps there will be one more upsurge when the days start lengthening again.

I am very fond of what Juttel is reading to me out of *Wahrheit und Dichtung*. More and more I find that I really have not known Goethe. His wandering around his old home town of Frankfurt really has something in common with your and my aimless loafing. He was always with his sister. How he roams around everywhere, finding his way to poetry by winding paths as it were, until suddenly he is a poet.

Imagine, Erna Bittner who lives below us was once a pupil of mine. She will certainly lend me what I need, even a drawing-board. So that I really have no excuse other than advancing age. But I have known for a long time that there are many people older than myself. I need only think of our mother. My memory has become something mechanical. Thus today I recalled something long buried. Do you remember Goethe's *Novelle:*

> *For the Lord God reigns on land*
> *And rules over all the seas,*
> *Lion shall be tame as lamb*
> *And the waves He will appease.*

My dear Lise! Oh yes, the weather is brilliant, with a rare blue sky, but it is a shame your ride back was so bad. You know how I saw you in a kind of trance, with the grey shawl around you, standing outside, completely wrapped in it.

Oh, Lise, the parting was hard anyway, even though we cut it short. It seems to me as if some one waved after you, but I might be mistaken. The shawl is yours, remember that always. Only you are to wear it afterward. Lise, my dear, my dear, all my love to you. My greetings to your Katta.

November 1944

Dear Lise! We thank you very much for the apples. Was there meant to be a note with them, saying that you are coming here soon? I shall cling to that hope, for I so want to see you again.

This morning the oculist was here to examine my eyes. He said they will still do; if this and this should happen they will hold out for a while. Which is fine. Even though I may not be able to work any more—but on top of all to lose my eyesight entirely would have been very hard for me.—Jutta is working tremendously hard. On the whole she is bearing up well. I always look forward eagerly to the evenings when she reads to me out of Goethe's autobiography. That is delightful.

You will receive some nice pears in return. Katharina Heise has sent me a whole lot.

November 1944

Dear children! At last the sky is a little less dull and overcast today. I am sitting at the window where we sat together; the trees still have their lovely foliage. Meanwhile a fine electric stove has come from Beck; but unfortunately it probably does not take the type of current we have here.—Your letters cheered us; they sounded as though the war were ending at last.

Dear Hans! . . . Jutta has just come in. I suppose there is nothing else for it, but I feel sorry for the girl. What a dreary prospect for her, to spend the long winter months at my side. She has just brought in a glass of grog. We want to read *Wahrheit und Dichtung* together. So we will start now. The weather is dreary, rain and wind; I suppose it is the same for you too. If only the days would begin to grow longer soon.—Your old Mother.

Moritzburg, November 14, 1944

My dear children! I have not written for a long time and must tell you what I am doing now. I am imitating old Goethe, using Arne's calendar-diary to write down every day whatever the day brings me.

The shore opposite has lost its beautiful colors; the dammed-up water has grown stagnant and great flocks of gulls sit massed on it. The accumulated waters are being released now; they were kept dammed up because the whole lake had been rented for fishing purposes. My work consists now in faithfully following the course of each day and keeping an account of it. I note down how the clouds drift, which way the wind blows, and so I trace the course of the days. It provides me with a measure of contentment to keep accounts this way, for example: wind turning to such and such a quarter. Hans dear, if you have a compass you can lend me, it would make me very happy—I can't undertake any other work, and there is a systematic element about this which satisfies me. Often in the past I wished some day to be able to follow all the phases of an entire year. Goethe did this scientifically; I am now doing it in lesser fashion, but in my own fashion.

You or Father once gave me a diary of Goethe's, and I expected to get Heaven knows what out of it; but apparently his records, before being transformed into poetry, were the driest sort of thing imaginable. What else can I tell you about? That Lise's visit here will end Monday and I must bid goodbye to her now. That the Prince is coming soon and I want to show him my appreciation. His wishes are easily satisfied and I shall be happy to fulfill them. I intend to inscribe one of my works to him.

That Jutta is sweet. For a while I had the impression that the monotony of the work here was telling on her; but now she is the same as always and her reading aloud in the evening is as great a comfort to me as ever. What is Kathrine doing? Is she still on her walking trip?

Yesterday Jutta brought drawing paper from Dresden, and even some drawing materials, and we have made the following agreement. Every morning I am to drink a cup of real coffee; then on the strength of that I must get up and try to work a little. A very fine agreement, but unhappily my eyes have gotten very bad. The glasses no longer help me; I do better without them.

The day Peter died. I still remember as if it were yesterday how I came down the stairs from above and met Walter Koch coming up, and he then turned about and told Karl. Later we visited Hans Koch in the hospital. We had no letter from him, and even if there had been one, I would not have it any longer.*

It is nice that you are reading *Goetz von Berlichingen* with Arne.

I am sending along a few bills. For the present we have stopped entirely using the Goerner medicine, as an experiment. Tomorrow I intend to ask the doctor whether she can bring down my blood pressure somewhat; it is decidedly too high. Good-bye, my loves. Observe that I have had real coffee to drink.

December 5, 1944

Dear Otto, dear Wally—Many thanks for the snapshot; it is altogether charming and I have it standing here before me. The child has your eyes; otherwise she looks like Wally. You have given me great pleasure by sending the picture. How glad I would be if I could see her with my own eyes, but that is entirely out of the question. At any rate, now I have her picture. But I am afraid, Otto, that things are not so well with you. For me the long winter months drag along; it is good at least that the window where I sit looks out over a wide lake. My thoughts go back to many, many things that we laughed at together and sorrowed over together.

I send you my heartfelt love.—Your old Kaethe Kollwitz.

* Because of the destruction of her home.

Dear children—Now I have both your darling girls here, together; I am so very glad about it. Joerdis is just a shade darker than Jutta, both in appearance and in voice. How I love the two of them. But early this morning they made a terrible commotion. Never in all my life have I experienced such a housecleaning. My whole bed was moved. Everything, even a chest which did not properly belong to our apartment, was pushed around. But it is all over now. Then they began scrubbing away at my person—that too I survived. And now there is peace and Juttel is having a smoke as a reward. But for tomorrow, as a special Sunday treat, they've promised me castor-oil!

Fraeulein Rudert (you know her) has just brought in a wonderful freshly-picked bouquet of greenery; it gives the room a wonderful fragrance. The Prince was overjoyed at the prints I gave him for his collection.

Now, my darlings, all my love; half the winter, which I so dreaded, is past. Soon the year will be on the upgrade again.

Both the girls send their love. Keep well, my darlings.—Your somewhat more hopeful Mother.

Christmas 1944

My beloved children! All my love for this Christmastide. I hoped with all my heart that your wish for a Christmas tree would be fulfilled, for the children's sake. But there was nothing to be done about it. The Prince has no scruples about shooting any of the animals, but he does not want to touch any of his Christmas trees. So we must leave it at that.

Your Christmases are among the happiest times I—and Father—had. When Ottilie used to sit down at the piano and your boy's little hands rested on the keys in front of her, and you, my darling boy, sang: "God's Son— God's Son"—when the family was still complete—what happiness that was, The festivities went on and on.

Now it is all so different, so much harder. But it is such a joy to me to have your twins here; and who knows, I may still see Arne also, even though the trip out to here seems endless these days. But I shall not begin to think about that yet. All I want to do now is thank you from the very bottom of my

heart for all you have meant to us. All love, you beloved children, from your old Mother.

January 23, 1945

. . . Oh, my dearest Lise, everything is all higgledy-piggledy in my head—everything I have ever thought or dreamt or heard is all mixed up in it and whirling around.

February 2, 1945

My dearest Lise—If only I could see you once more while in sound mind. But I think I have already written you that everything is going higgledy-piggledy through my head. And you cannot possibly come. So take this one more greeting from me, if no more than that. Of what use is it to me if I grow as old as Methuselah and my mind is no longer there. . . . Good-bye, good-bye, you whom I love so much.—Your sister Kaethe.

You know, don't you, that dear Faasen has fallen, faithful to his comrades? Twice in a dream I saw him, his head thrown back, weeping bitterly. As bitterly as a human being could weep. I *had* to tell you about that. Each time he wrote: I know that we will see one another again. And now it's over.

February 1945

Dearest Lise— . . . You say that all my life I have had a dialogue with Death. —Oh, Lise, being dead must be good, but I am too much afraid of dying, of being terribly afraid at the moment of death.

Jutta is so marvelously kind; it is so awful of me to be such a burden on her, and yet I have no choice. Good-bye, my Lise; give my love to dear Katta. —Your old, old Kaethe.

February 1945

Dear Hans—If you can come sometime now, I have enough coffee at hand to gladden your heart; there will be coffee here whenever you come. Aside

from the coffee there is no news. It made me very sad to dream twice about Faasen, each time seeing his sorrowful, weeping eyes, weeping and weeping. Good-bye, my darling.

[*March 1945*]

My dear firstborn—I am very old now; am I to add still another year to my age? Every night I dream about you. I must see you once more. If it is really so that you cannot come under any circumstances, I do believe you.

But I must hear that from you yourself. Then give me the freedom to make an end of it. Then write to me: Dearest Mother, I cannot see you any more. For without having seen you one more time, I cannot go. My darling boy, if only I could see you just one more time.

April 16, 1945

My dear Hans, dear, dear parents. Sometimes the notion strikes me that some-one is coming, and then I think it might be you.

It cannot be, I know, but again and again the thought comes that I might be able to hold you in my arms, and then I would clasp you with such rejoic-ing.

I am told it is cold outside. Juttel has postponed her trip for the time being; perhaps she will plan it again for later.

The war accompanies me to the end.

> *Krieg ist das Losungswort,*
> *Sieg und so hallt es fort.*

How does it go on?

> *Traeumst du vom Sieges-Port?*
> *Sieg und so hallt es fort.*
> *Traeume, wer traeumen mag.*

Beloveds, take only this greeting.—Your very old Kaethe.

THE LAST DAYS
OF KAETHE KOLLWITZ

by Jutta Kollwitz

SHE had really been longing for death all the time. Night after night she dreamed that she had died. "And it was so good," she would tell me. But one morning when I asked her about her dreams, she said, "Just think, I again dreamed that I had died, and you can't imagine how terribly boring it was. Do you know the poem of Heine's: 'And I'm afraid, yes I'm afraid the resurrection will not come off so easily'?"

I rather think she did not really believe in a resurrection, at least not in a resurrection of the physical self. Peace, rest at last, that more than anything was what death meant to her and what she so longed for and awaited. She was so tired of life that she had taken death wholly into her existence, like an intimate old friend. Especially in the afternoons when she sat on the balcony with its fine view of the lake and the brilliant autumnal forest, her thoughts circled around and around this one point. Life was significant for her only in that it had a relationship to death. Any day could bring death; every day led her toward it. "Do you know the passage in Goethe where Wilhelm says to Ottilie, 'Come, let us talk about dying'?" she would ask, or she

would murmur her favorite phrase from the Revelation of St. John: "Blessed are the dead which lie in the Lord from henceforth. Yea, says the Spirit, that they may rest from their labors; and their works do follow them."

She no longer lived in hope of the approaching end of the war, no longer desired to experience this or that. She felt only a boundless weariness. But in spite of this, she retained her belief in the ultimate higher development of mankind—a belief which she stalwartly defended against all evidence to the contrary.

I recall a conversation I had with her in the fall of the year before her death.

"I am terribly sorry for your father because of his love for Germany," she said. "Here the second war is already lost."

I: "Don't you love Germany?"

"Oh yes, I love it very much, very much, but I love the new ideal more. Do you know the words of the Revelation: 'There will come a new time, a new heaven and a new earth'? And it will come.—I love Germany deeply and I know that she has a mission. But that mission is not to send all eighteen-year-olds into the field of battle. When we were in Nordhausen we read a book by a man who also loved Germany and who said that Germany would never be destroyed because she had to carry on something that would not exist without her."

She looked thoughtfully out of the window where the afternoon sun shone upon the gardens by the lake and made the red apples glisten among their dusty grey leaves.

"Do you see those lovely little apples out there? Everything could be so beautiful if it were not for this insanity of the war. Don't say, 'There have always been wars,' for you won't convince me. Wars, yes, but not *war*."

I: "You know someone once said that if there were no God, he would have had to be invented. Sometimes I think that it is the same with war. If there were no war, it would undoubtedly be invented."

"It would be invented, yes, and people would wage war as they have done for so long. But some day a new ideal will arise and there will be an end of all wars. Remember Conrad Ferdinand Meyer's poem about the 'royal race.' I am dying in this faith. People will have to work hard for that new state of things, but they will achieve it."

198

I: "You mean pacifism?"

"Yes, if by pacifism you mean more than merely anti-war feeling. It is a new idea, the idea of human brotherhood."

During the late autumn and winter she often sat at the window for long periods, observing the clouds. She kept notes in her large desk-calendar on the form and movement of the clouds, on the wind and the lake. I do not know whether she was overfond of the sun during this last period; it seemed too bright and hot for her. But she had a curious, tense relationship with the moon. On nights of full moon she suffered from sleeplessness and restiveness, no matter how carefully the drapes were drawn over the windows; and in the evening when the moonlight shone into the room in all its whiteness and inexorability, she would threaten it with her cane and call out to it a grudging, "Good night, old enemy."

Her relationship to things, to many old and familiar objects, was extremely intense. There was, for example, the mask of Goethe above her bed. She would feel it again and again with her fingertips, keeping her eyes shut. "Trying to orient myself," she would say. And she could become completely absorbed in looking at it. One evening she handed it to me. "Look," she said, "he doesn't look happy, does he? But I have long since got out of the habit of thinking of Goethe as a happy man. Though from the time I was fourteen he always has made me happy. Our parents had confidence in us; they left their bookcases open. We children could take out whatever books we wanted. I chose Goethe, and have stuck to that choice. I think I have read everything of his, except for scientific writings. I omitted them because to me Goethe has always been the poet."

"Could you say what of his you like best?" I asked.

"Everything, everything. Take this bit, for example: 'An old man is always a King Lear. . . .' "

After a few moments of reflection she went on: "No, he certainly was not happy. I am thinking of that marvelous correspondence between Goethe and Zelter which always gave me the impression that Zelter was the really creative personality of the two. Goethe worked and worked, but he rarely had the joyous intoxication of creation. Hardly ever in his later period."

After the mask of Goethe, she valued her cane. I remember distinctly that until Grandfather's death she never used a cane. But now it belonged to her;

it was hard to think of her apart from that stout stick in natural wood, with its curved handle. That cane was a faithful companion which had remained with her all through those last years. "Good fellow, faithful fellow," she would call it, giving it a friendly pat. Once she turned to me and said, "Juttel, I want the cane laid in my coffin." I did not reply at once, and she sighed. Later that evening she returned to the matter again. "You know, one often talks such nonsense. Of course I didn't mean that about the cane. But if any cane were to be buried with me, I would want it to be this one."

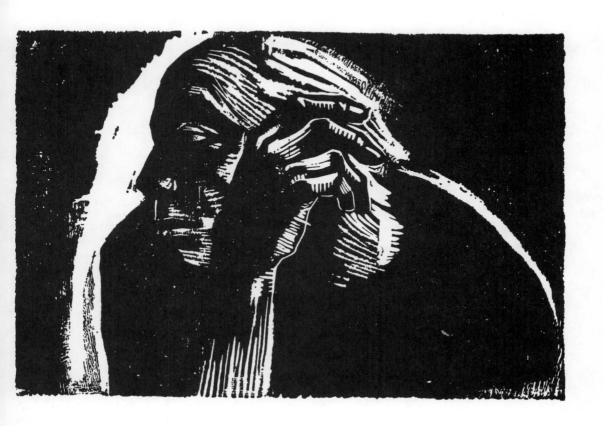

DESCRIPTIVE LIST
OF ILLUSTRATIONS

1 Self portrait. Early 1890's. 16.5 x 11 cm.

2 Consultation. Folio 3 of the series "The Weavers." Etching. 1895. 29.6
 x 17.8 cm.

3 Weavers. Folio 4 of the series "The Weavers." Etching. 1897. 21.6 x
 29.5 cm.

4 The end. Folio 6 of the series "The Weavers." Etching. 1898. 24.5 x
 30.5 cm.

5 Carmagnole. Etching. 1901. 57.3 x 41 cm.

6 Plowmen. Folio 1 of the series "Peasant War." Etching. 1906. 31.4 x
 45.3 cm.

7 Whetting the scythe. Folio 3 of the series "Peasant War." Etching. 1905.
 29.8 x 29.8 cm.

8 The assault. Folio 5 of the series "Peasant War." Etching. 1903. 50.7 x
 59.2 cm.

9 Prisoners. Folio 7 of the series "Peasant War." Etching. 1908. 32.7 x
 42.3 cm.

10 Head of a woman. Etching. 1905. 38 x 31.9 cm.

11 Self portrait. Etching (unfinished). 1910. 15.4 x 13.7 cm.

12 Cemetery. Lithograph. 1913. 46 x 36 cm.

13 Waiting. Lithograph. 1914. 33 x 24.5 cm.

14 Self portrait. Black crayon on gray paper. 1916.

15 Mother and child. Lithograph. 1916. 33 x 18.5 cm.

16 Return from the market. Etching. 1932. 19.5 x 12.5 cm.

17 Mother with child. Etching. 1910. 19.5 x 12.6 cm.

18 Beggars. Lithograph. 1924. 35 x 22.5 cm.

19 Woman offering her hand to Death. Folio 1 of the series "Death." Lithograph. 1934/35. 45.5 x 39.5 cm.

20 Self portrait. Etching. 1921. 21.5 x 26.5 cm.

21 Vienna is dying! Save its children! Placard. Lithograph. 1920. 93 x 56 cm.

22 Parents. Charcoal. 1920. 43 x 56 cm.

23 Parents. Folio 3 of the series "War." Woodcut. 1923. 35 x 42 cm.

24 Death seizes children. From the portfolio "Farewell and Death." Charcoal on gray paper. Before 1924. 49.8 x 36.8 cm.

25 Death giving comfort. From the portfolio "Farewell and Death." Black crayon on green-tinted paper. Before 1924. 49.4 x 37.4 cm.

26 Mothers, give of your bounty! Placard. Lithograph. 1926. 33.5 x 32 cm.

27 Never again war! Placard. Lithograph. 1924. 94 x 70 cm.

28 Children's court. Charcoal. Around 1925. 81.6 x 53 cm.

29 At the shrine. Sketch for a Lithograph. Charcoal. 63.1 by 45.1 cm.

30 The father. Monument in the military cemetery at Eessen in Flaunders. Granite. 1924 to 1932. Life-size.

31 The mother. Monument in the military cemetery at Eessen in Flaunders. Granite. 1924 to 1932. Life-size.

32 Mary and Elizabeth. Sketch for a woodcut. Crayon 1929 (?). 46.9 x 54 cm.

33 Death calls Konrad. Litho-crayon. 1932. 64.5 x 48.2 cm.

34 Mother with children. Charcoal. 1932. 64.4 x 48.3 cm.

35 Death snatches a child. Folio 3 of the series "Death." Lithograph. 1934. 50 x 41.5 cm.

36 The call of Death. Folio 8 of the series "Death." Lithograph. 1934/35. 38 x 38 cm.

37 Self portrait. Bronze. 1936. 36 x 28 x 23 cm. (without stand).

38 Dr. Heinrich Braun. Crayon. Before 1927. 48.1 x 48.8 cm.

39 Barlach on his deathbed. Crayon. 1938. 47.8 x 53.5 cm.

40 Study for a sculpture. Litho-crayon. 40.6 x 28.2 cm.

41 Mother protecting her children—"Seedcorn must not be ground." Lithograph. 1942. 37 x 39.5 cm.

PLATES

THE FOLLOWING PLATES WERE PRINTED BY VERLAG GEBR. MANN, HAUPTSTRASSE 26, SCHÖNEBERG, BERLIN, GERMANY.

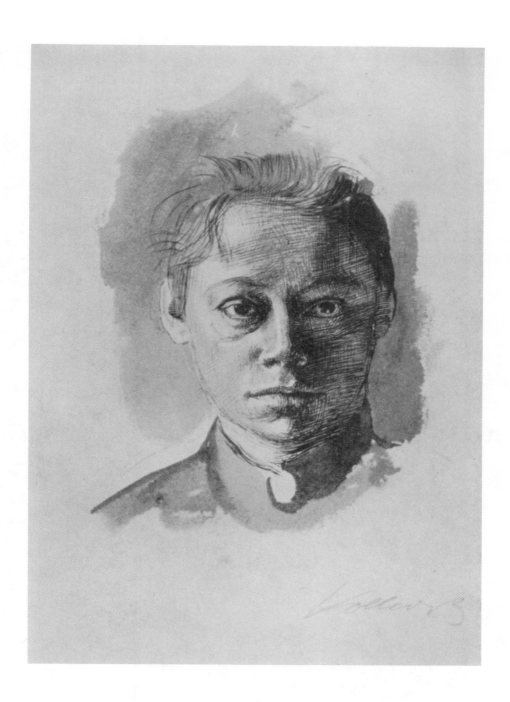

1 Self portrait

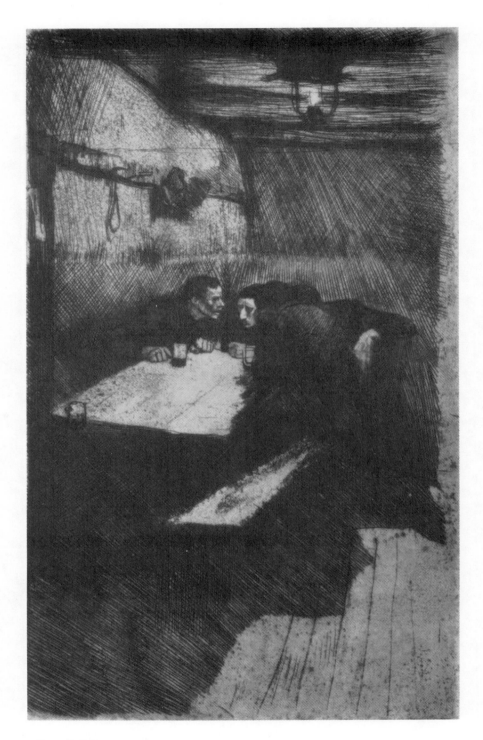

2 Consultation

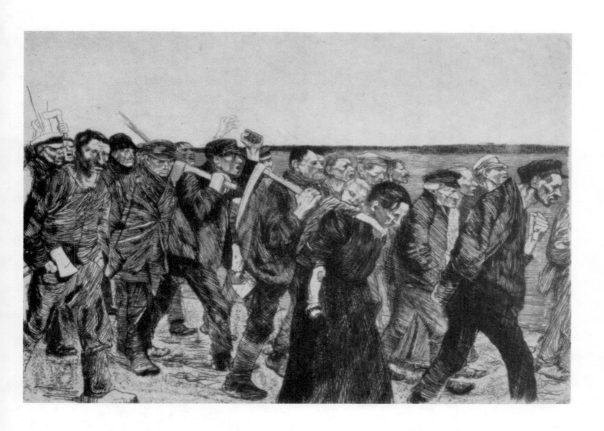

3 Weavers

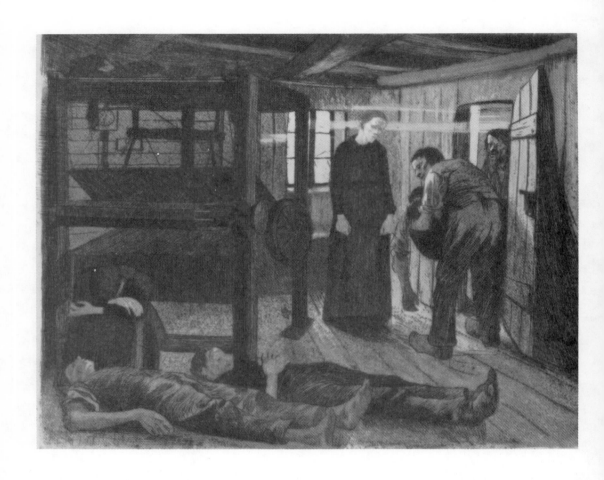

4 The end

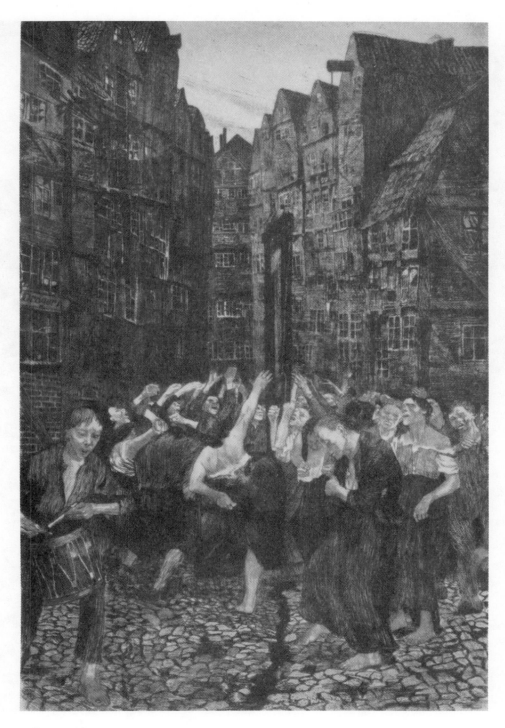

5 Carmagnole

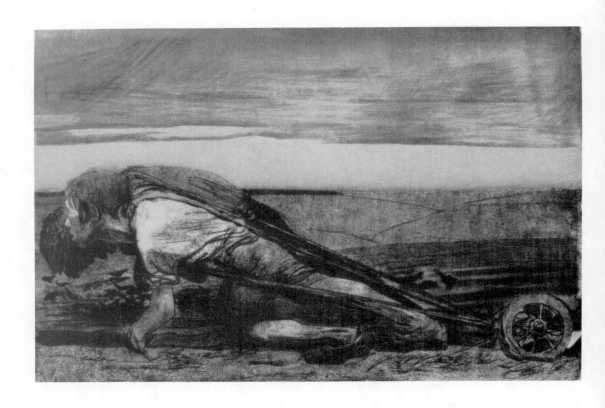

6 Plowmen

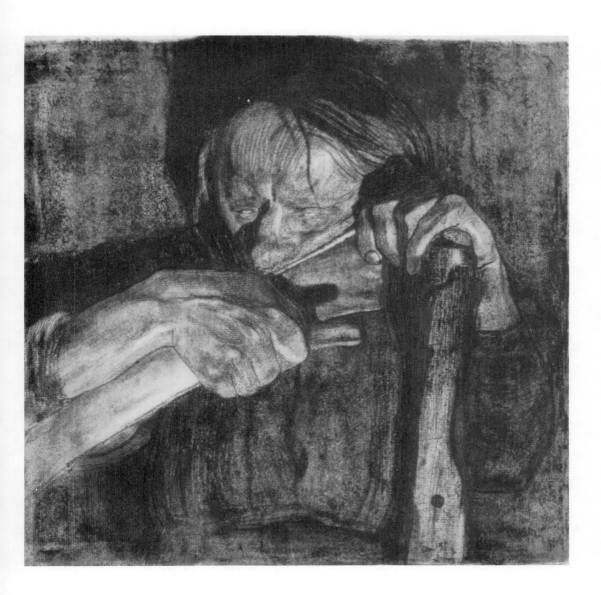

7 Whetting the scythe

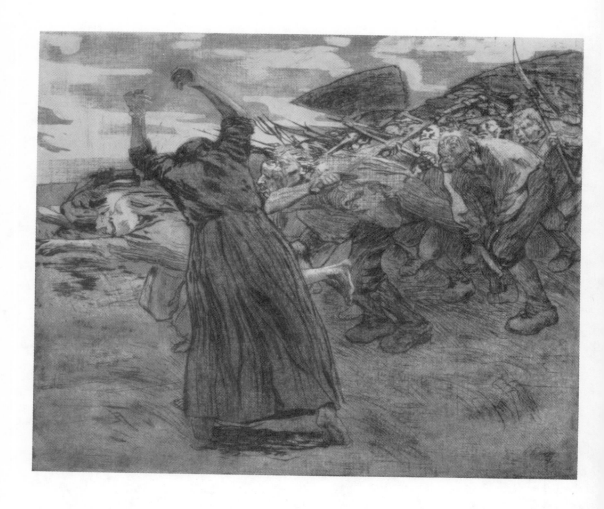

8 The assault

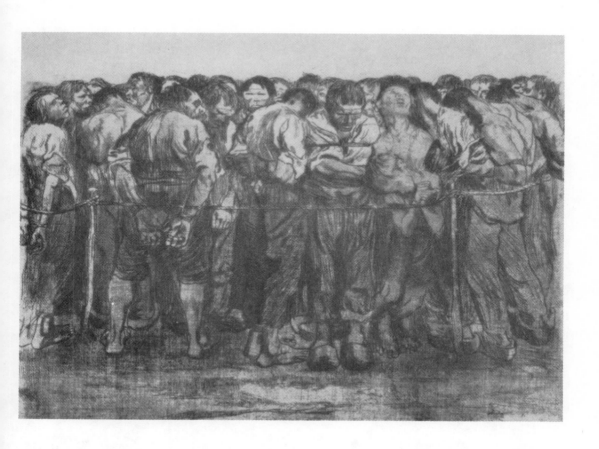

9 Prisoners

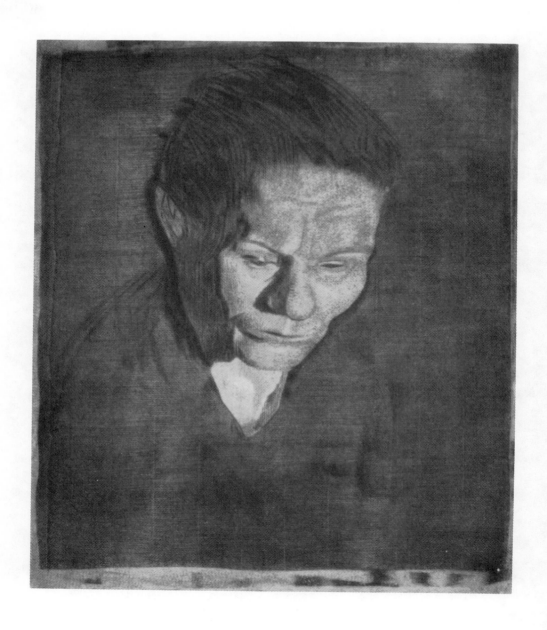

10 Head of a woman

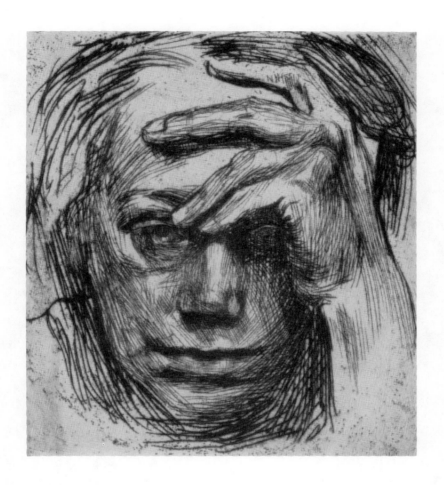

11 Self portrait

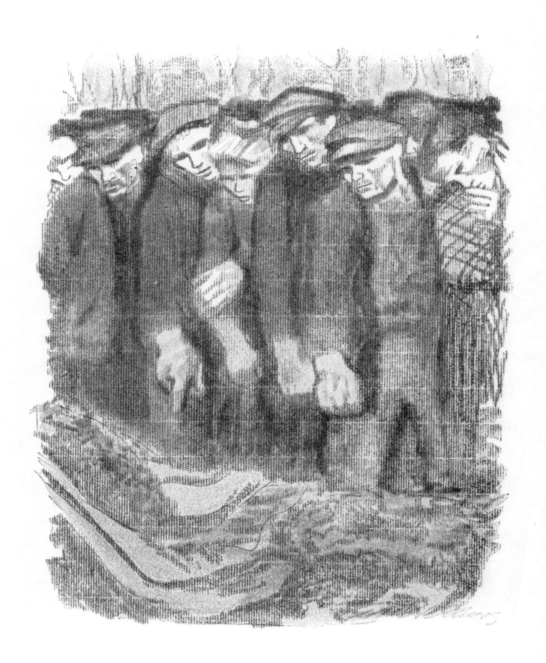

12 Cemetery

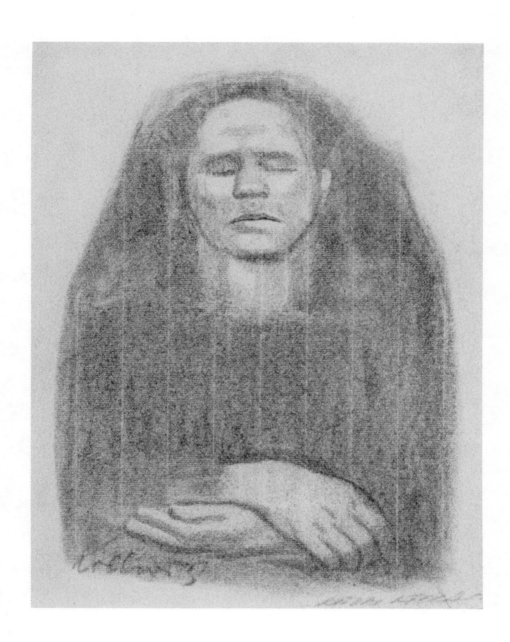

13 Waiting

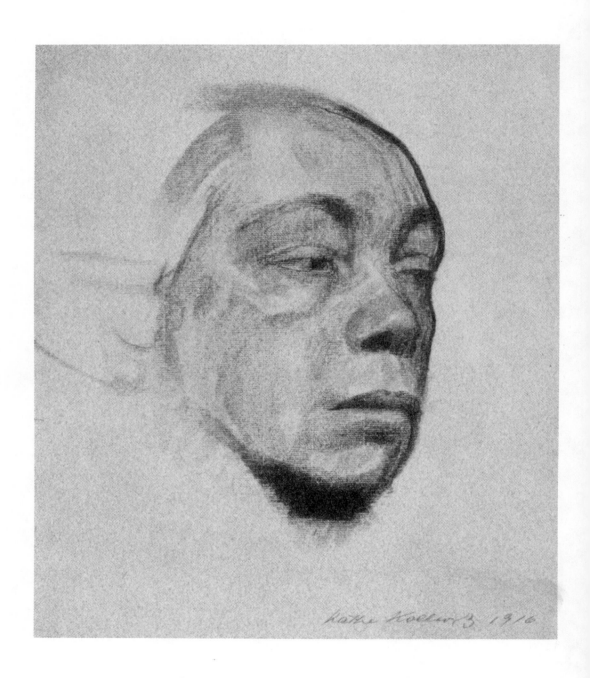

14 Self portrait

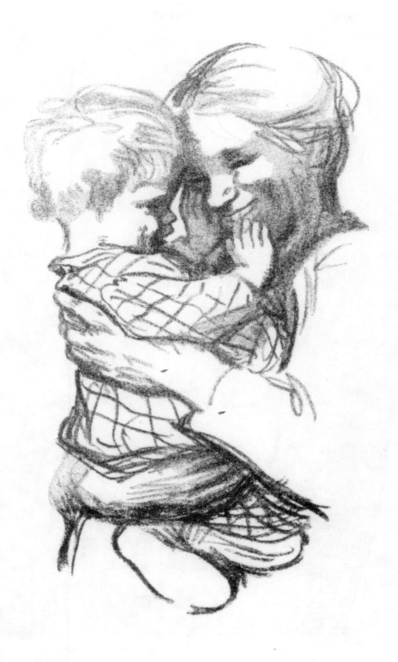

15 Mother and child

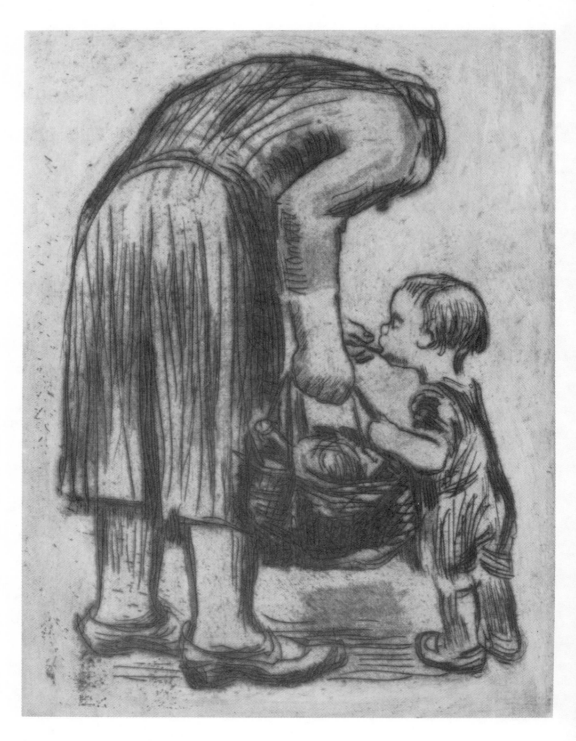

16 Return from the market

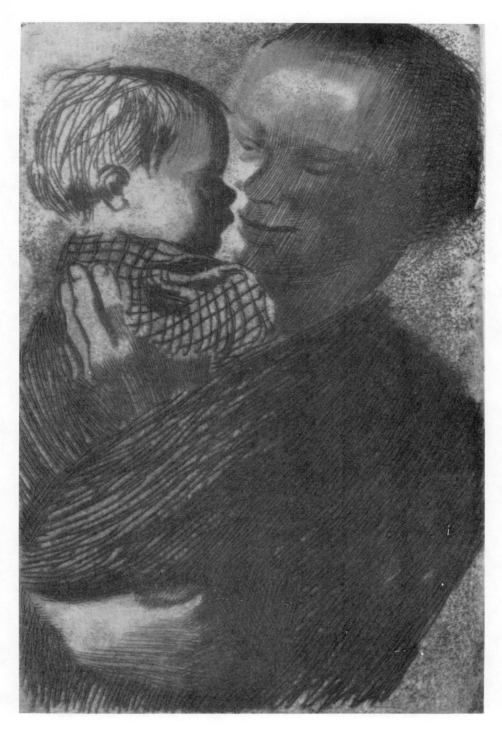

17 Mother with child

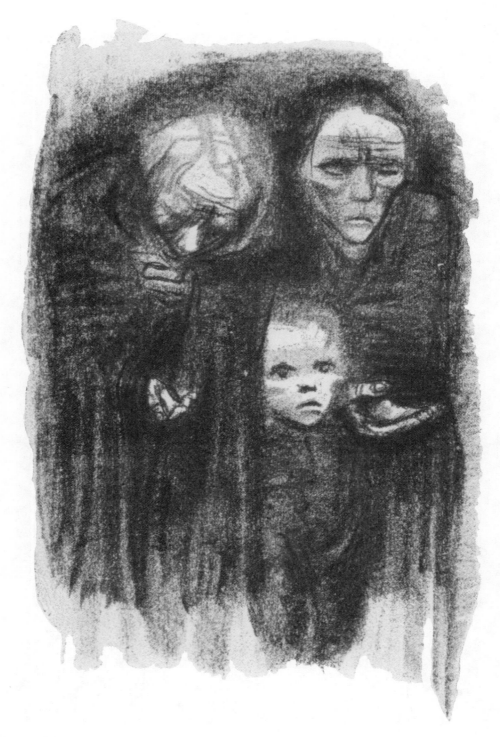

18 Beggars

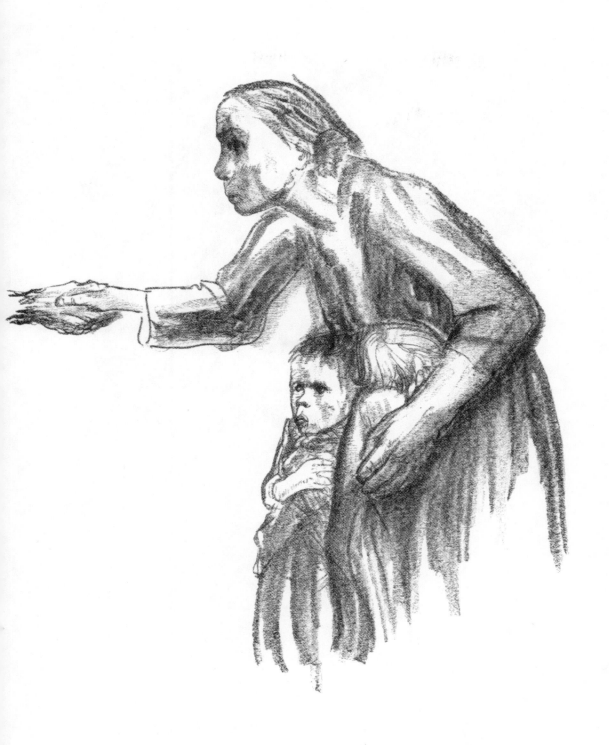

19 Woman offering her hand to Death

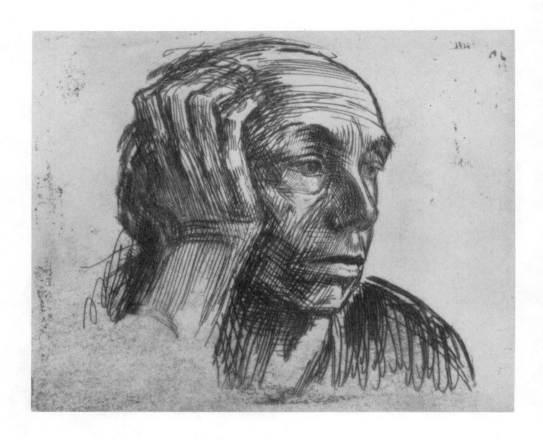

20 Self portrait

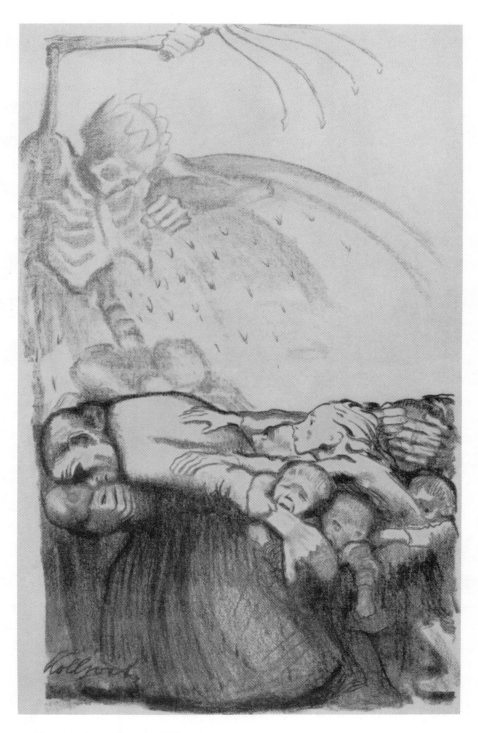

21 Vienna is dying! Save its children!

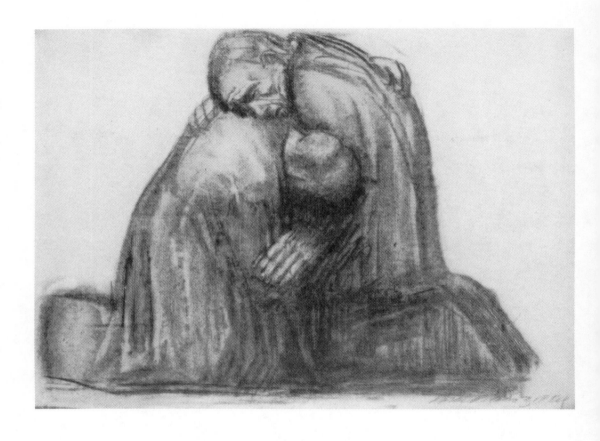

22 Parents

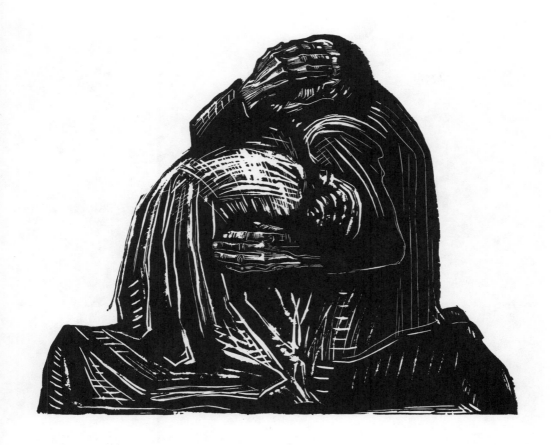

23 Parents

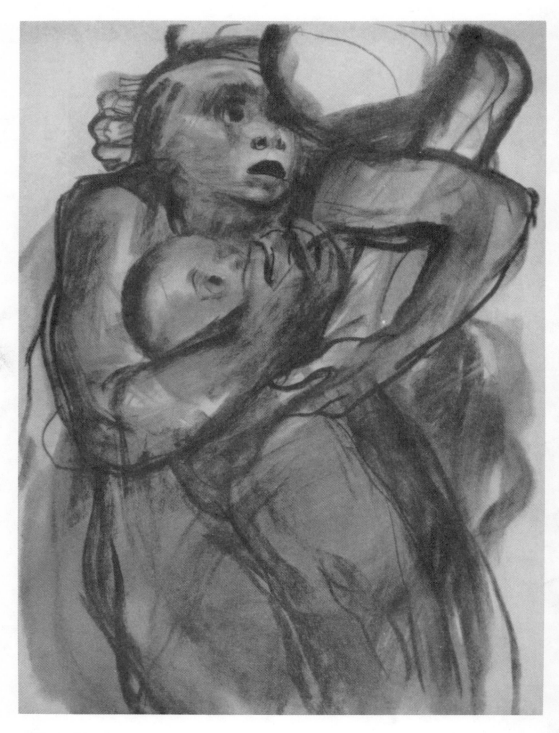

24 Death seizes children

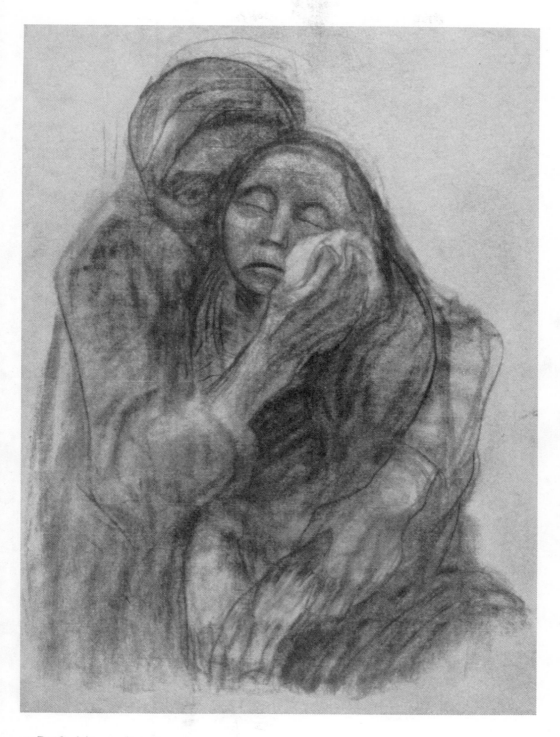

25 Death giving comfort

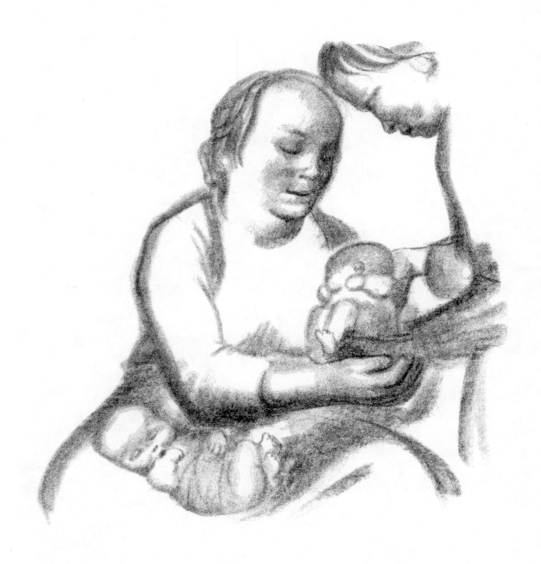

26 Mothers, give of your bounty!

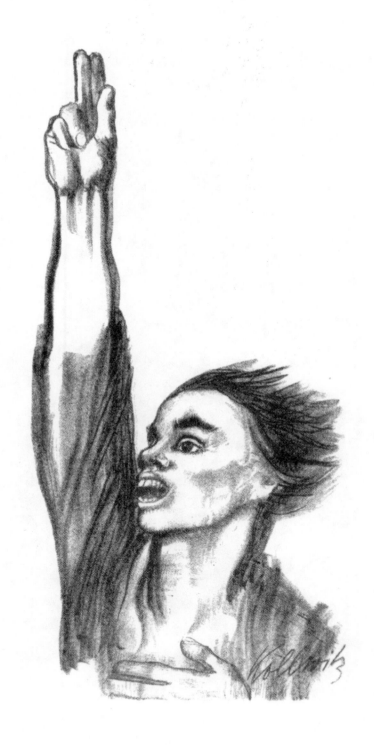

27 Never again war!

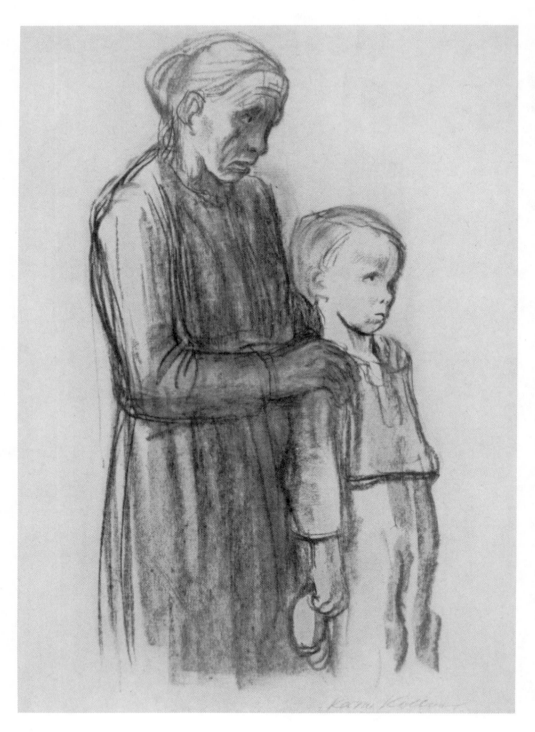

28 Children's court

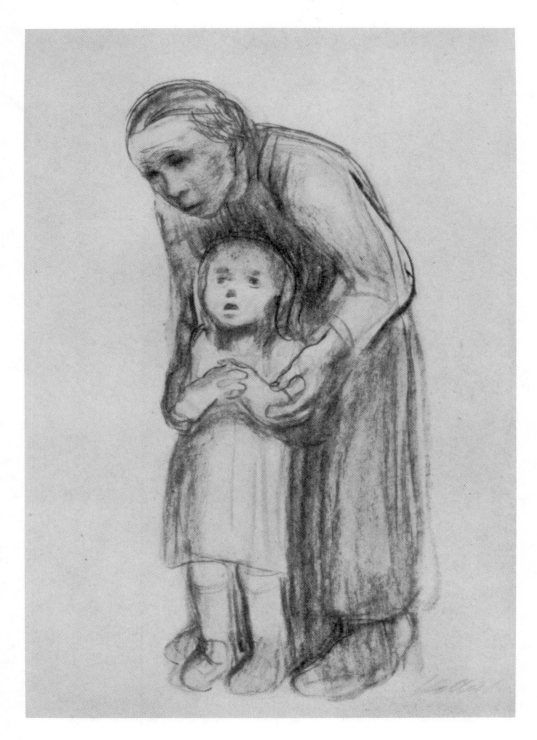

29　At the shrine

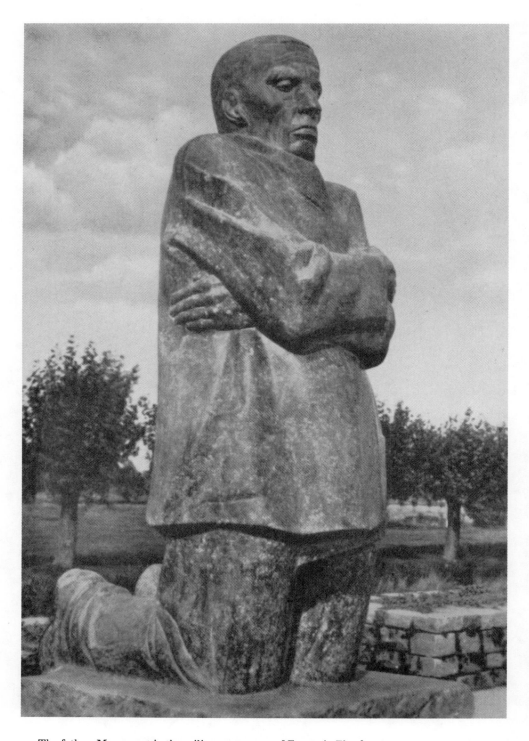

30 The father. Monument in the military cemetery of Eessen in Flanders

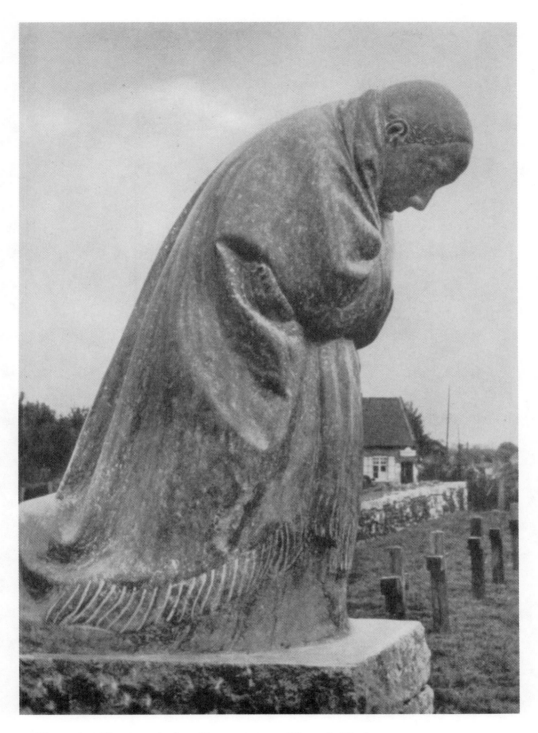

31 The mother. Monument in the military cemetery of Eessen in Flanders

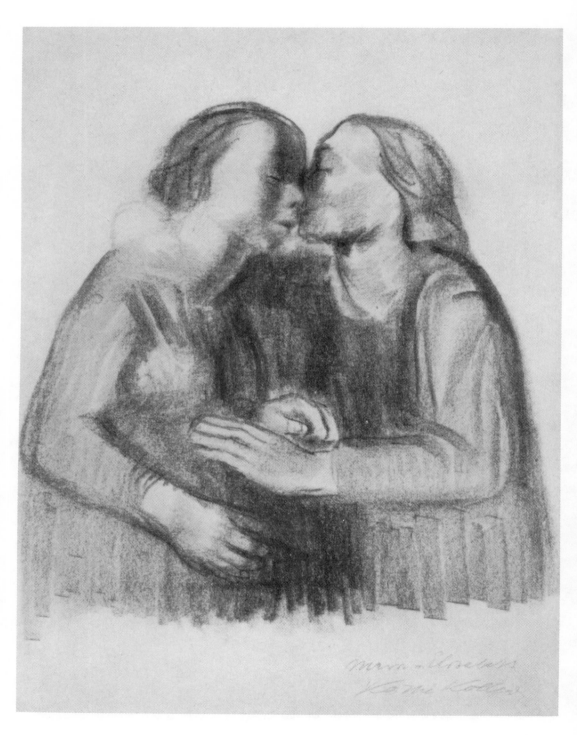

32 Mary and Elizabeth

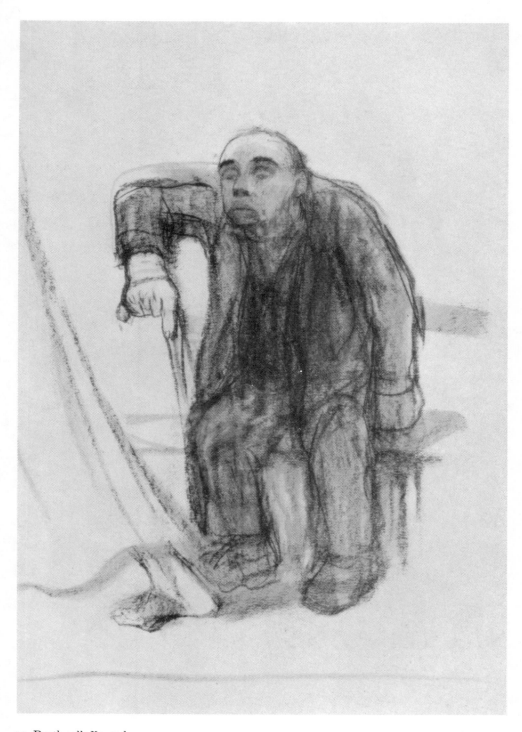

33 Death calls Konrad

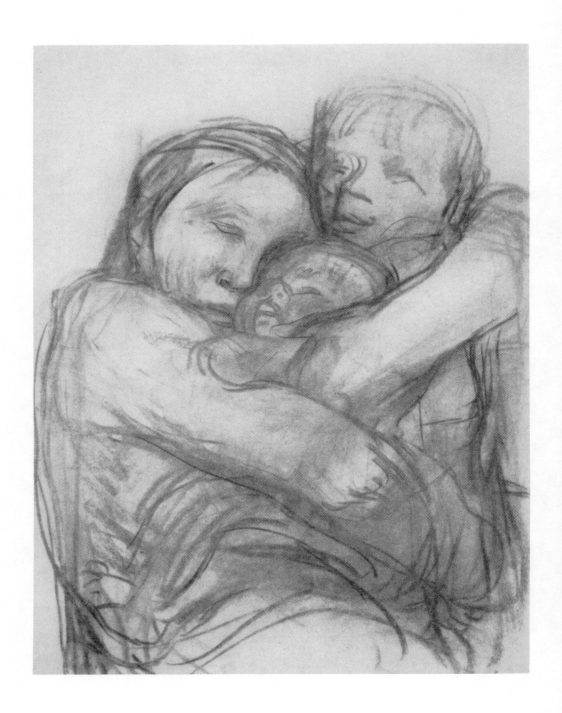

34 Mother with children

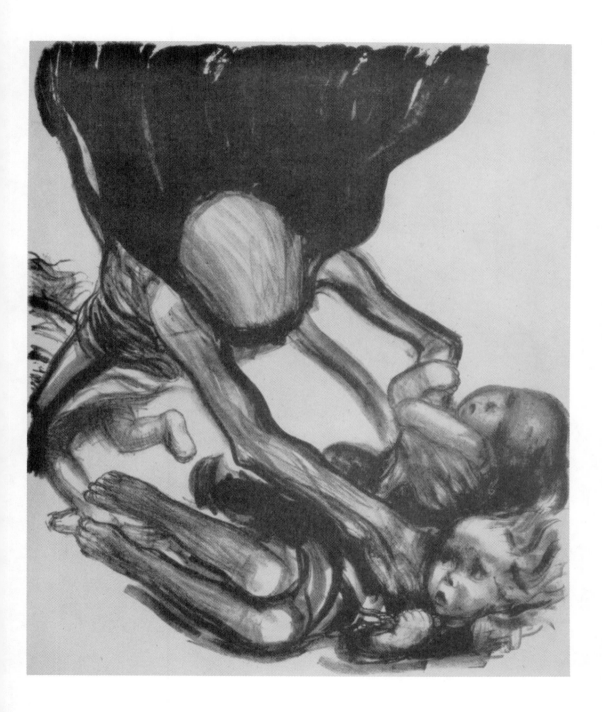

35 Death snatches a child

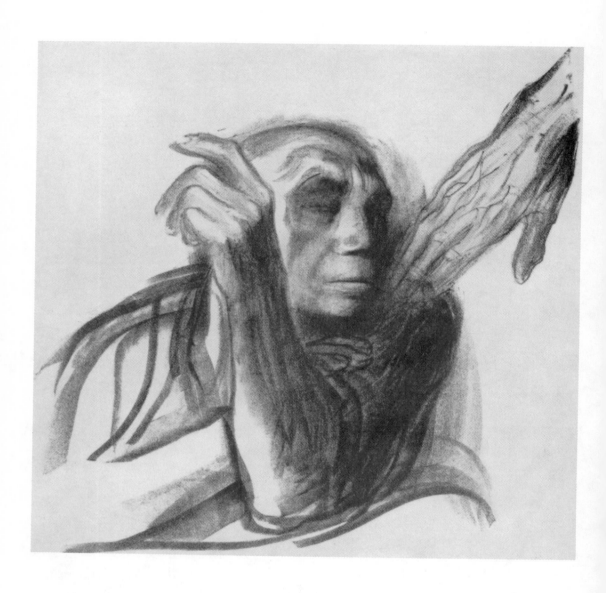

36 The call of Death

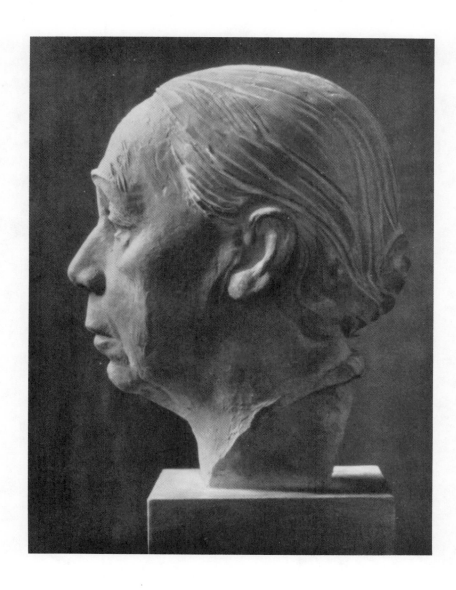

37 Self portrait

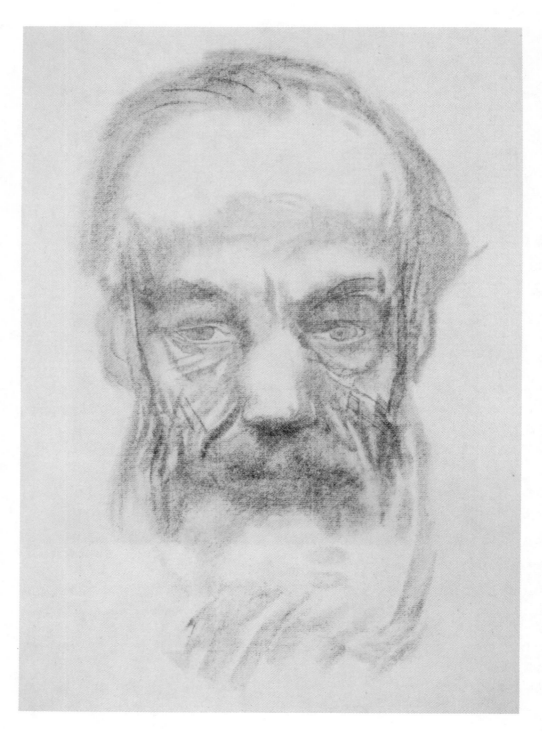

38 Doctor Heinrich Braun

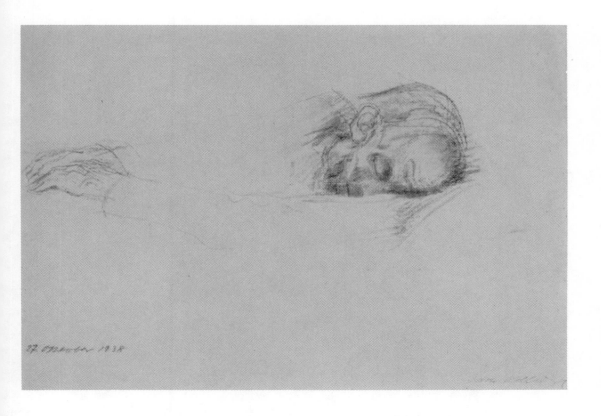

39 Barlach on his deathbed

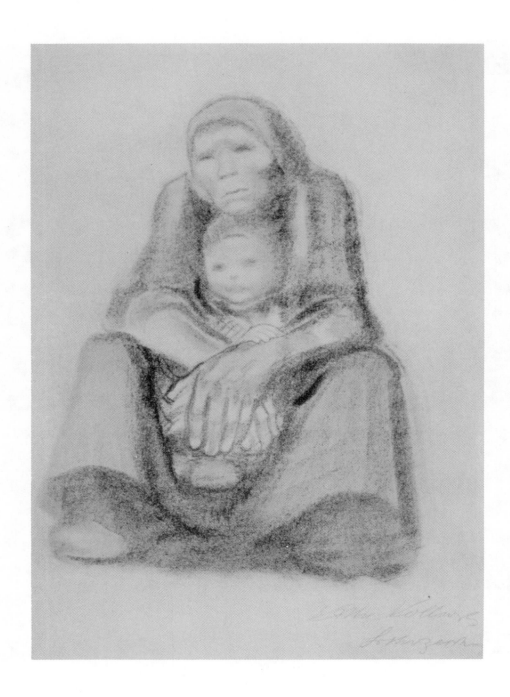

40 **Study for a sculpture**

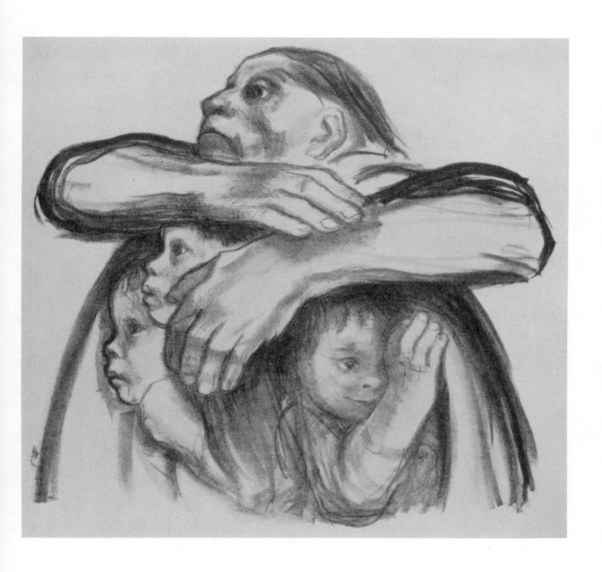

41 Mother protecting her children — "Seedcorn must not be ground"

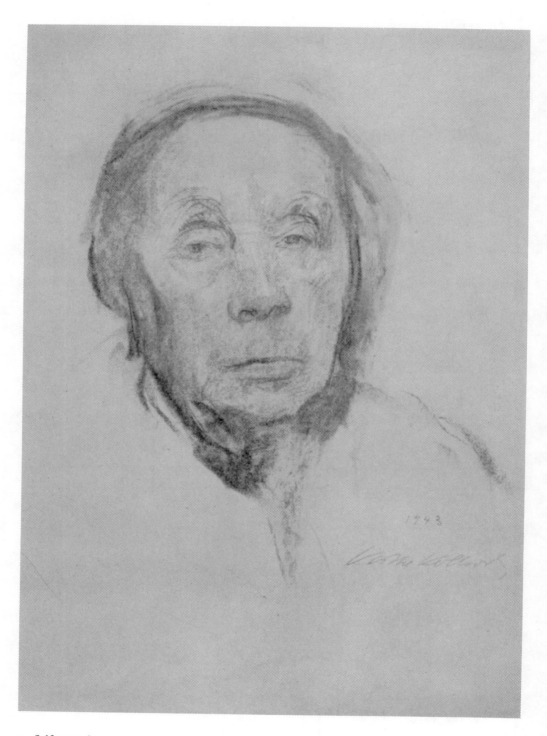

42 Self portrait

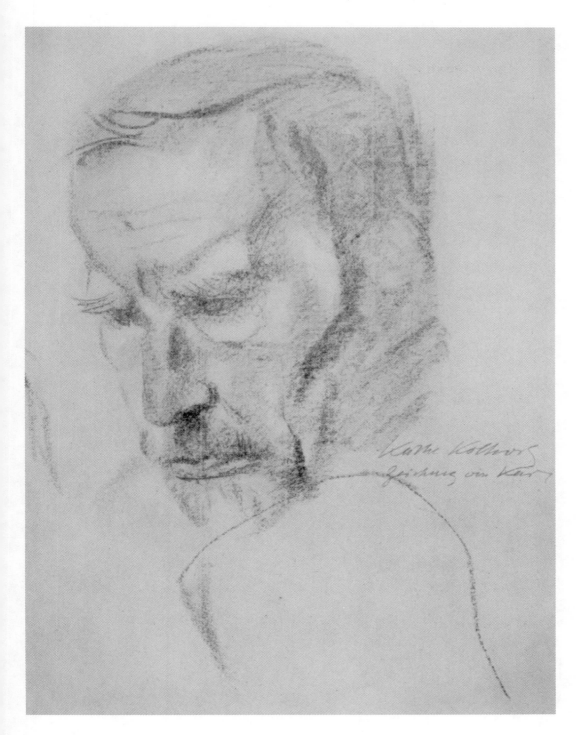

43 Karl Kollwitz

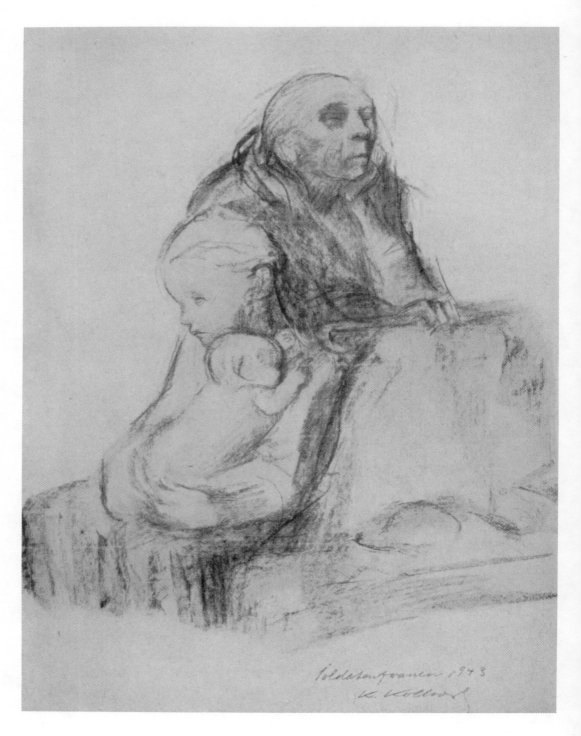

44 A soldier's wife

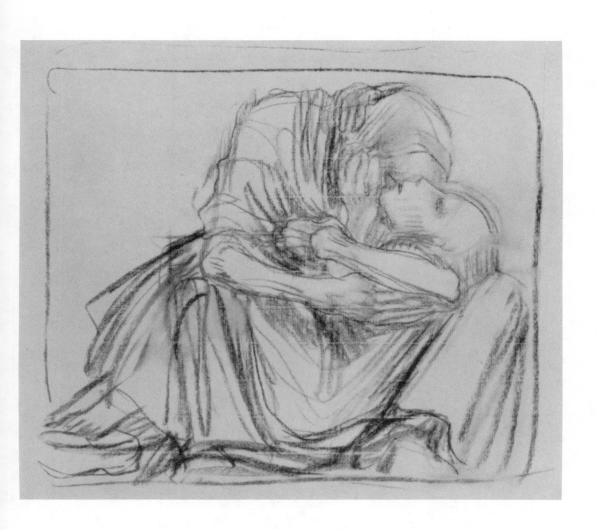

45 Death

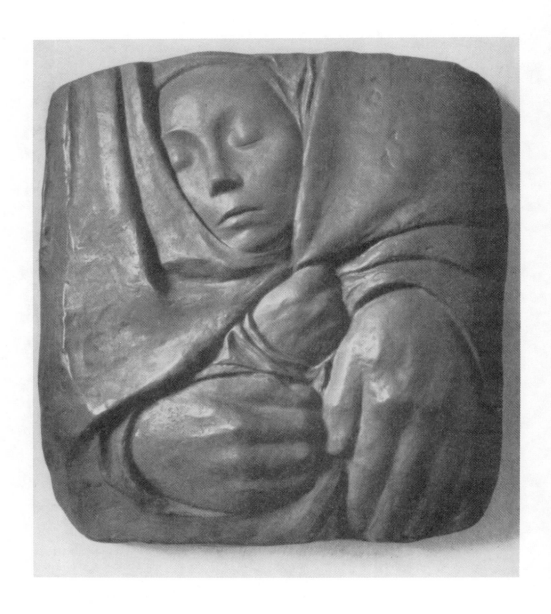

46 "Rest in the peace of His hands" (Relief for a grave)

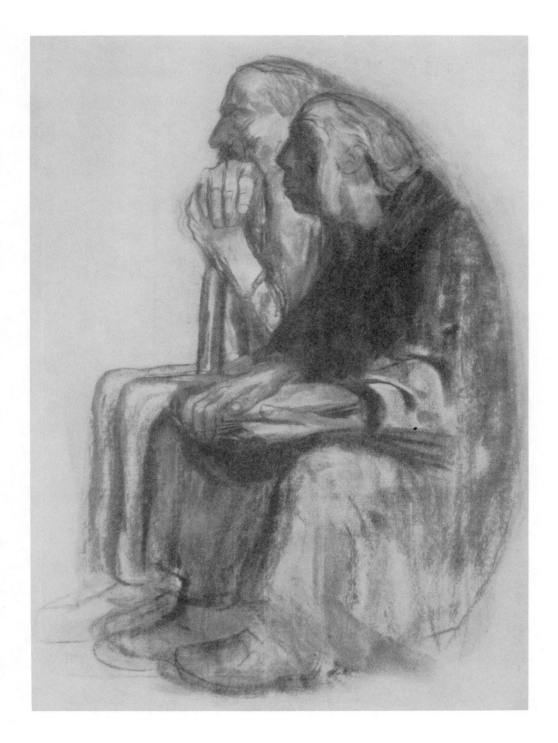

47 Self portrait with Karl Kollwitz

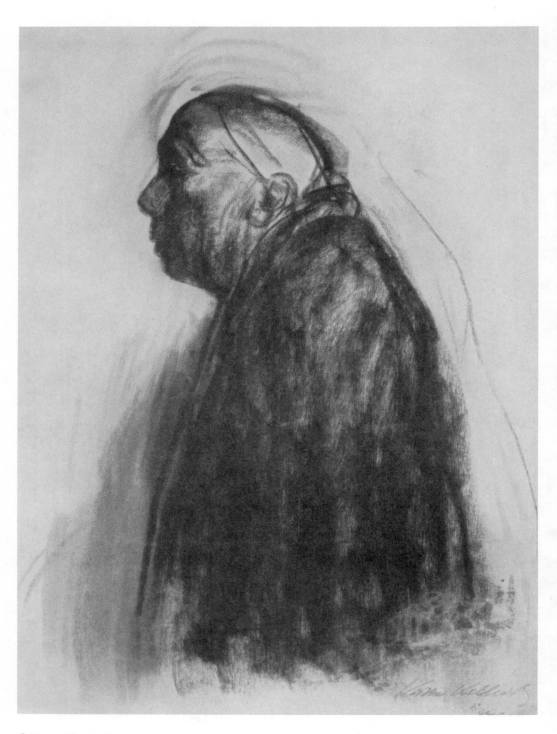

48 Last self portrait